This is a Parragon Publishing Book
This edition published in 2004

Parragon Publishing
Queen Street House
4 Queen Street
Bath BA1 1HE, UK

ISBN: 1-40542-986-0

Printed and bound in China

VAN GOGH

JOSEPHINE CUTTS AND
JAMES SMITH

Introduction by Lucinda Hawksley

p

CONTENTS

CONTENTS

INTRODUCTION

VINCENT Van Gogh has become known as one of the art world's most tragic figures. Although he was little recognized in his lifetime, within just a few years of his early death his distinctive style was influencing the artistic movements of the future and today his works sell for record sums. Vincent was an intelligent, articulate man, who spent much of his adult life dogged by depressive anxiety, caused by an unfathomed illness, currently attributed to either syphilis or porphyria (the illness that caused the famous "madness" of King George III of England). This unstable mind helped Vincent to create some of the most incredible works of fine art ever produced—but also led to his tragic suicide at the age of 37. Van Gogh's work remains some of the most exceptional ever produced by one artist. His diverse works encompassed radical changes in style, color, and subject matter, which was perhaps indicative of his varying states of mind.

Vincent Van Gogh was born on March 30, 1853 in the small Dutch village of Groot-Zundert, to a parson, Theodorus, and his wife, Anna Carbentus. Anna had actually given birth to a stillborn son, also called Vincent, on March 30, 1852, a coincidence which the surviving Vincent must have been conscious of throughout his life; and possibly one of the reasons for his excessively morbid imagination in later years. His childhood was, to all appearances, a happy one, spent in a forward-thinking family environment, surrounded by one of his greatest loves—the beauty of the countryside. He was the eldest of six siblings: Anna (b. 1855); Theo (b. 1857); Elizabeth (b. 1859); Wilhelmien (b. 1862); and Cornelius (b. 1866), who also tragically committed suicide, at the even younger age of 34.

Vincent's career in the art world began at the age of 16—at which time he was selling other people's art, not creating his own. His father's three

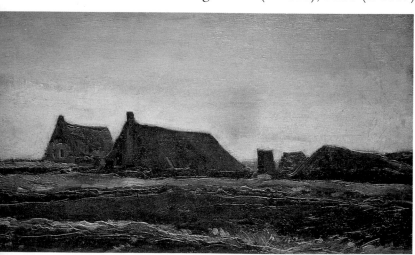

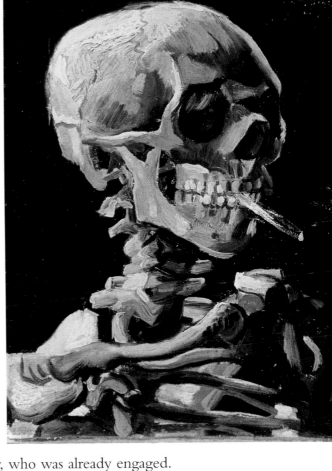

brothers were all dealers in fine art, so it was an unsurprising choice of career, and one at which he originally excelled. His first job was with his uncle Vincent, who worked at the Hague offices of a famous French art dealers, Goupil and Company. The young Vincent was employed as an apprentice in 1869. In 1872, his brother Theo began working at Goupil Company's Brussels office.

In 1873, Vincent was promoted—with the promotion came a move to the London offices of Goupil, in Stockwell. It was there that the first great emotional crisis occurred in his life: the unrequited love he felt for the daughter of his landlady, who was already engaged. It was after Eugenie Loyer's rejection of him that he experienced his first fits of melancholia, which later graduated into severe depression. As a result of his erratic behavior, Vincent's work began to suffer irredeemably. He no longer cared for his job and threw himself into a religious fervor, becoming less and less rational and causing his family and employers increasing alarm. He was eventually sent to the Paris offices—the firm's attempt to restore his equilibrium by taking him away from London. However, in Paris his behavior deteriorated further. He became something of a hermit, retreating from his work as much as possible, living an almost totally isolated life and devoting his life to studying the Bible fanatically. After several incidents of rudeness to customers, Vincent was permanently dismissed from Goupil and Company in April 1876.

Despite the heartbreak suffered in London, Vincent had developed a strong affection for England and decided to return there on leaving Paris. He took an unpaid teaching job at a school in Ramsgate, Kent, but the situation became intolerable as he became increasingly poverty stricken. After two months, this was alleviated by a parson from London, who offered him bed, board, and a paid teaching post. This began a contented period for Vincent, living and working with the Reverend and Mrs Slade-Jones, a couple with whom he forged a deep affection. During his time in London, he lived and

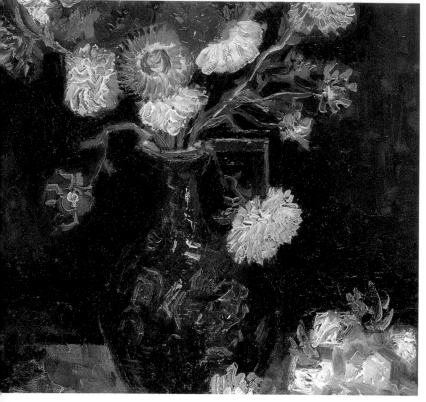

worked in several areas; these include the Bedford Park area (around Turnham Green), Isleworth, and Brixton. In the late 19th century, these areas were far less urbanized than they are today and his letters home include detailed sketches of the local countryside, buildings, and wildlife, as the budding artist strove to express in pictures the areas he had grown to love. Vincent was an extremely faithful correspondent, particularly to his favorite sibling, Theo, and to his mother. During his time in London, Vincent's religious and social conscience expanded. He became deeply troubled by the poor of the city, a sympathy that was to remain with him throughout his life and to become incorporated into many of his greatest works.

At the end of 1876, Vincent returned to the Netherlands; he worked in a bookshop for the first few months of 1877, thus maintaining the love of literature that stayed with him throughout his life. This is expressed in his own fluid and eloquent style of prose, exhibited in surviving letters to his family and friends. At this time, his intention was to become a minister, for which purpose he enrolled at the University of Amsterdam in May 1877. However, he did not complete the academic training, leaving university in July 1878 and moving to Brussels to undertake three months of studying to become a missionary. After completing his training, he moved to a poverty-stricken coal-mining area in South Belgium called the Borinage, which is not far from the town of Mons. His fervent belief that he had a vocation to help the poor, had taken hold during his time in London and continued upon his return to the Netherlands. For his first six months as a missionary he lived in the village of Paturges, before

before moving to the town of Wasmes. Over these last few years, Vincent had begun to pay more attention to his artistic skills. This continued throughout his preaching years and into his time in Borinage; many sketches and works, inspired by the Belgian coal-mining area, remain extant.

During his time at the Borinage, Vincent threw himself into preaching; sadly he was considered strange because of his overpowering religious zeal and he became distrusted by the community. The longer he spent as a missionary, the more zealous he became, with his actions bordering on insanity. He began to live a rigidly ascetic lifestyle; he gave up all his possessions, stopped eating properly and lived in a squalid, insanitary hut in an attempt to become more Christ-like. The church found this too much to take and dismissed him from his post. His failure to succeed in the church, following his failure in the art world, affected Vincent deeply, and it appears to have begun a second crisis in his life, though exactly what happened is uncertain as he, normally such a prolific correspondent, stopped all communication with his family, even with his adored brother Theo. After a few months, Vincent, seemingly rejuvenated, suddenly reappeared, writing to Theo and telling him that he had come out of his despair and had realized that his true vocation lay with painting. He made this decision in September 1880: "I am

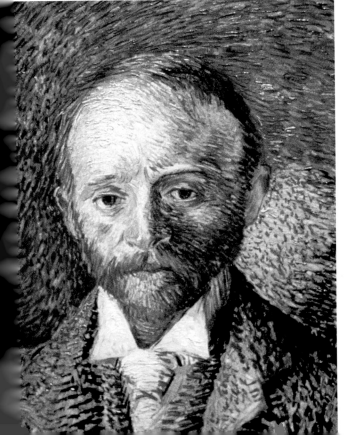

taking up my pencil again, I am putting myself to drawing anew and since then everything for me has been changed."

The many manual workers whom Vincent encountered during his time in Belgium inspired him to make many drawings and etchings of laborers seen in a religious atmosphere. His time at the Borinage inspired many sketches of the miners and he began looking to the work of Jean-François Millet (1814–75) for inspiration and style. As part of his self-taught technique, Vincent made copies of several of Millet's works,

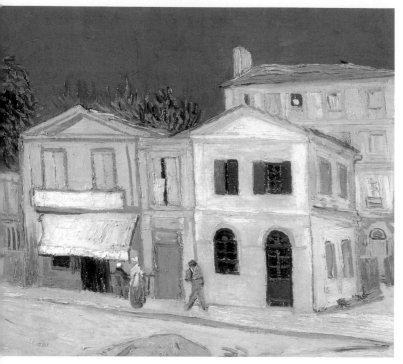

attempting to recreate the latter's themes and techniques. This theme, that of the god-fearing, hard-working people, the "salt of the earth" being more deserving of salvation, was to permeate his work. Perhaps the most famous example of this philosophy is espoused in his painting *The Potato Eaters* (1885).

Vincent's first home as an artist was in Brussels, where, from October 1880 until April 1881, he shared a studio with the Dutch painter Anton van Rappard. Vincent began his new career as a book illustrator; his lifestyle was financed by Theo.

Later in 1881 Vincent returned home, spending several months living with his parents in their new parish of Etten, not far from Groot-Zundert. Here he continued his studies of rural life and the local workers. The time at his parents' home provoked a second unrequited passion—this time for a widowed relative. Not surprisingly, his very recently bereaved cousin Kee Vos-Stricker was unmoved by his declarations. Vincent followed her and her family to Amsterdam where Kee, in exasperation, made it explicitly clear that she was not interested in him, and never would be.

Dejected and depressed, Vincent nonetheless had the ability to move on after this second unrequited passion, and settled in the Hague, where he began studying art in earnest under the tutelage of one of the foremost artists of the day. Anton Mauve (1838–88) was a prominent member of the Hague School, as well as being related to the Van Gogh family. By this time Vincent had fallen out with his father and was now totally dependent on any money he could earn from his art and the meager allowance sent to him by Theo. His time in the Hague began promisingly enough: Mauve introduced him to the celebrated painters of his acquaintance and Vincent began moving in the most important artistic circles of the time. He began to study the styles of many different painters and to read voraciously. He loved the works of contemporary novelists such as Charles Dickens, Emile Zola, and Victor

Hugo. The months he spent working and studying were extremely formative in the creation of his particularly unique style.

Just as Eugenie Loyer's rejection of him had caused him to shut himself away in London, Kee's rejection led Vincent to look elsewhere. Within a few months of settling in the Hague, he met and moved in with a local woman, Sien Hoornik. She was a single mother, a prostitute, and pregnant with her second child when she met Vincent. She appears in several of Vincent's sketches, including a poignant drawing entitled Sorrow, in which she is depicted sitting naked, with her head bowed. Vincent's mastery of the human form can be seen in these drawings, which are depicted in a style unlike any of his later oil paintings.

Van Gogh's unconventional behavior added fuel to the already prevailing rift with his deeply Christian father, scandalized Hague society, and effectively cut him off from what could have led to a more prosperous lifestyle and important financial patronage. During this tempestuous period in his life, the elder van Gogh considered having his son committed to an asylum for the insane, although his ever-faithful brother Theo stood by him.

By the end of 1883, Vincent and Sien had parted company. Leaving her behind, he moved to Drente in the north-east of Holland, where he lived from September to November. Here, guilt about Sien and frustration with his inability to make his way in the world without Theo's financial assistance depressed him, heralding another period of deep melancholia.

The depression led him to return, in December, to the new home of his parents, who had moved to a parish at Nuenen, in the east of North Brabant. The rift remained between him and his father and the Van Goghs lived in an extremely strained

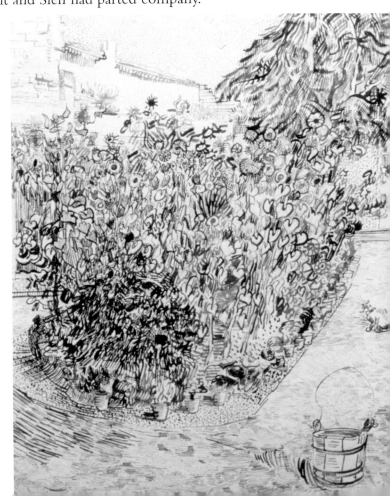

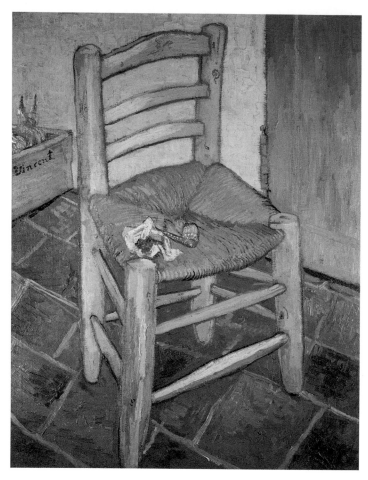

atmosphere for the first few months after his arrival. This was resolved when his mother suffered a debilitating accident and Vincent became her nurse, tenderly guiding her back to health. The reconciliation this brought about with his father was timely, coming just weeks before the latter died suddenly, in the spring of 1885.

The rural area of Nuenen inspired Vincent and his work became more prolific. Between 1883 and 1885, he produced more than 50 sketches of local people, which he used as preliminary drawings for his 1885 masterpiece, *The Potato Eaters*. Into this work he pushed all his creative energy, which was fueled by the emotion caused by his father's death. He was also fired by the energy of the peasants, particularly by the hard-working women of Nuenen. *The Potato Eaters* was his paean to the working classes, the social group he considered to be the closest to Christ. He wrote the following comments about his painting in a letter to Theo, "I thought of what had been said of those [peasants] of Millet, that they seem to have been painted with the very earth that they sow." As he was later to do with *The Sower* (1888), he followed Millet's example in the pastoral subject matter chosen.

In November 1885, Vincent traveled to Antwerp, where he enrolled as a student at the Academy of Fine Art. He remained only a few months, due to disagreements with his tutors—his drawing tutor insisted he be moved to the preparatory class as his standard of drawing was not high enough. These few months at the Academy were to have a lasting effect on his art, introducing him to the works of Rubens and

of Rubens and changing his previous conceptions about color. His palette became lighter and paintings executed after this time often show a brightness not seen formerly.

In spring 1886, after leaving the Academy, Vincent moved to Paris. He had been ill and craved the calming, loving force of Theo, who was now working at the offices of Goupil and Company from which Vincent had been dismissed. Never able to cope with rejection, Vincent also sought reassurance from Theo after the blow of relegation at the Academy. The brothers spent two years living together, during which time Vincent's artwork became more and more prolific. He saw the new exciting works of art that Theo was selling, works by painters such as Camille Pisarro (1830–1903), Alfred Sisley, (1839–99) and Armand Guillamin (1841–1927). He also became acquainted with Toulouse-Lautrec and grew increasingly interested in Japanese art; the influence of these can be seen in several of his paintings dating from this time. By now Vincent had mastered several media, including etching, watercolors, oils, and pencil. It was an exciting time for art, with Impressionism and Pointillism making a strong impact on the worlds of both artists and collectors. Van Gogh was fascinated by these styles and spent much time studying the techniques and palettes of the radically new schools. Alongside Millet he began to study the works of Rubens, Degas, Signac, Delacroix, Doré, and Daumier, among others.

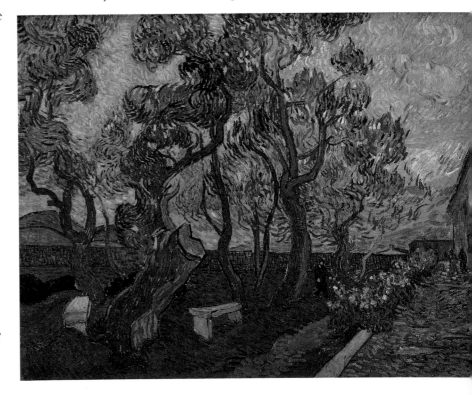

In February 1888, Vincent left Theo and Paris, longing to return to the countryside. He moved to Provence, where he created some of his most famous works, such as *Sunflowers* and *The Harvest*. He lived in

of the River Rhône, for ten months, in what is now seen as the pinnacle of his career. Provence inspired him in a way he had seldom felt inspired before; he wrote to Theo of the "limpidity of its atmosphere" and raved about "the brilliance of its color." His works from this time are mesmerizing; he worked prolifically and leapt wildly between styles, often veering from one direction to another within a single week. In 1888, for instance, he produced, amongst others, *The Sower at Sunset*, *Street in Saintes-Maries*, *Peach Trees in Blossom,* and *Harvest in Provence.* At times his style appears strongly influenced by Impressionism: a strong sense of natural light merging the colors together and blurring the edges; the brushstrokes are heavy, leaving the canvases encrusted with a richly tactile layer of paint, the edges of shadows and objects blurred, to give the viewer an indistinct impression of looking at a scene in full sunlight. Yet, in stark comparison, his work can also be bitingly sharply defined in bold primary colors. In this latter style, he uses fine, unbroken lines, thinner paints, strong blocks of color and finer brush strokes. Both styles are equally masterful in content and construction, and both evoke the same sense of a reality of light, albeit through wildly differing methods.

During Vincent's time in Provence, he was visited by fellow artist Paul Gauguin (1848–1903), with whom he had developed a close, but tempestuous, relationship. Gauguin was intending to make the move to Provence permanent, thereby beginning Vincent's long-held dream of creating a commune of artists, all living and working in the same area, feeding off one another's artistic energy, and providing a close-knit community of assistance and understanding. Sadly, after a couple of months of living together, the two men had fought and Gauguin left. This had contributed to Vincent suffering a severe mental

breakdown—the fit of madness that led to his cutting off part of his ear. One of his most poignant self-portraits shows himself with the ear bandaged. Terrified by this fit of insanity, he admitted himself to Saint-Paul's Asylum, situated not far from Saint-Rémy, the bills footed by Theo. For a year he vacillated wildly between fits of madness (including one suicide attempt) and lucid periods of sanity. The progressive-thinking asylum was set amid beautiful grounds, and the intense experience of being here—both anguishing and calming—proved an artistically productive time for Vincent, who created over 200 works during this period. One of his most memorable works of 1889 was the evocative oil painting *Starry Night*. The words Vincent used to explain his painting to his brother indicate his state of mind: "Why should those points of light in the firmament ... be less accessible than the dark ones on the map of France? We take a train to go to Tarascon or Rouen and we take death to reach a star."

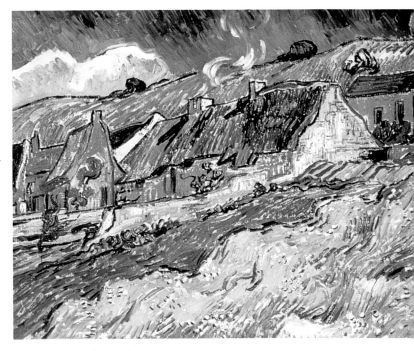

January 1890 saw the first positive artistic review of Vincent's work, which was written by the critic Albert Auricr. This may have contributed to Vincent's return to positivity. By May 1890, he felt revitalized and able to return to the outside world. Discharging himself from the asylum at Saint-Rémy, he returned to live with Theo, who had now married. The artist's life seemed to be heading back on track and soon he had moved 20 miles north of Paris, to the countryside of Auvers-sur-Oise. In the weeks that followed he painted constantly, producing more than 70 works between May and July. Tragically his mental recovery proved only temporary and, on July 27, 1890, Vincent shot himself. It took two days for him to die. Fittingly, Theo was with him for his last hours.

LUCINDA HAWKSLEY

OLD WOMAN SEWING (1881)

Rijksmuseum Kröller-Müller, Otterlo. Courtesy of Edimedia

*I*NTERESTINGLY, *Old Women Sewing* was one of Van Gogh's first paintings, although even at this early stage, he was already beginning to experiment with the effects of light and color. A natural light from the window flows in and falls gently over the woman's face and her sewing. This is contrasted with the darker color that envelops the walls. A second portrait of a woman sewing, from 1885, displays a very similar style and technique. This was a difficult achievement for the artist, who tried to capture backlit figures in profile, within an interior. He wrote in one of his letters to Theo, in 1885: "I do not know whether or not I shall ever finish it, as this is a difficult effect, although I believe I have learned one or two things by it." It was a theme that was to occupy many of his Dutch paintings.

Van Gogh took this influence from the French master, Jean-François Millet (1814–75), who was famous throughout Europe for his realistic and evocative scenes of peasant life. Van Gogh produced several works depicting women and men weaving, as well a large number of sketches and paintings, illustrating peasants performing daily work activities. This early series presenting the routines of peasant workers were executed in watercolor, ink, and pencil. Later, Van Gogh would begin to experiment with oils.

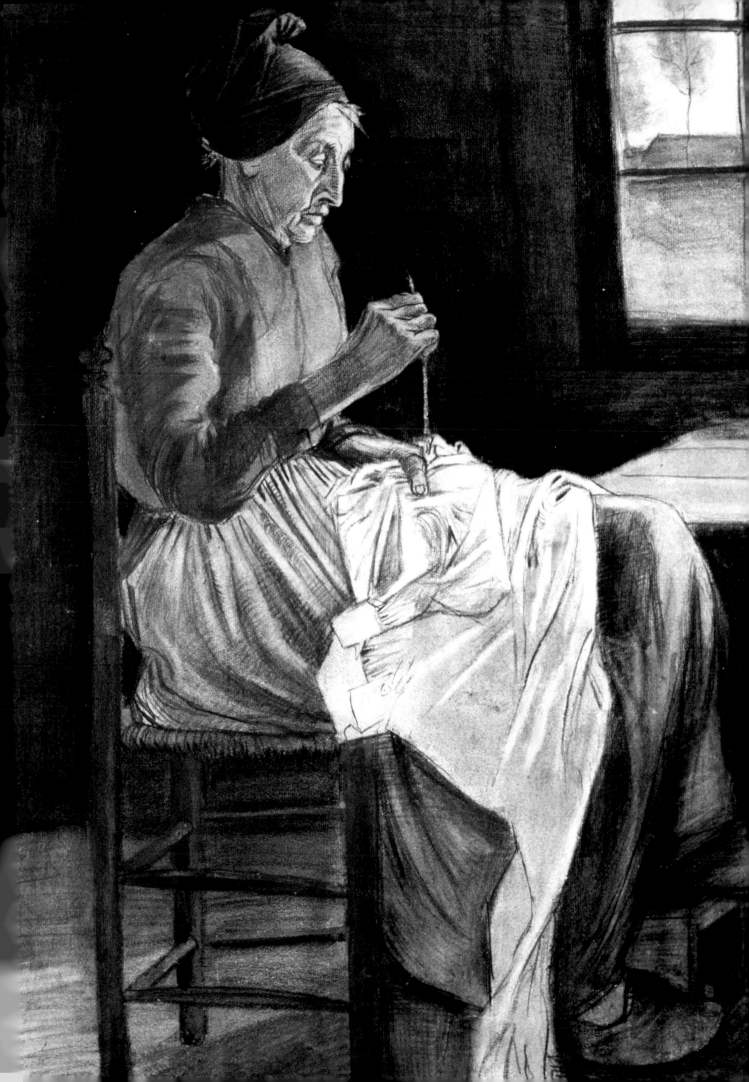

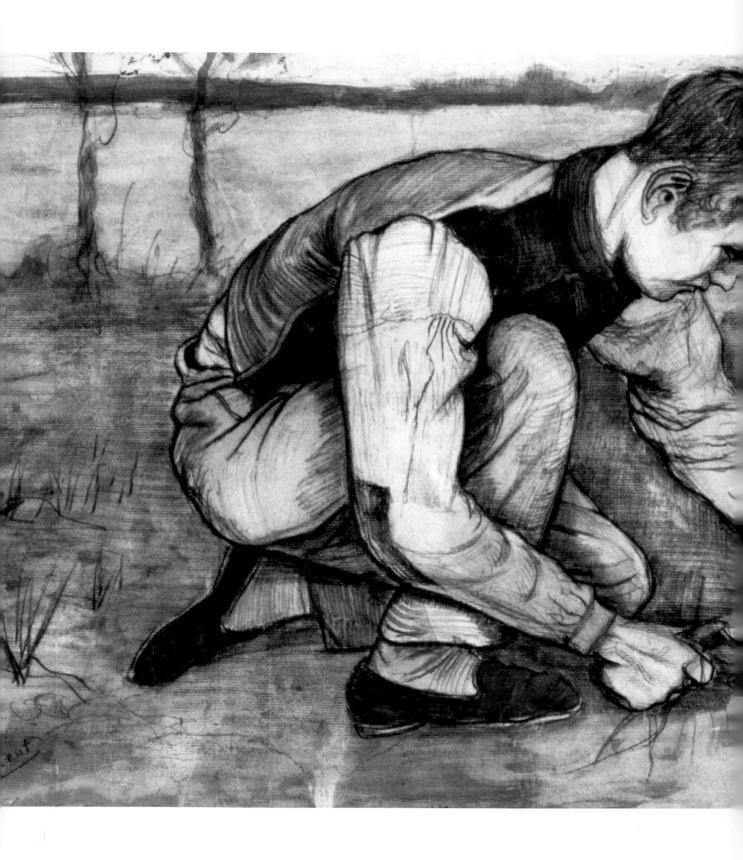

BOY WITH SICKLE (1881)

Rijksmuseum Kröller-Müller, Otterlo.
Courtesy of Edimedia

EVEN though the figure in this drawing is that of a young boy, he appears to be prematurely aged, an impression conveyed through the tired, worn, and shadowed areas of his eyes and the dark lines on his hands.

Boy with Sickle is a drawing suitably representative of the style, nature, and content of Van Gogh's works from this early period of his career. The subject is depicted at work, seemingly unaware that he is being watched. A specific compositional comparison can be drawn between this work and Van Gogh's later painting, *Man at Work* (1883). Both subjects are portrayed in very similar poses, and observed from the same perspective. They are also shown within the context of the land, which reflects a personal aspect of the artist, for Van Gogh's early drawings often presented his figures in such an environment. However, a more unique aspect of *Boy with Sickle* is that the youth is cast in disproportionate size to the surrounding fields, since we see him in close proximity.

MAN READING THE BIBLE (1882)

Rijksmuseum Kröller-Müller, Otterlo. Courtesy of Edimedia

THIS is another delicate and graphic image from Van Gogh's early period, spent in the Hague. Initially, Vincent had hoped to pursue his passion for religion as a career. He enrolled in a missionary school in Belgium, determined to help those in need and preach to the poor. Van Gogh spent this time living amongst the miners in southern Belgium. This period was short-lived, since his revolutionary ideas meant that the Church did not reengage him the following year.

After this he made the decision to become an artist, since he believed this was now the means by which he could best perform God's work. Vincent spent many evenings reading aloud from the Bible, and in this portrait of a man with his bible, it seems as though Van Gogh is asserting a continuous religious allegiance. It is likely that he is discussing this drawing in one of the letters he wrote to his brother Theo, in which he describes two recently completed works: "I have two new drawings now, one of a man reading his bible, and the other of a man saying grace before his dinner."

This portrait displays harsh realistic values through the use of dark pencil tones and the absence of color, which can be likened to the effect achieved in a black and white print or photograph. The folds of the man's shirt, the printed text in the book and the expression on the face are all executed with compassionate and descriptive detail.

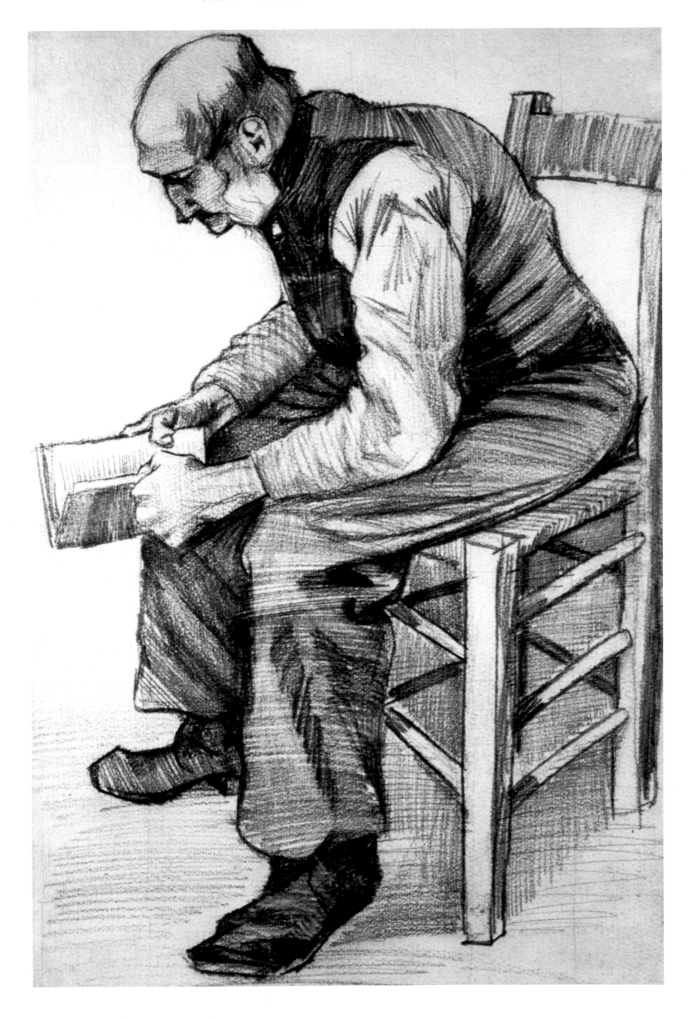

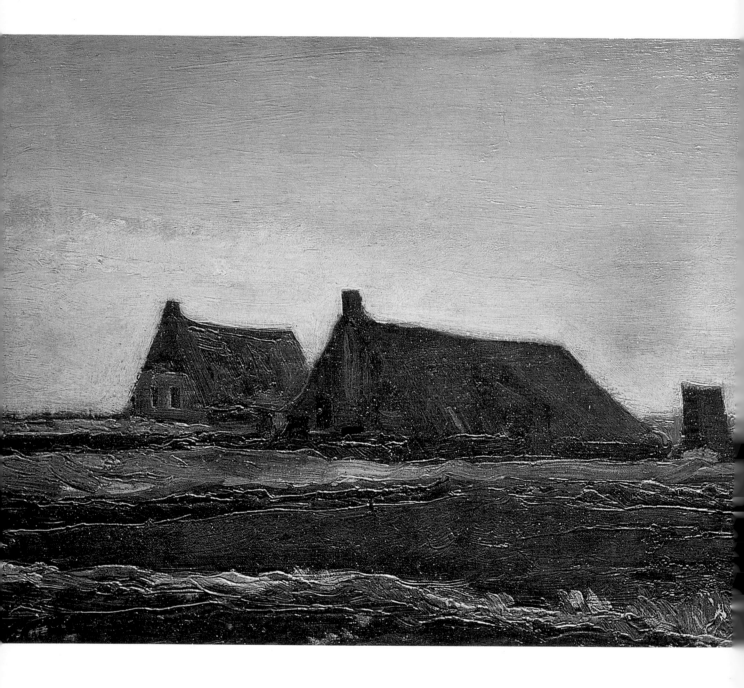

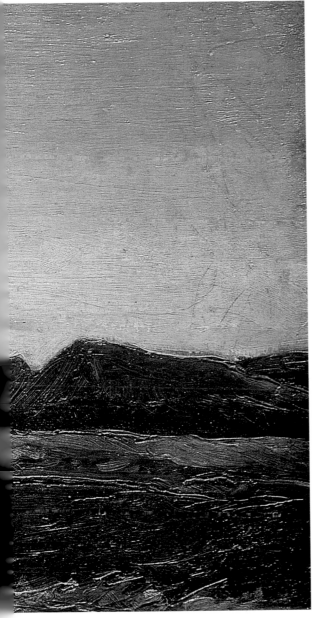

TURF HUTS (1883)

The Van Gogh Museum, Amsterdam.
Courtesy of Edimedia

*I*N 1883 Van Gogh spent a short period of time in the Hague. It was here that he made oil studies, of which this is one. In Etten he had usually used watercolors, but his transition to the new medium was a happy one. Indeed, he was so positive about his first attempts in oils that he mentioned them in all his letters to his brother Theo. Critics have suggested that this relentless enthusiasm might have had more to do with Vincent encouraging his brother's continued philanthropy than any feelings of genuine breakthrough. Oil paint was more expensive than watercolor paint and it was Theo, as benefactor, who would incur the increased charges.

Turf Huts, like most of Van Gogh's work from the Hague, was typical of the 19th-century orthodoxy in painting. Peasant landscapes in almost exaggeratedly dark tones were very much the flavor of the day. Where Van Gogh departed from convention was in his working method. Typically, artists would complete all their work in the studio, but Van Gogh took his easel with him and painted directly from nature. Furthermore, he rejected the trend for smooth, flawless finishes, choosing instead to squeeze the paint directly onto the canvas and layer it on the surface quite freely and thickly.

WOMAN SEATED ON OVERTURNED BASKET (1883)

Rijksmuseum Kröller-Müller, Otterlo. Courtesy of Edimedia

A BLEND of crayon and chalk is used here to conjure a sad and melancholic image, which reflects the darkly characteristic tones of Van Gogh's Nuenen period, from 1883 to 1885.

In this work, the artist portrays a peasant woman in an attitude of personal despair. She sits with her face hidden in her hands, as though she is mourning. Her sorrow occupies the entire canvas, and we are drawn to her presence in an otherwise vacant room.

Technically, *Woman Seated on Overturned Basket* demonstrates Van Gogh's skill as a draftsman, which is illustrated in similar works, such as *Girl with a Shawl* (1883) and *Woman Binding Sheaves* (1885). All of these drawings expound a creative life and movement, which emanates from them despite their demure palette. Each displays an overt realistic quality, which makes them memorably evocative.

Compositionally, *Woman Seated on Overturned Basket* can be likened to Van Gogh's later painting, *Mourning Old Man* (1890). Considered together, they show that although the artist's style and palette experienced a dramatic development between the completion of the two works, the characters convey a similar mood of loneliness and self-reflection. The artist assumes a close proximity between himself and his subject. This is another example of how Van Gogh also revisited certain themes in his work at different points in his life. Reinterpretation was to emerge as an important feature of his career.

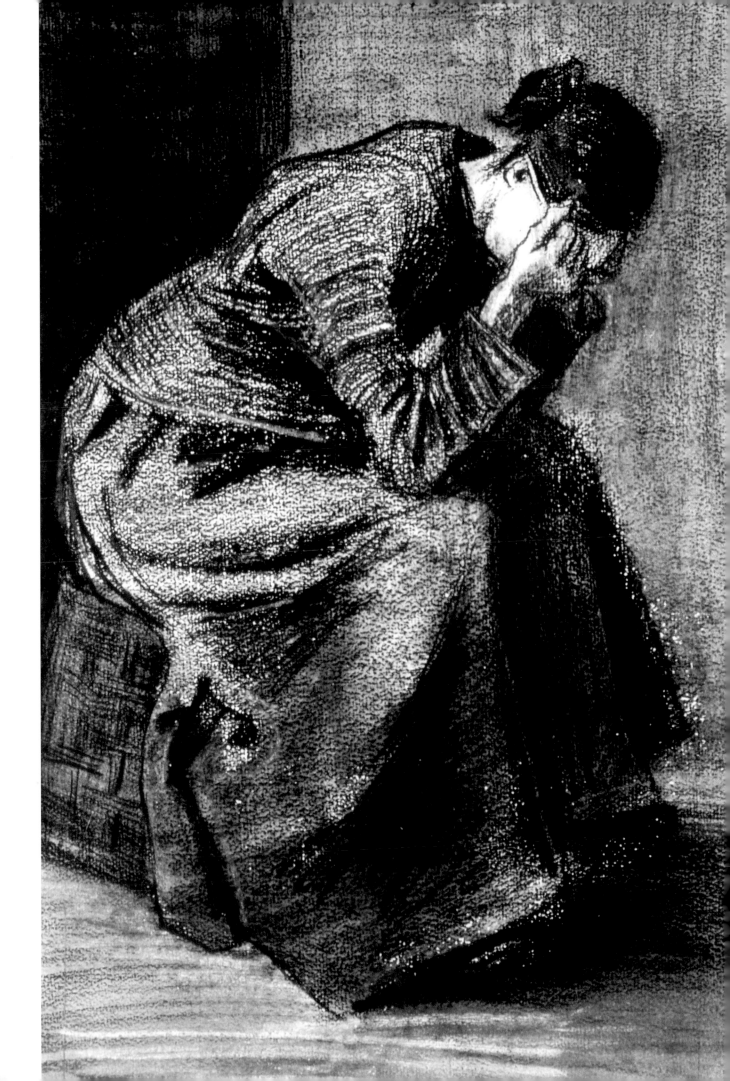

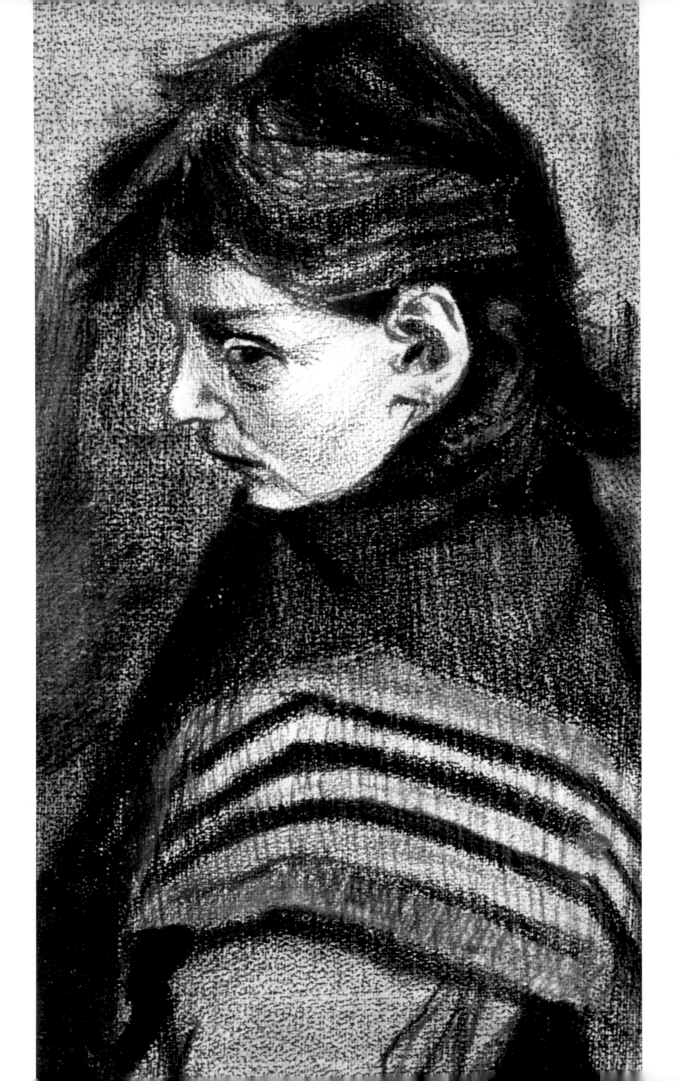

GIRL WITH A SHAWL (1883)

Vincent Van Gogh Museum, Amsterdam, Netherlands. Courtesy of Edimedia

*T*HIS private and intimate portrait presents a lonely impression of a young peasant girl. She is regarded from an unusual perspective, as we view her in side profile. The girl belonged to the parish that Van Gogh served. She was from the poorest working-class background, and we can see Van Gogh's deep concern and sensitivity toward the poor and deprived in his treatment of this subject.

The artist's choice of medium is cleverly suited to the theme of poverty; Van Gogh has outlined the girl's figure and features in muted and demure shades of black chalk. He has also added areas of wash, pencil, and black lithographic crayon, working into other parts of the drawing with a scoring knife.

The grain of the material beneath seeps through parts of the image, heightening the mood and expression of the drawing, whilst providing the girl's form with a more three-dimensional appearance. *Girl with a Shawl* was completed whilst Van Gogh was living in the Hague, during the early part of January 1883. The sketch successfully illustrates the artist's somber mood and the effect upon him of the winter months.

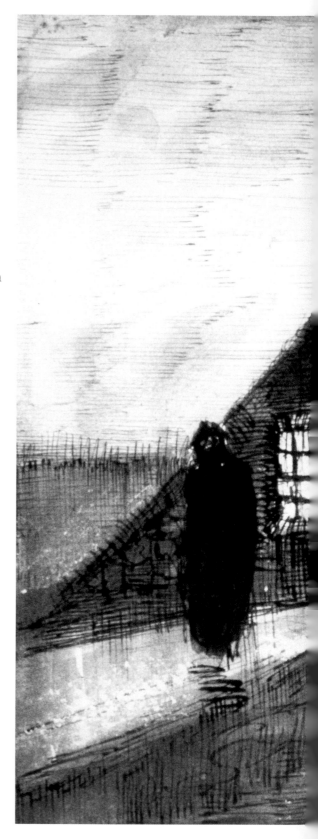

COTTAGES IN THE HEATH (1883)
Courtesy of Edimedia

*V*AN Gogh's move to the Hague marked a significant step in his development as an artist. The political capital of Holland was also the center of the Dutch art world and Van Gogh was keen to become a part of it. Despite the fact that he had moved in with an ex-prostitute and her two children—all of whom he took on the burden of supporting—his specific aim became to embark seriously on an artistic career. He managed to get a studio and his first paintings were influenced by Anton Mauve, a cousin of Van Gogh and a celebrated contemporary Dutch artist. Mauve was a member of a group of artists who painted en plein air (outside), and Van Gogh took up this example with all the enthusiasm of one eager to learn. Tapping into the rich landscape tradition of his native Holland, Van Gogh's choice of subjects also showed his willingness to take lessons from the Dutch Old Masters.

This canvas is typical of Van Gogh's early work and reveals all his initial influences, as well as his break with them. It may be a landscape in the great Dutch tradition but, unlike the remote and detached vistas of the past, it shows significant evidence of human intervention.

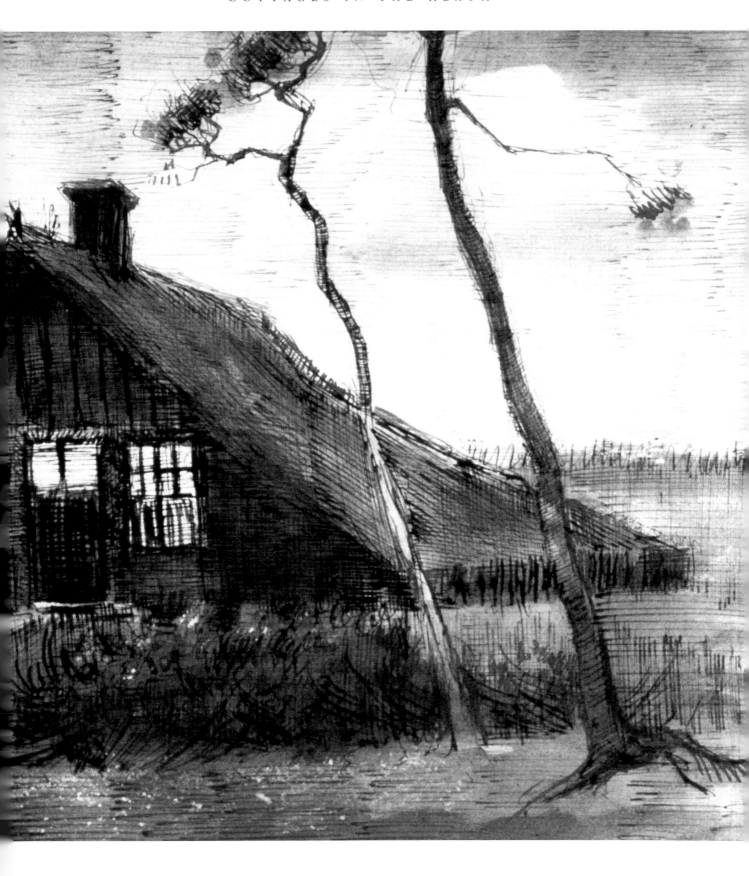

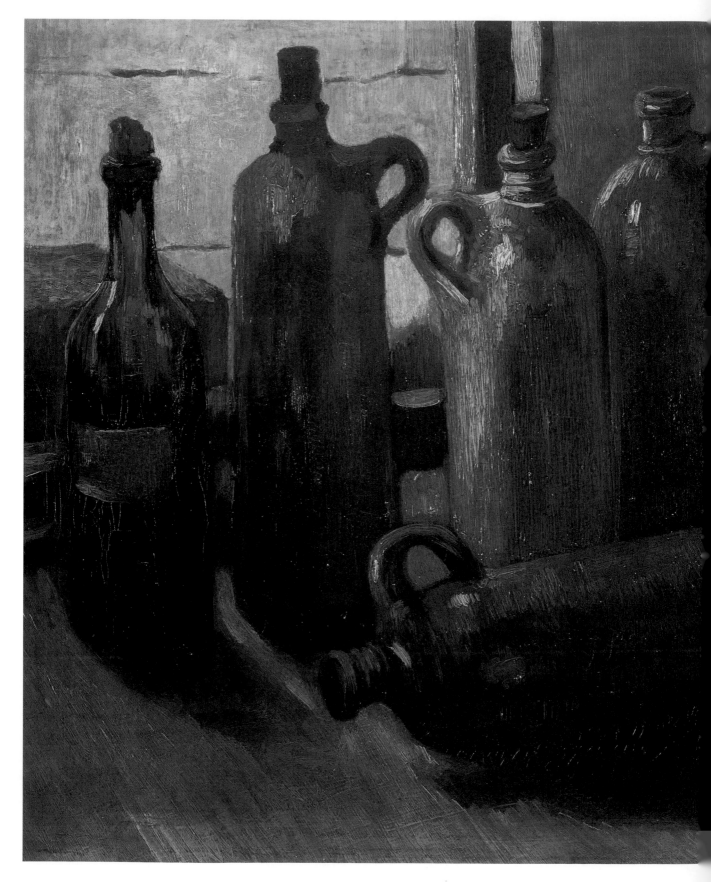

STILL LIFE WITH BOTTLES
(C. 1884–85)

Oesterreichische Galerie im Belvedere, Vienna.
Celimage.sa/Lessing Archive

ALTHOUGH dark, or perhaps somber in mood, Van Gogh's Dutch paintings successfully incorporate a surprising variety of colors, as seen here. Earthy and hazy shades define the individual bottles, and a warm and dusty yellow suggests areas of natural light. The golden mist embellishing the arrangement makes it appear as though we are observing this scene in early morning light.

As with the self-portraits, Van Gogh's still lifes also illustrate a changing and progressive method, confounding the critics' attempts to contain him within a single style. The artist painted a number of still lifes throughout his career, largely because of his financial situation, which meant that he was unable to afford models as subjects.

While some regard these early paintings, such as *Still Life with Bottles and Earthenware* (1884–85) or *Still Life with Bottles*, as studies, part of Vincent's early artistic development, they are in fact, just as personally revealing and commendable as his later works. Stylistically, *Still Life with Bottles* may seem quite flat, as though the colors have not been utilized to their best effect. However, the painting undeniably reflects an emerging genius.

PEASANT WOMAN WORKING OUTSIDE COTTAGE (1885)
Art Institute, Chicago. Courtesy of Edimedia

VAN Gogh's preoccupation with peasants initially saw him concentrate his attentions on the weavers, but soon broadened out to become a virtual obsession. In his own words: "Through seeing peasant life so continually at all hours of the day I have become so involved in it that I certainly almost never think of anything else." The daily reality of peasant life became the central theme in Van Gogh's entire artistic output at this time.

Scenes such as this formed part of the long and difficult struggle Van Gogh underwent in order to attain a technical grounding for his art. Having taken up painting at a relatively late stage in his life, Van Gogh had no formal artistic training behind him when this picture was painted. His subsequent achievements owed much to the hard work he put in during this period.

The scene itself features two thatched houses, which Van Gogh compared to the birds' nests he was collecting, calling the cottages "human nests." In his choice and treatment of subject, he was very much inspired by the artist he admired most, Jean-François Millet (1814–75). Millet's scenes of social realism were copied more directly in later works such as *La Sieste* (1889).

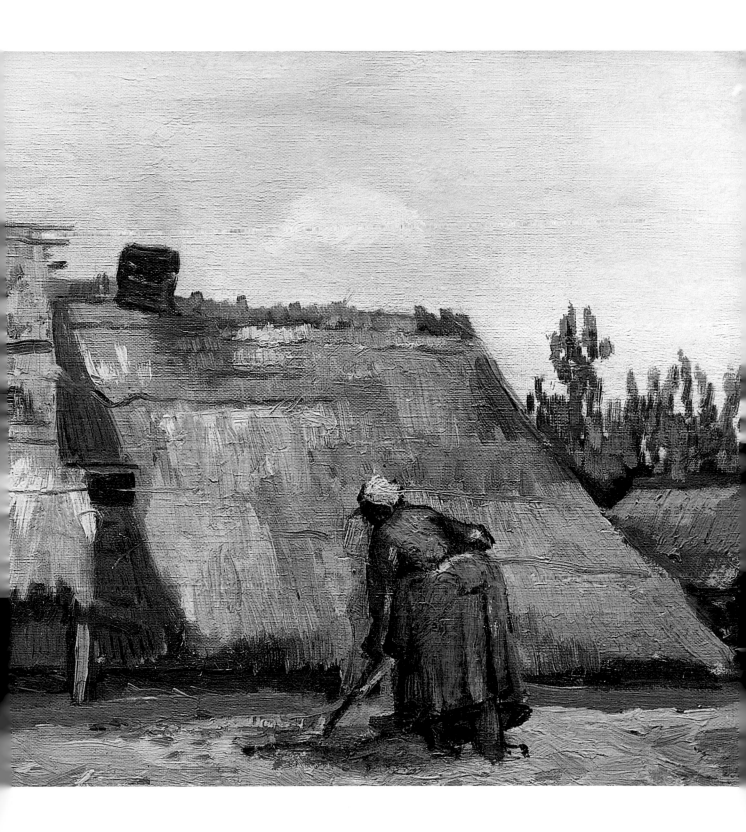

WOMAN BINDING SHEAVES (1885)
Courtesy of Edimedia

*J*N 1885 Van Gogh embarked on a series of portraits, of which this is one. He had been encouraged to do so by friend and fellow artist, Anton Van Rappard, who thought it would be a good form of preparation for Van Gogh's imminent trip to Antwerp. The advice was taken up wholeheartedly: "To get more experience," Van Gogh pronounced, "I must paint fifty heads because right now I am hitting my stride. As soon as possible, and one after the other" A while later, he was keeping his promises: "As you know," he wrote to Theo, "I have painted scarcely anything but heads of late."

Van Gogh's determination to master the essential tools of draftsmanship found him spending a large proportion of his time in the Hague, compiling studies of models. The woman here is portrayed performing a daily duty of binding sheaves. As with numerous such works, the subject is observed without her knowledge, as Van Gogh intended to capture the true nature and hardship of peasant life.

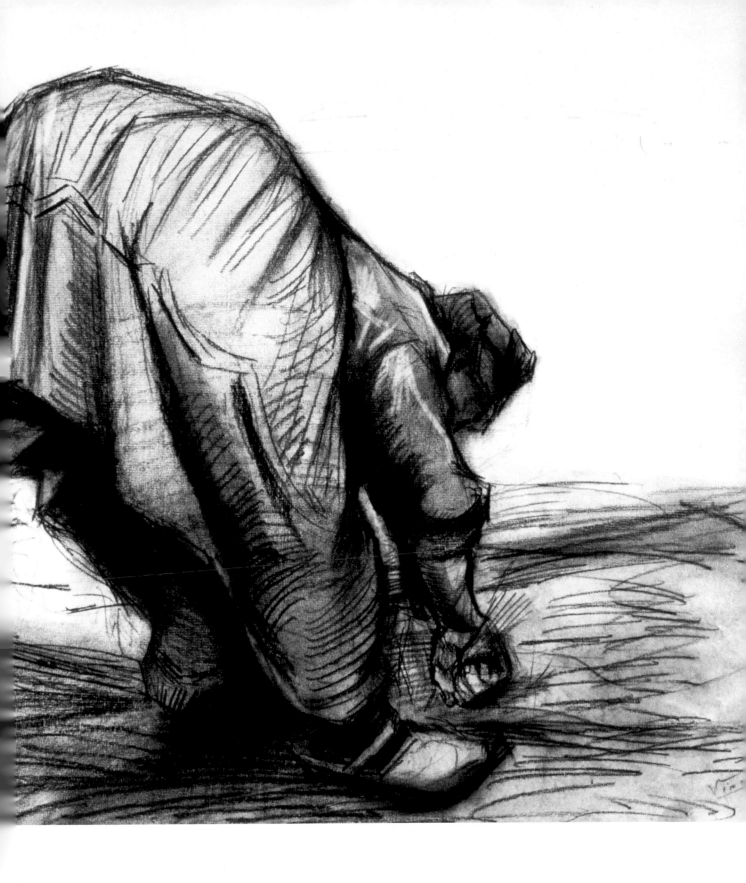

35

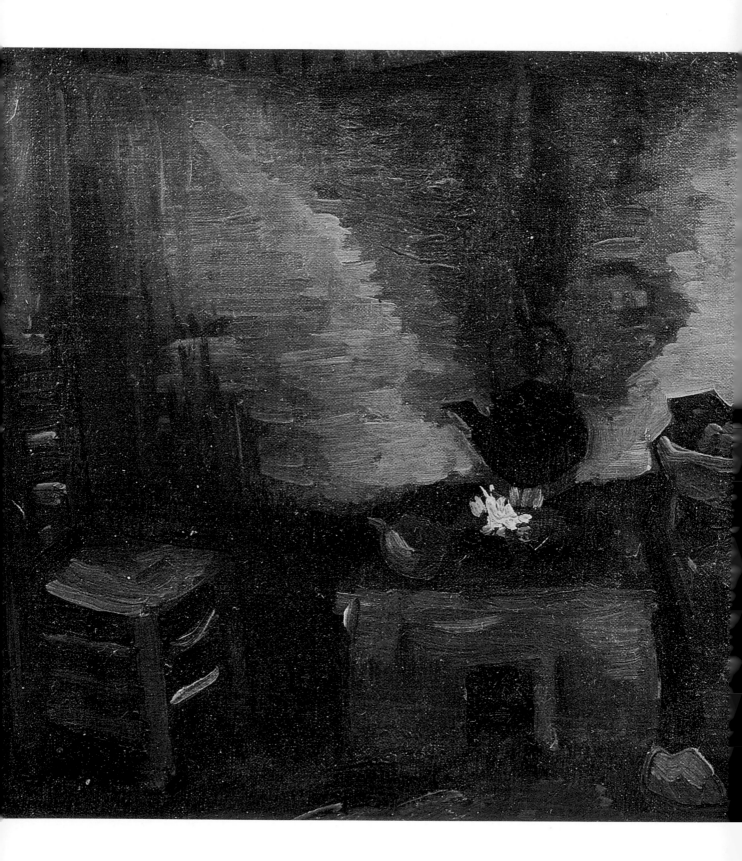

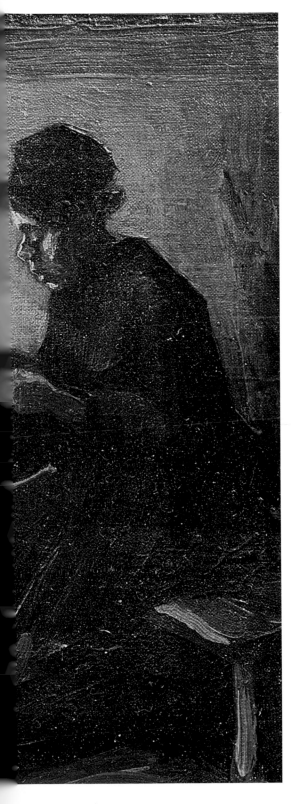

PEASANT WOMAN AT FIRESIDE (1885)

Musée d'Orsay, Paris. Celimage.sa/Lessing Archive

*V*AN Gogh's affinity with peasants and their *modus vivendi* again makes itself plain in this painting. It was an iconography that he turned to time and time again. Here a woman prepares the evening meal, an event itself depicted in the famous *The Potato Eaters* of the same year. A plain straw chair on the left is the same type of furniture with which Van Gogh furnished his own room in the Yellow House at Arles three years later. The attachment Van Gogh felt, therefore, to this whole milieu was familiar and intimate. Van Gogh related to this kind of person as "one of his own."

For all his empathy, however, Van Gogh did not actually want to *be* a peasant. His ambition to launch upon a successful career as an artist saw him send paintings from this time to Theo in Paris. He, in turn, would show them to art dealers in the hope that those dealers would buy them for large sums of money. It was the latter part of this scheme that ran into difficulties.

As a profit-seeking art dealer, Theo did want to sell his brother's paintings, if only he could find a buyer. The problem, typical of *fin de siécle* Paris, was one of fashion. Excessively dark, provincial peasant scenes such as this were never going to compete with the latest colorful, airy trend to hit the capital around this time—Impressionism.

SKULL WITH A CIGARETTE (1885)

Vincent Van Gogh Museum, Amsterdam. Courtesy of Edimedia

*T*HIS painting was produced during the winter of 1885–86, while Van Gogh was staying in Antwerp. He moved here so that he would have the opportunity to draw and paint live models, at the Academy of Fine Art. Here, Van Gogh learned with the aid of prints and plaster casts before being allowed to study nude models. Skeletons were often used to increase the students' understanding of human anatomy.

Skull with a Cigarette is one of Van Gogh's most memorable works. The recording of the skeleton's bone structure is quite accurate, and yet, through the application of his medium, Van Gogh is still able to convey his individual technique and style onto this canvas. It is as though he brings the structure to life, through animated strokes of golden color that seem restricted only by the constraints of this form. Their contrast with a dark and flat backdrop simply accentuates this impression.

The lighter parts of the skull are more concentrated and thickly painted, but are challenged by the dark shadow that lurks beneath. A clever interplay of light and dark tones is achieved through a varying brush technique and a limited palette. Thus, Van Gogh establishes his own interpretation of a common anatomical artistic motif.

Skull with a Cigarette was probably painted with a humorous intention, although underlying it was a private criticism of conservative academic practice.

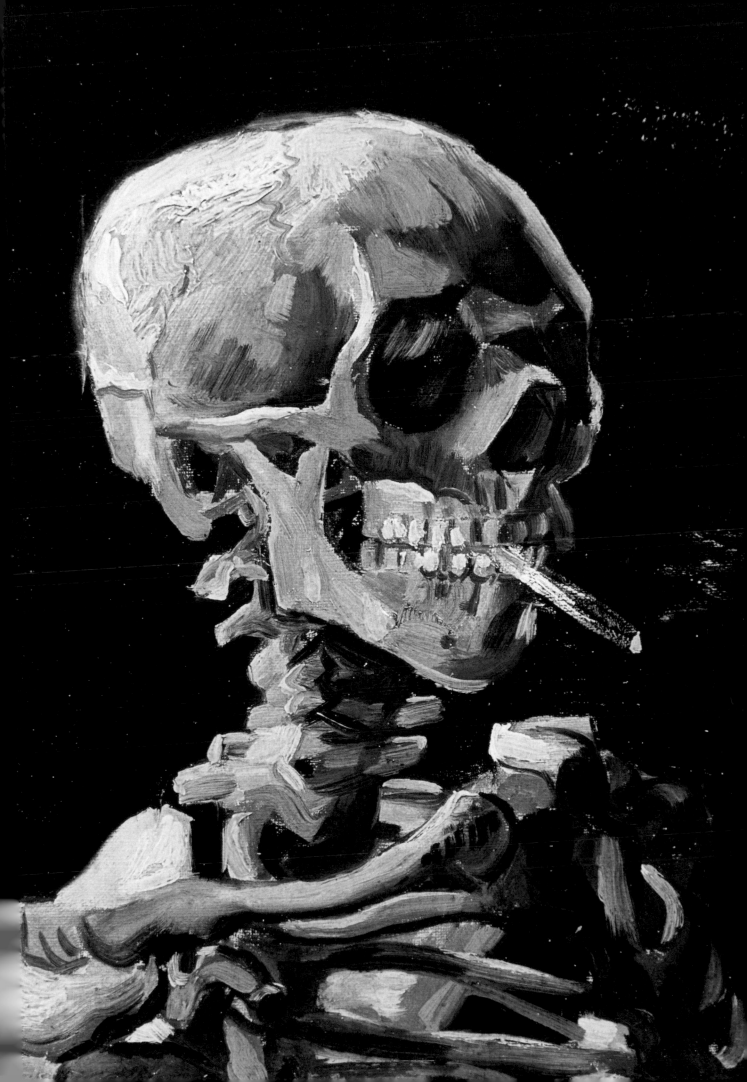

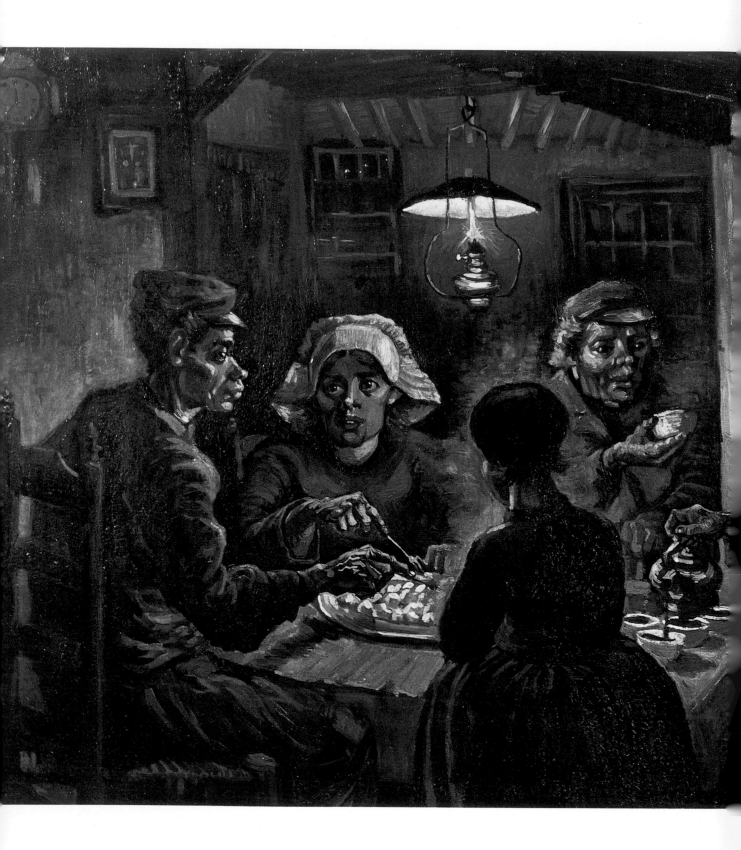

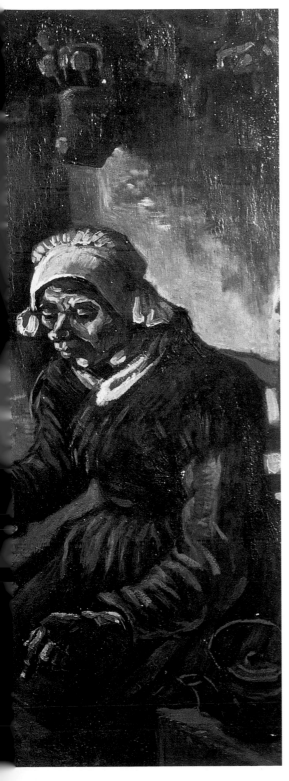

THE POTATO EATERS (1885)

The Van Gogh Museum, Amsterdam.
Celimage.sa/Lessing Archive

REPRESENTING the artistic climax of Van Gogh's stay in Neunen with his parents, this is a work that was unusual for the amount of time spent both in its preparation and execution. Usually he preferred to paint quickly and complete a canvas at one sitting. In this case Van Gogh made a long series of preliminary portraits and studies featuring peasants whose large, coarse features and weathered, work-worn skins are pronounced emphatically.

Like his favorite artist, Jean-François Millet, Van Gogh's principal aim at this stage in his career was to represent the lives of those who toiled on the land with realism. Here that realism manifests itself in a domestic interior that almost resembles a cave or an animal's burrow. Everything, from the peasants' basic meal of boiled potatoes and coffee, to their dark skins and highlighted bones, serves to emphasize the brutalization of hard labor—so much so in fact that the painting seems to be almost a caricature. But there is no doubt of the serious purpose that Van Gogh intended it to serve: "I have tried to emphasize that those people, eating their potatoes in the lamplight, have dug the earth with those very hands they put in the dish, and so it speaks of manual labor, and how they have honestly earned their food."

DETAIL FROM THE POTATO EATERS (1885)

Van Gogh Museum, Amsterdam. Courtesy of Edimedia

*T*HE *Potato Eaters* constituted Van Gogh's first challenge to portray a group of figures. Just before the work was commenced, Vincent had met with resistance from the church for his radical views concerning the bourgeois perception of the working classes, which he challenged vehemently. *The Potato Eaters* was produced as a testament to Van Gogh's social morals, as well as being a tribute to the peasants of the farm.

Partly due to the influence of the peasant paintings of Jean-François Millet, Van Gogh's work and palette were set to record the day-to-day life and activities amongst the peasants of Nuenen. His preoccupation with the working classes was to continue until he settled in Paris, the center of the growing Impressionist movement.

In this detail from *The Potato Eaters*, the dark shadows and tones of Vincent's palette evoke a sense of feeling, but one that does not engender emotion. The faces and hands of the characters are visibly coarse and over-exaggerated. The eyes of the young woman sitting at the center of the image are accomplished with a fantastic realism and power. They convey despair but, at the same time, compassion for the man who sits beside her.

Van Gogh painted some 40 studies of peasant heads, as well as numerous reproductions based upon this composition.

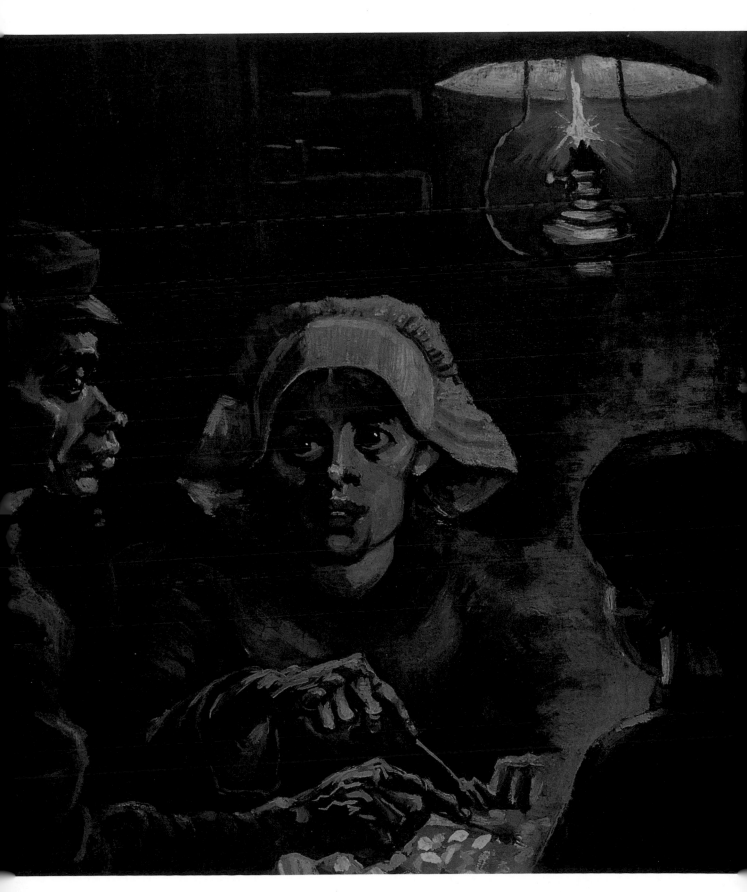

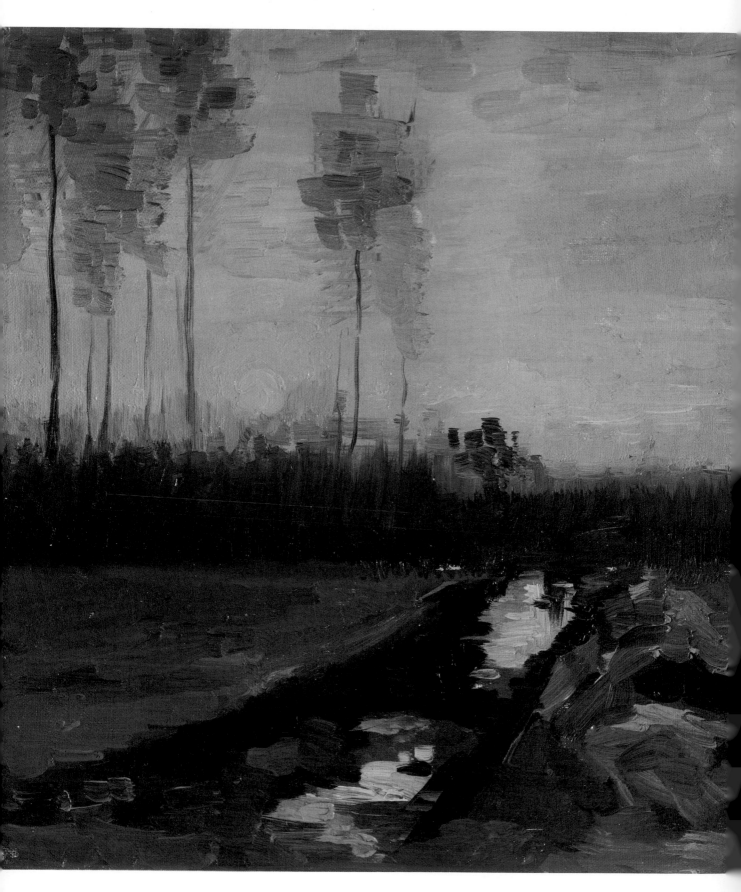

LANDSCAPE WITH A CANAL (1885)

Thyssen-Bornemisza Museum, Madrid.
Celimage.sa/Scala Archives

VAN Gogh was 27 when he decided to become an artist, in 1880. In order to do so, he had to rely upon financial support from his brother, Theo, who sent him an allowance to encourage him to work. The two wrote regularly and the artist's thoughts and ideas are well documented in some 700 letters to Theo and others.

Landscape with a Canal has a thick blanket of brushstroke crowned by a Turner-esque sky. The activity across the ground contrasts with the soft and flat plane of the sky, almost as though Van Gogh crafted his canvas like a sculpture, with the same considered thought for composition and balance. Van Gogh pursued a clear and consistent artistic goal throughout his career, creating images of great emotional intensity, through variations of color and arrangement.

This particular work, not among his better known paintings, was part of Van Gogh's Dutch Period, which lasted from 1881 to 1885. These four years mark his relentless efforts to master the techniques and difficulties of drawing.

The year 1885 was distinguished by the fall series of landscapes produced while the artist was living and working amongst the peasant farmers. In *Landscape with a Canal*, the use of red, orange, and yellow is similar to that which we find in his fall paintings. However, his realistic approach to the subject is suspended in favor of a more lavish, looser, and bolder use of color. Such a style and method can be likened to the techniques of Claude Monet in his Water Lilies series from the 1920s.

VIEW OF PARIS FROM THEO'S HOUSE (1886)

Vincent Van Gogh Museum, Amsterdam.
Courtesy of Edimedia

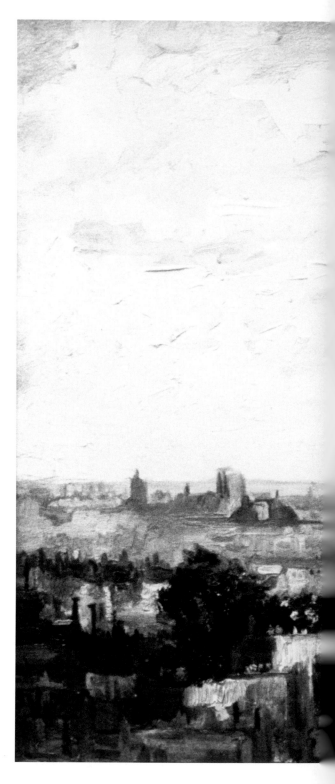

*I*N 1886, Van Gogh moved to Paris to live with his brother, Theo. This time with his brother was crucial to Van Gogh's artistic development. He was confronted with Modern Art, specifically the influences of Impressionism and Post-Impressionism, and he made the acquaintance of artists such as Paul Gauguin, Paul Signac, and Georges Seurat, who would greatly influence the course of his career.

This painting incorporates the styles and techniques that are characteristic of Van Gogh's dark palette, as seen in his "Dutch" paintings. The lighter, hastier brushstroke can be attributed to Impressionist influences gained by living in Paris. Thus we see an enormous contrast between the paleness of the sky and the shadow of the city buildings.

In the erratic, opposing, thick strokes of color that paste the sky, we can see the emergence of the heavy and colorful brush method that would dominate Van Gogh's later works. However, at this stage the he was still drawing upon the compositional and technical legacy of his Dutch Period.

Theo's house was located in Montmartre, where the noise, traffic, and bustle of the rest of Paris seemed to give way to a uniquely bohemian milieu. Today, Montmartre is still full of art galleries.

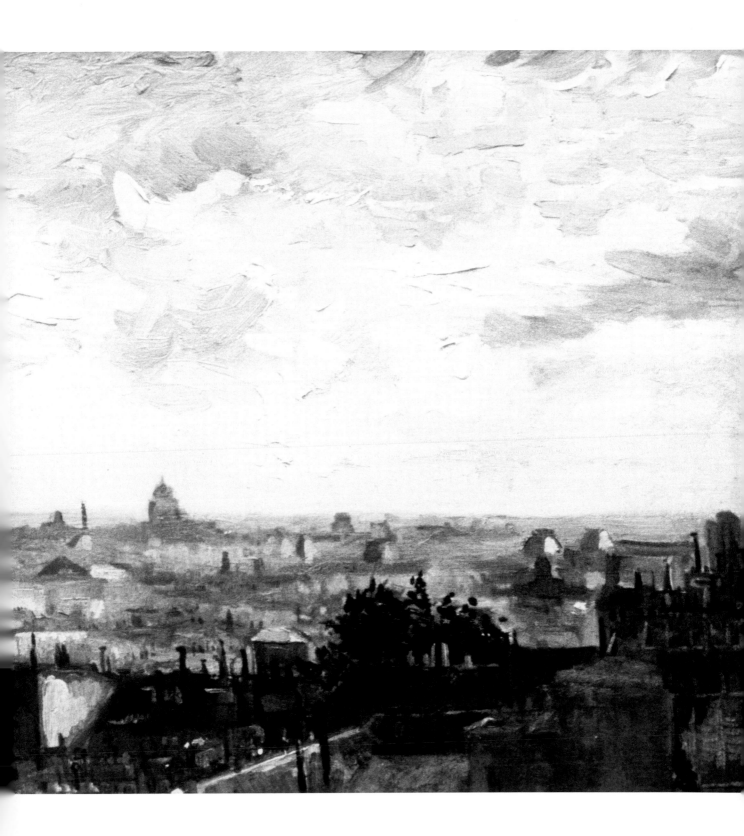

Le Moulin de la Galette
Vu de la rue Girardon (1886)

Staatl Museen, Nationalgalerie, Berlin. Celimage.sa / Lessing Archive

THIS image has all the characteristics of a somber and desolate scene, touched by the bitterness of a winter's day. Even with the inclusion of people, the harsh white of the sky, the lightless windows, and the flat brushstroke across the canvas all fuel the impression of a lifeless scene. In this sense, *Le Moulin de La Galette* illustrates an important change in both the style and content of Van Gogh's work.

Having fallen out with the authorities at the Academy of Fine Art in Antwerp, Van Gogh moved to Paris in 1886. Although initially concerned, Theo could not deter Vincent from the lure of the city. He only hoped that by living and working in the hub of the Impressionist movement, Vincent would benefit from its influence.

It was only a matter of time before Van Gogh began integrating the ideals of Impressionism into his paintings. The Impressionists sought actively to work in opposition to the established constraints of the art world. Therefore, they deliberately treated ordinary scenes as important. *Moulin de la Galette* is an example of this artistic philosophy. Van Gogh painted several versions, each from a different angle. Initially, however, he found it difficult to distance himself from his Dutch past, and this influenced his palette during this period.

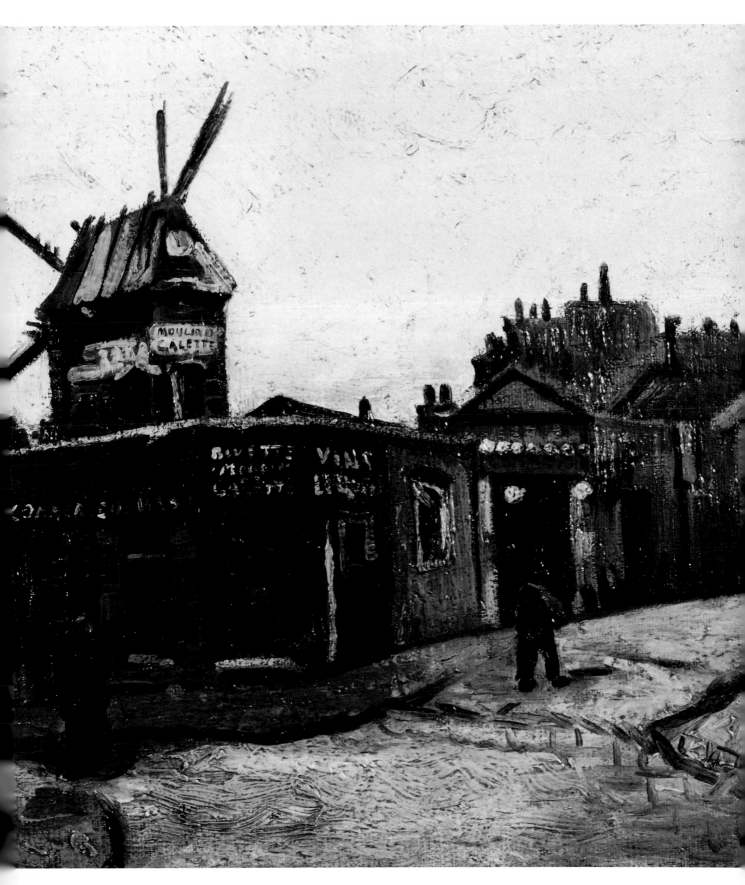

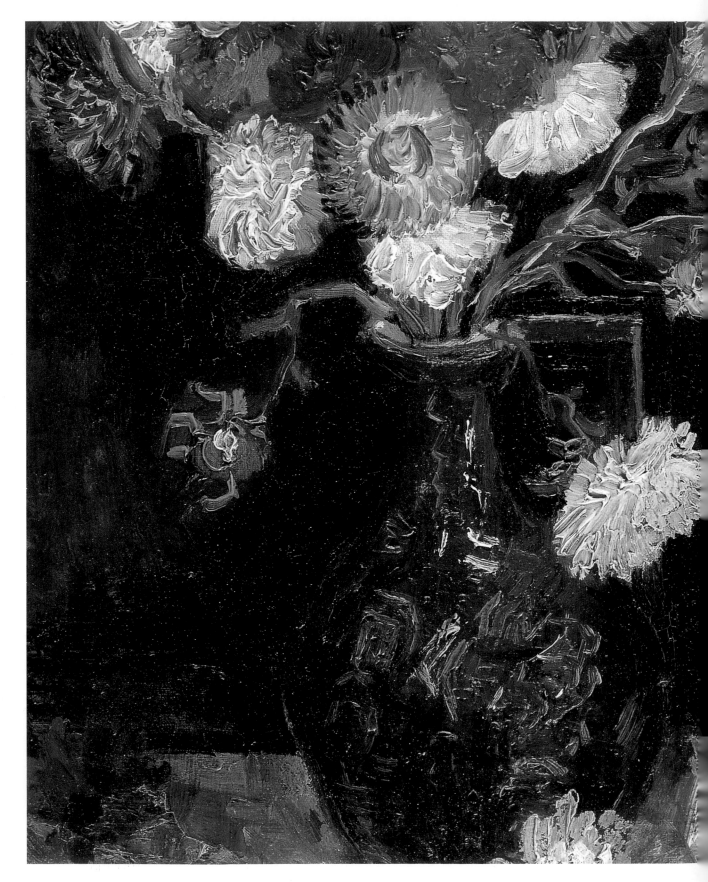

DETAIL FROM VASE WITH AUTUMN ASTERS (1886)

Van Gogh Museum, Amsterdam. Courtesy of Edimedia

VASE with Autumn Asters was inspired by a visit to the Paris Salon, where Van Gogh saw the works of artists such as Ernest Quost, Pierre Auguste Renoir, and Claude Monet. The influence of their styles is subtly apparent in this painting, which displays similar Impressionist qualities. Van Gogh uses flickers of white paint across the petals of the flowers, on the vase, and in the foreground. The only aspect of the painting that does not display such a stylistic nuance is the black shadow that lingers behind the vase.

Painted in the summer and autumn months of 1886, this still life captures the vibrant mood and flavor of this warm season. The deep red background, the dark vase, and the looming shadow around the flowers all conjure an aesthetic wealth and depth. The application of paint is thick and heavy across most of the canvas, and the strength of the maroon-red color used for the backdrop threatens to preside over the lighter, more delicate whites, pinks, and yellows of the flowers. This work was completed as part of Van Gogh's experimentation with the effects of color in his palette, although he certainly struggled to strike a balance between the varying shades.

BOUQUET OF FLOWERS (1886)
Kunst Haus, Zurich. Celimage.sa/Lessing Archive

THE oppositional red-green palette used in *Bouquet of Flowers* is a common color technique, one that we can also see in Claude Monet's Water Lilies series and Pablo Picasso's portraits of Marie-Thérèse. The effect is always a rich but balanced interweave of juxtaposed shades.

This painting was produced during Van Gogh's two-year stay in Paris, between 1866 and 1888. During this time, he was surrounded by the contemporary trends and hype of the French avant-garde. His time spent at the center of this artistic innovation resulted in a crucial creative development, which can be see in *Bouquet of Flowers*. The painting has a refined individual style.

Van Gogh's discovery of Impressionism and Post-Impressionism, and the friendships he formed with painters such as Paul Gauguin and Paul Signac, culminated in a rapid and significant transition of his palette and brushwork. The young artist was increasingly intrigued by color theories, and so began experimenting with the use of bright, undiluted oils to heighten the expressiveness of his work. He also adopted the Impressionist trait of split brushstrokes in several of his paintings. This technique appeared in his views of Paris and the hills of Montmartre.

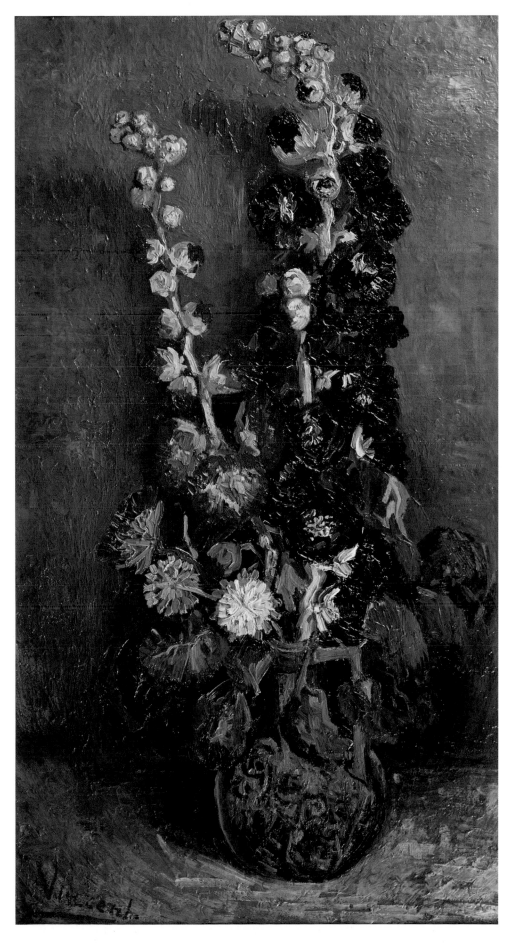

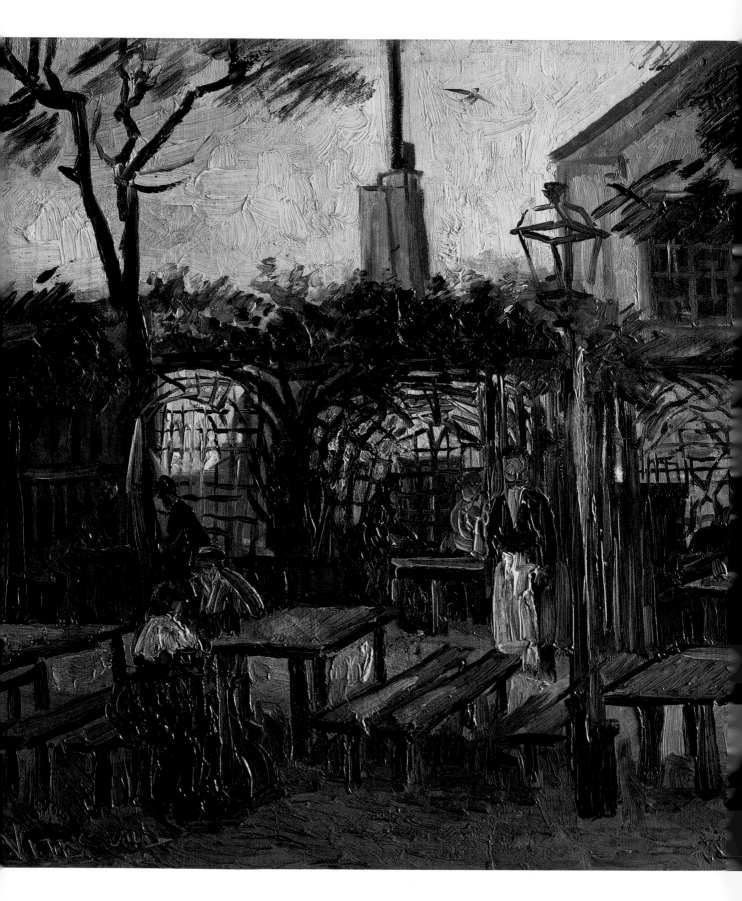

TERRACE OF A CAFÉ ON MONTMARTRE (1886)

Galerie du Jeu de Paume, Louvre, Paris.
Celimage.sa/Lessing Archive

BY the late 19th century, Paris had long overtaken Italy as a site of pilgrimage for artists and other creative types. The longing for a rustic idyll and Roman arcadia was displaced by the vogue for all things modern. Contemporary Paris was widely regarded as the best place to experience this modernity in its most unadulterated form. Van Gogh, like many other artists of the time, rejected historical pictures in favor of the "brash" new reality. *Terrace of a Café on Montmartre* represents a scene that epitomized modern, everyday life in the city. However, Van Gogh generally tended to steer clear of urban subject matter and, indeed, his palette here harks back to Holland. With its predominantly earthy colors and roughness of technique, the only evidence of an Impressionist influence is in the painting's theme.

Painted very quickly, Van Gogh chose to ignore the minutiae of faces and features in this picture, concentrating instead on the scene as an integrated whole. Perspective is treated with similar perfunctoriness. It is the painting's status as a physical object, with an identity distinct from the outside world, that counts. This was, of course, a highly modern concern and lends meaning to, among other things, the bold green vertical streak of paint in the picture's center. As a means of giving three-dimensional form to the foreground lamp-post, it is barely credible, but as evidence of the artist's process it is a highly pertinent mark.

QUARRY AT MONTMARTRE (1886)
The Van Gogh Museum, Amsterdam. Celimage.sa/Lessing Archive

*T*HE famous windmills of Montmartre depicted here were a popular holiday destination at the time and perhaps reminded Van Gogh of his native Holland. They were certainly one of his favorite subjects while in Paris. In this picture, Van Gogh emphasizes their status as relics of a rural age by contrasting them with the surrounding area, which was a place of urban renewal. Indeed, large tracts of Montmartre were, at the end of the 19th century, little more than extended building sites; quarries such as this were a common feature.

Van Gogh makes little attempt to beautify the scene, deploying muted colors throughout and a realism that harked back to his Dutch days. His only obvious concession to the imagination is the inclusion of two small, silhouetted figures in the foreground. They stand dark and anonymous in an otherwise deserted landscape, facing a panoramic view and expansive sky that lend them more than a touch of mystery. Van Gogh hinted at their inclusion when describing his working methods to Theo: "When a painter goes out into the open country to do a study, he tries to copy what he sees as exactly as possible. It is only later, in his studio, that he permits himself to rearrange Nature and introduce attributes that may to some extent be absurd."

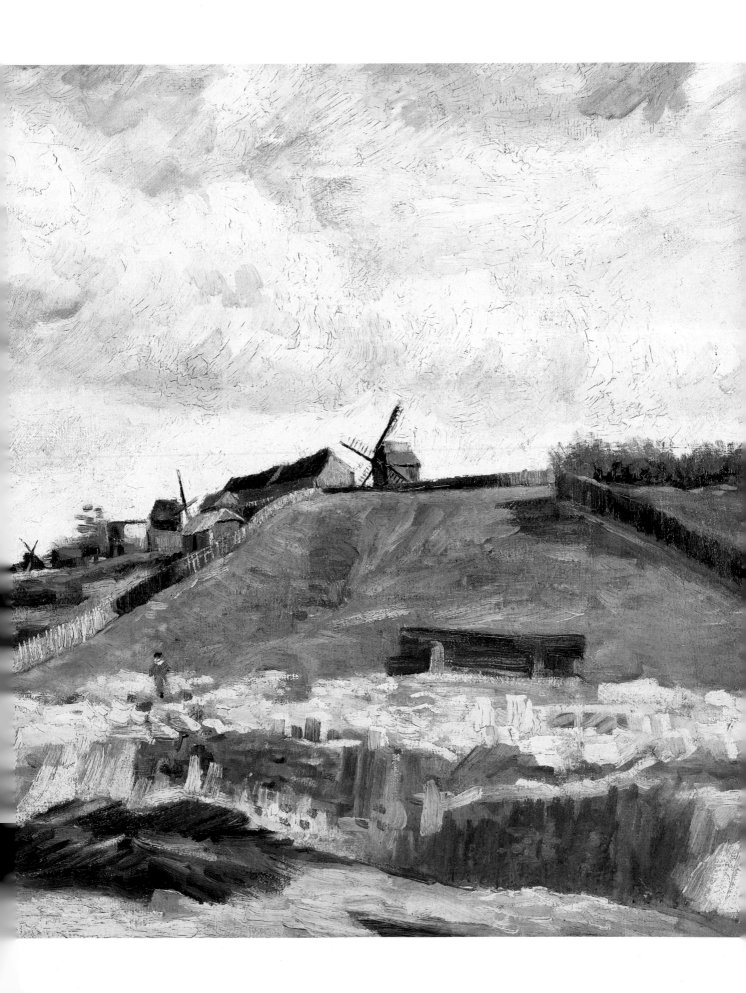

STILL LIFE WITH QUINCES AND LEMONS (1887)

Van Gogh Museum, Amsterdam. Courtesy of Edimedia

DURING his time in Paris, Van Gogh sought to consolidate what he had learned so far from the influences around him. *Still Life with Quinces and Lemons* is a fine example of this artistic development. Whilst living with Theo in Paris in 1886 Van Gogh discovered that his dark Dutch palette of previous years and works was unsuited to that of the Impressionists, so he began to produce still lifes and flower compositions, in order to brighten his color range.

Between 1886 and 1887, he progressed through the styles and subjects of the Impressionists, which gave way to his lighter and warmer use of color, and a hastier, more erratic method of brushstroke. This period saw a profound intensification of his sensitivity to color and its dimensions.

The affectionate yellow hues that bathe the fruit and background in this painting, coupled with Van Gogh's Impressionist brush technique, invest it with delicacy and richness. *Still Life with Quinces and Lemons* emits a warm, joyous, and vibrant light. The color escapes from the sides of the canvas onto the frame, as though Van Gogh's excitement at painting could not be confined to the physical limits of the canvas.

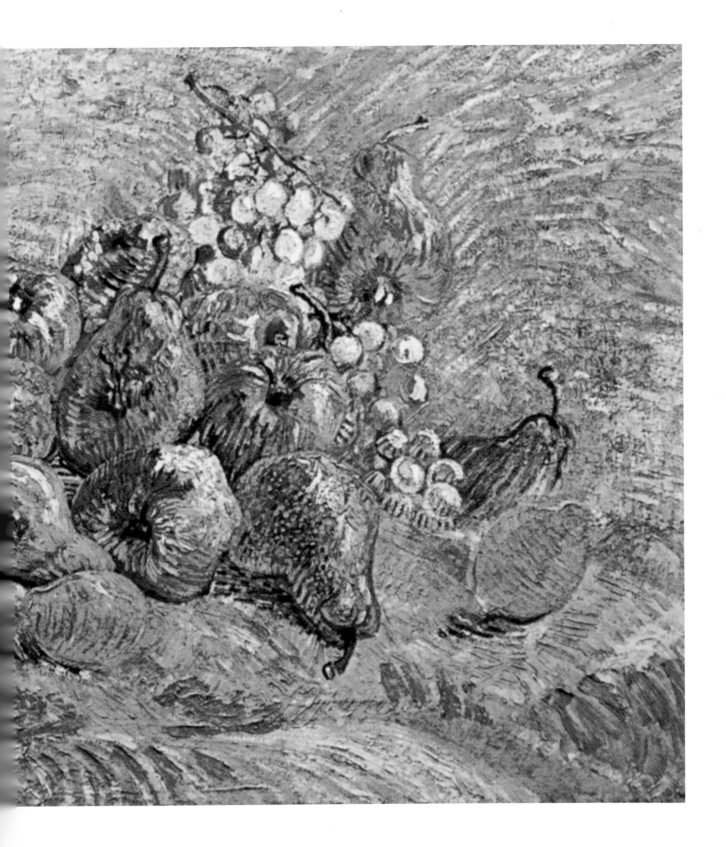

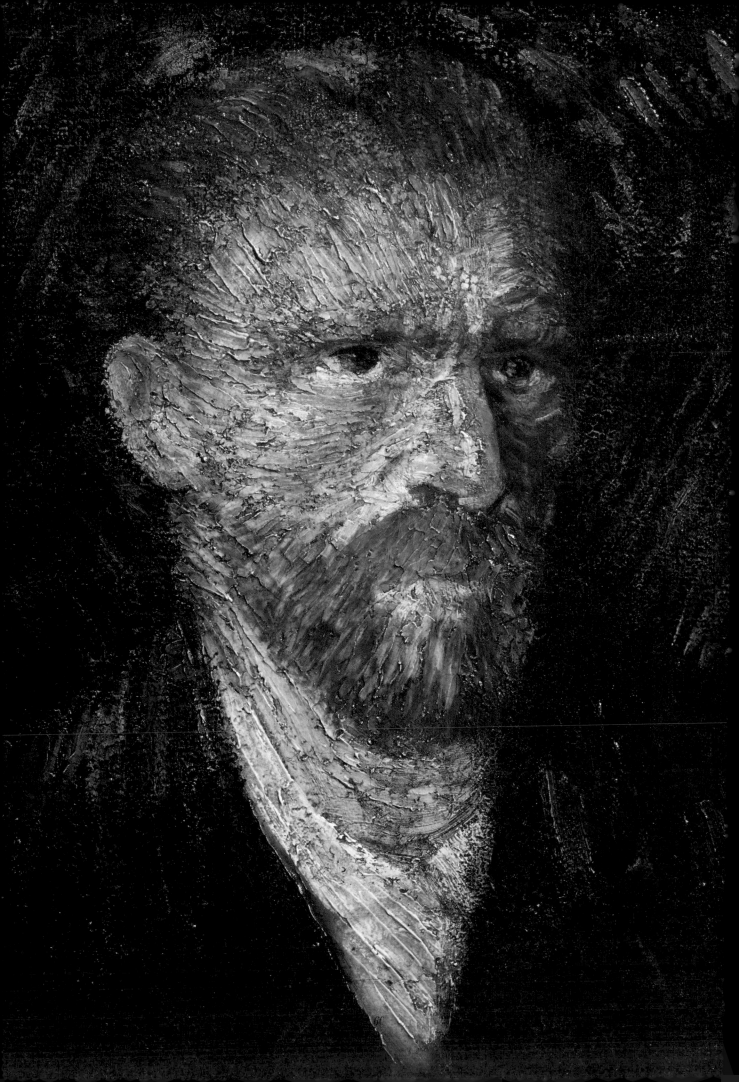

SELF-PORTRAIT (C. 1887)

Oesterreichische Galerie im Belvedere, Vienna. Celimage.sa/Lessing Archive

*T*HIS canvas is fueled by the erratic flurry of the brushstrokes that etch the features and shape of Van Gogh's face. At the age of 30, he commented on his own appearance thus: "My forehead is marked with wrinkles, the lines on my face are those of a 40-year-old, my hands are furrowed." In this portrait he certainly does look older than his age. He strikes a conventional pose and wears traditional dress, in an allusion to the portraits of the Dutch Old Masters. Maybe the artist was reasserting his roots, or simply could not detach himself from them.

As might be expected in a self-portrait of an artist, the eyes are a revealing aspect. The shrouding bright yellow lines of paint are strongly formed around the two black circles of the eyes, which gaze contemplatively, perhaps sadly. These are the tools with which Van Gogh relentlessly interrogated himself.

The scarf or necktie that appears above the dark cloth of Vincent's suit jacket is perhaps a sign of a new beginning. However, the wild brushstrokes and use of dark color to surround his face suggest otherwise. This is certainly one of Van Gogh's more evocative self-portraits. Similar works from his Paris period (1886-88), such as *Self-Portrait with Dark Felt Hat* (1886), display far softer tones and use of color.

Detail from Vegetable Gardens and the Moulin de Blute-Fin on Montmartre (1887)

Van Gogh Museum, Amsterdam. Courtesy of Edimedia

THIS painting has a unique Impressionist and Pointillist style. Subdued gray and bluish tones dominate the scene, creating an impression of a murky, rainy day in Montmartre. The absence of dominant forms provides a challenging task for Van Gogh, especially within the confines of a horizontal canvas. However, he achieves success by using different techniques across the varying fields and vegetable crops. The delicate flickers of white and blue span the ground, and are raised and repeated in the allotment buildings and Moulin de Blute-Fin. These small dots of paint are framed by areas of fine line, which subtly outline the shapes of the buildings and a female figure (who would otherwise be camouflaged by her surroundings). The windmills provide a point of focus for the painting, but it is the delicate and sincere capturing of the paths and allotments that occupy the imagination of the artist in this work.

The combination of white and blue is unusual for the artist, especially when we consider the vibrant application of color in some of his better-known landscapes. These shades have been placed in thin soft layers across the canvas, which is especially notable in the sky. Certain elements of the painting are more pronounced, as though the gaze of the artist rested upon them for longer. Overall, these slightly more detailed aspects of the work are balanced within the overall structure of the painting, demonstrating the delicate intricacy and intimate affection that Van Gogh obviously felt for this scene.

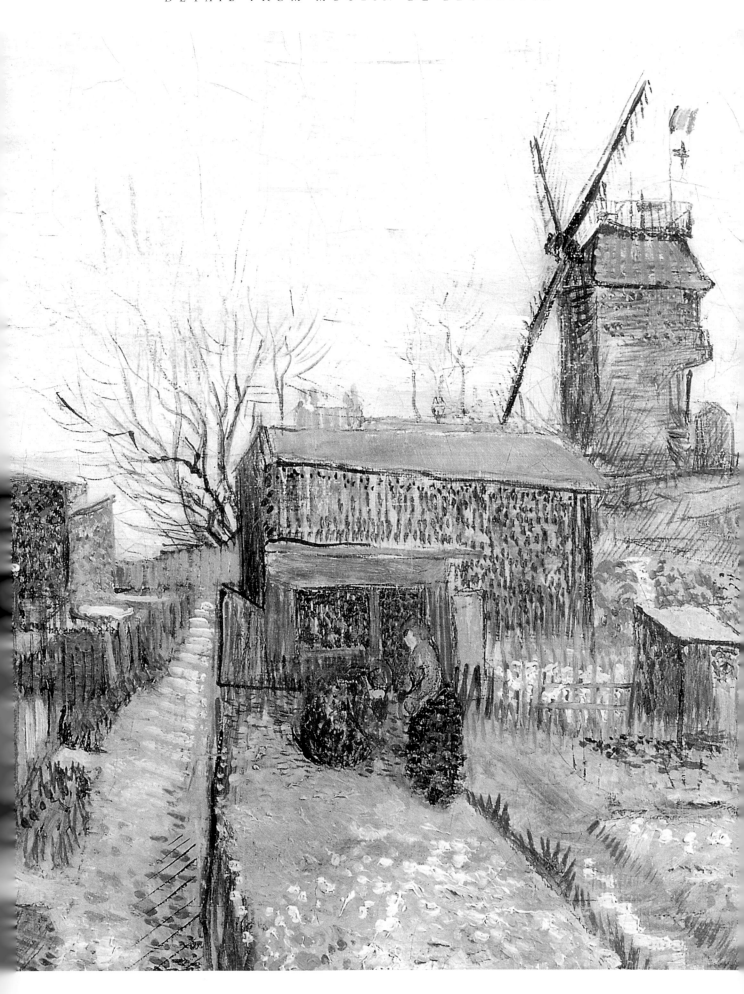

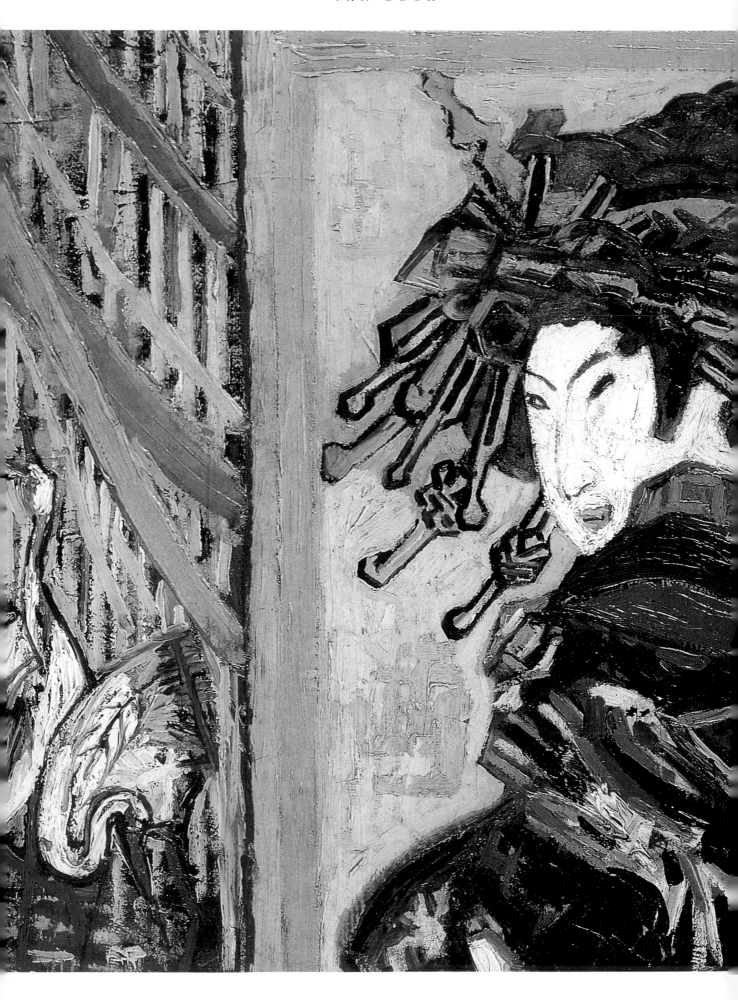

DETAIL FROM THE COURTESAN, AFTER EISEN (1887)

Van Gogh Museum, Amsterdam. Courtesy of Edimedia

THE period in which Vincent painted in the traditional Japanese fashion is brief, but nonetheless extremely interesting. "Japonisme" was an influence that was particularly popular in the mid- to late 19th century. Vincent was intrigued by the Japanese prints available to him at the time.

The influx and interweaving of color in this painting is fantastic. Reds, pinks, blues, greens, blacks, and yellows combine in this striking portrait.

Van Gogh uses a combination of color and technique to adorn the Japanese woman depicted in this portrait. He completed similar versions of this work, which appeared on the cover of *Paris Illustré* and as a pencil, pen, and ink reproduction of the figure. In these, the oriental influence envelops the artist as he ranges between this and his own highly individualistic style. Such a unique interpretation of the Japanese influence, which was becoming increasingly prevalent at the time, paved the way for other artists who were inspired by Van Gogh's intense and exaggerated palette.

This particular version of *The Courtesan*, viewed in its entirety, is nothing short of stunning. Even the frame has been embellished with a huge amount of color and detail to enhance the appearance of its content. Reeds, a stork, and lilies are depicted in an oriental genre, with long, straight horizontal lines highlighting the individual reeds and ripples of the water. Their firm vertical structure contrasts with and enhances the flowing and meandering patterns of the woman's dress.

RESTAURANT DE LA SIRENE (1887)

Musée d'Orsay, Paris. Celimage.sa/Lessing Archive

BY 1886 Impressionism had all but faded out as a coherent or clearly discernible movement, replaced by a series of new trends in painting. However, it continued to exert a significant influence on the next generation of artists, most notably a group whose very name indicated their debt to the old school. The "Neo-Impressionists," or "Pointillists," took some of Impressionism's theories to their logical scientific conclusions. "Points" is French for dots, and these were exactly what the new style consisted of— applied by its strictest adherents in a painstakingly slow and precise manner over the entire canvas. Furthermore, colous were used only in accordance with the latest chromatic theories, all of which resulted in an effect that was more Classical than Impressionistic.

However, such a technique was not really suited to Van Gogh's volatile temperament, and so *Restaurant de la Sirene*, whilst doubtless influenced by Neo-Impressionism, is far rougher and more energetic than a painting by, say, Pissarro. It is as if Van Gogh is working through a style before reaching his own distinctive and original language. Already, for example, we can see the more patterned, almost decorative, brushwork that was to become a regular feature of his more mature works. The subject matter also points forward, away from his dour Dutch beginnings and toward a bright French future.

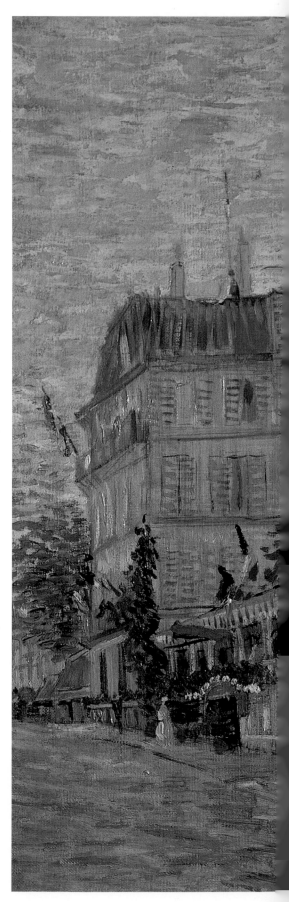

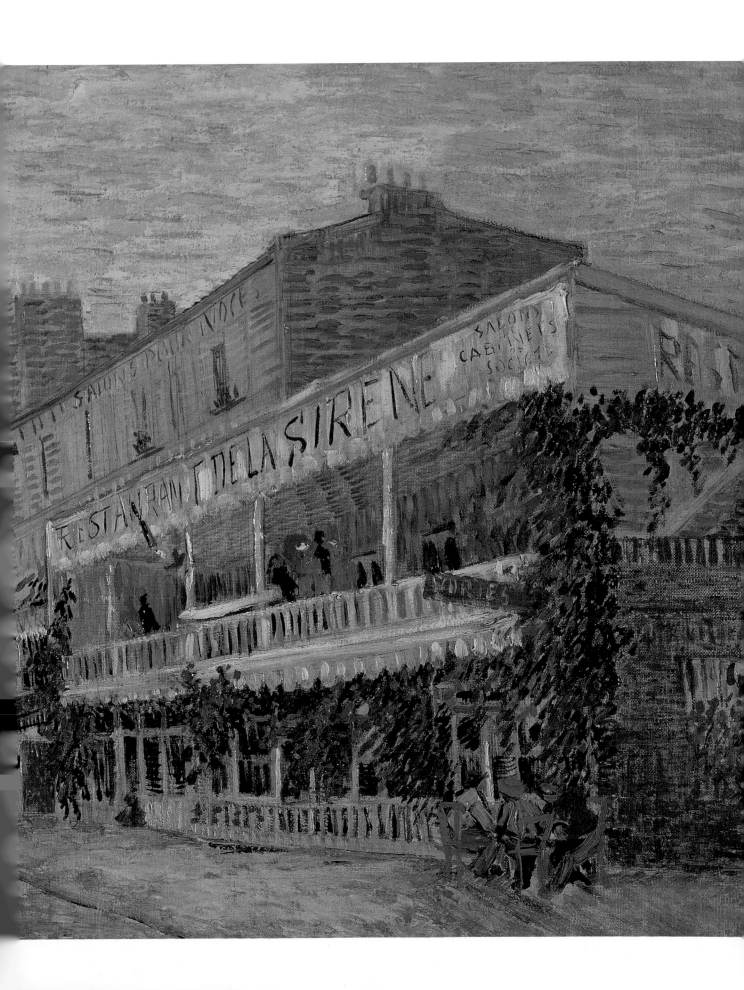

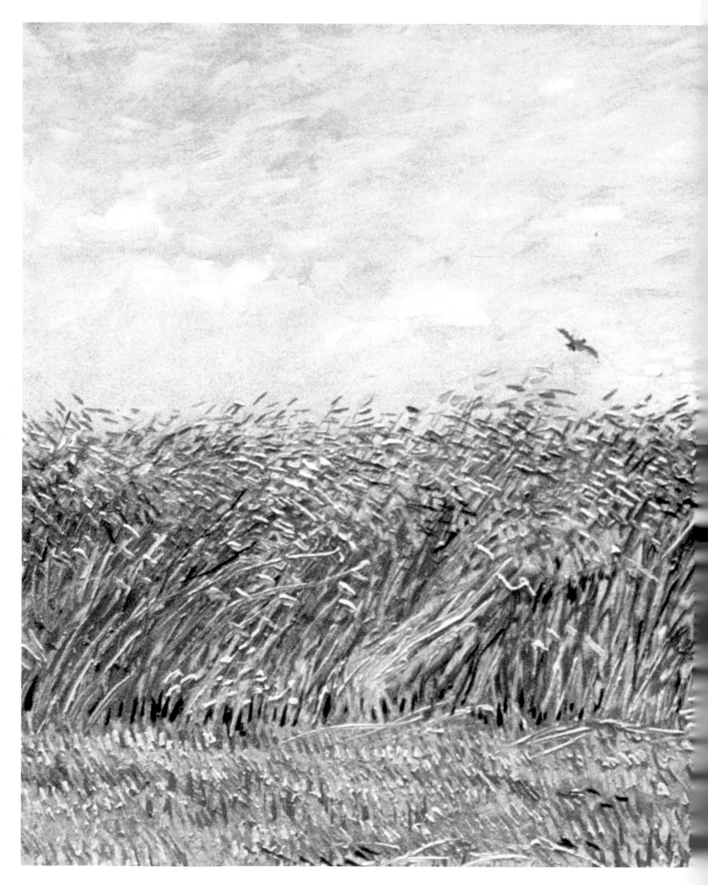

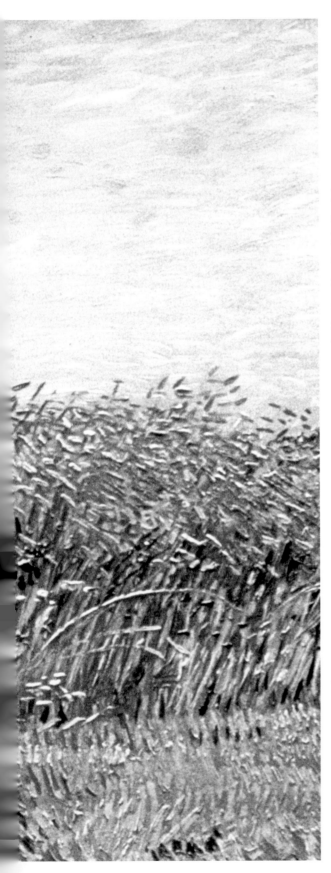

WHEAT FIELD WITH A LARK (1887)

Van Gogh Museum, Amsterdam.
Courtesy of Edimedia

*W*HEAT *Field with a Lark* was painted in the summer of 1887. In this painting, Van Gogh totally captures the tones of a summer's day, as he uncovers nature in its more natural element. The composition and subject matter are simple, and the bird floating above the wheat seems out of context in this quiet and unpopulated scene. Van Gogh is unconcerned with the shadows in the fields or the change in the sky. Instead, he focuses on the stillness and beauty of this one moment. The slight undulation of the wheat tells us that a gentle breeze is moving the air.

Van Gogh has discarded the use of heavy shadow and dark tonalities in favor of a brighter, warmer palette. He hoped to reveal colors in their purest forms by allowing a painting to exist as a primary construction of color, rather than simply a collection of forms. Van Gogh adopted the characteristic hasty and lively brush technique of the French Impressionists and Post–Impressionists, giving these individual shades their individual status within a painting.

Such a dynamic perspective on art paved the way to the range of vibrant and radical works that were to become Vincent's trademark.

ALEXANDER REID (1887)

Frick Art Museum, New York. Courtesy of Edimedia

*A*T first glance, one would think this to be another self-portrait of the artist. There are striking similarities between this painting of Alexander Reid and Van Gogh's *Self-Portrait with Dark Felt Hat* (1886). The colors, tones, composition, and features are all comparable. Even Reid's son, upon looking at this enigmatic portrait of his father, found it difficult to recognize him.

Alexander Reid (1854–1928), was a successful art dealer and a central figure in contemporary art in western Scotland. He focused his interests and acquisitions on Impressionist paintings, leading the way for the cultural curiosity of the wealthy Scottish industrialists at the turn of the 20th century.

Early in his career, Reid had shared an apartment in Paris with Theo and Vincent Van Gogh. There, the three established a close friendship, allowing Reid access to Impressionist exhibitions. He was therefore an important figure in the establishment of the splendid French collection of art, now held by the Kelvin Grove Art Gallery, Glasgow, which includes paintings from the acclaimed masters, such as Monet, Renoir, Cassatt, Cézanne, Van Gogh, and Picasso.

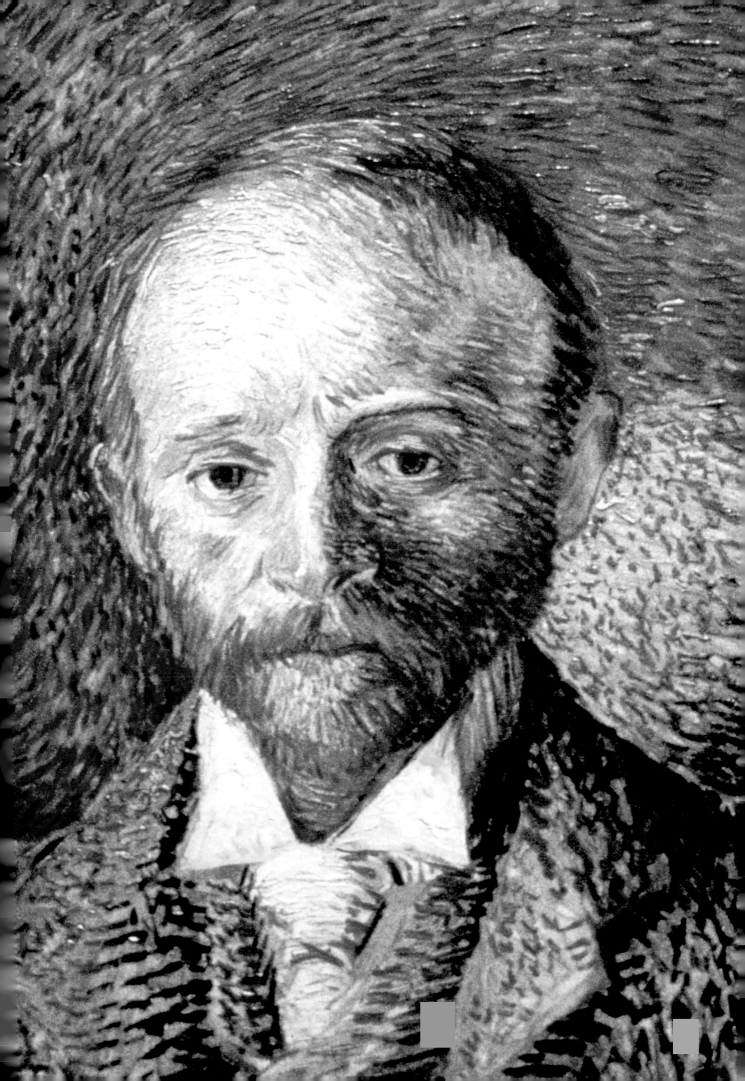

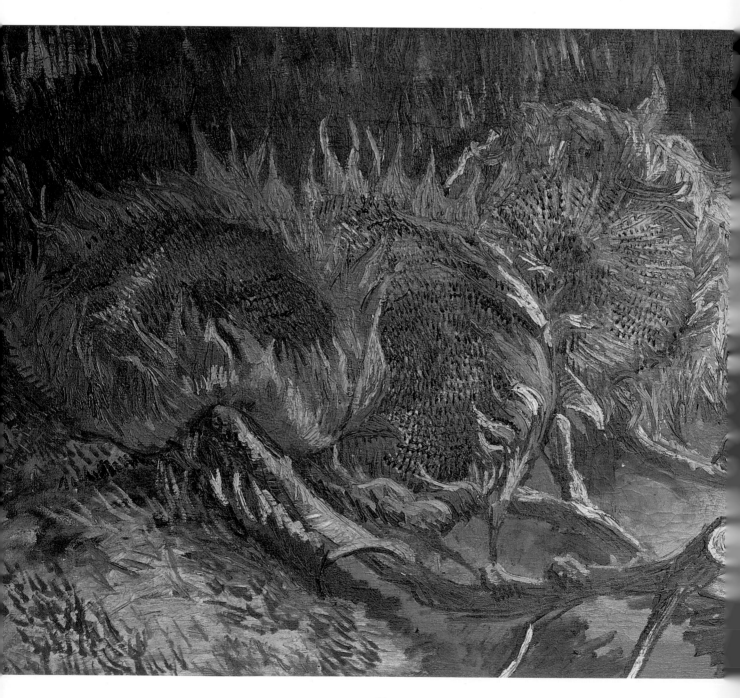

FOUR CUT SUNFLOWERS (1887)

Rijksmuseum Kröller-Müller, Otterlo. Celimage.sa/Lessing Archive

SUNFLOWERS have of course become synonymous with Van Gogh, but they only began to pre-occupy him as a potential subject for his art as late as 1887. Ironically, perhaps, it was only on moving away from the countryside to Paris that this interest became awakened. However, any apparent paradox involving the newly urbanized Van Gogh "turning back" to nature is perhaps explained by

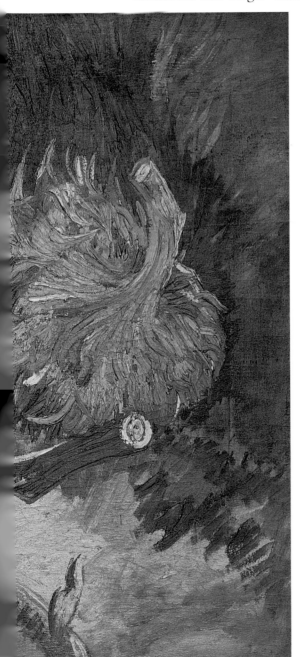

a simultaneous influence: that of Adolphe Monticelli. Well-known in the capital during the 1860s, Monticelli was a Provençal artist whose thick impasto surfaces and pure colors (which Van Gogh has deployed here) impressed the Dutch artist to the point of hero-worship. Meeting Monticelli in Paris also sowed the seeds of Van Gogh's desire to move south, where he eventually painted the more famous "live versions" of sunflowers.

Van Gogh's tendency to look back to the past for inspiration has prompted some critics to compared *Four Cut Sunflowers* to 19th-century Dutch still lifes, and particularly the *vanitas* (flower) theme so favored at that time. Probably more dominant among Van Gogh's thoughts in 1887 were the popular decorative arts, where sunflower motifs appeared regularly. Van Gogh's idea of nature was always mediated by culture.

CROWN IMPERIALS IN A COPPER VASE (1887)

Musée d'Orsay, Paris. Celimage.sa/Lessing Archive

As well as sunflowers, irises, and lilacs, Van Gogh painted a whole host of other less-celebrated flower pictures—mainly in Paris—of which this is one. Nearly all of them feature evidence of contemporary color theories and this is no exception. A mutual friend of Theo and Van Gogh testified to Van Gogh's preoccupation with chromatic concerns at the time: "The ensemble of the flower pieces is very cheerful and colorful, but some are flat, of that I cannot convince him. He always answers me 'But I was trying to introduce this and that color contrasts.'" These "color contrasts" were a characteristic of Van Gogh's work from this time onward. Here it is the yellowy orange of the flowers that complements the speckled blue of the background. The Pointillist technique used to depict the latter is also reminiscent of Japanese prints, as can be seen in *Margaret Gachet at the Piano* (1890).

The two drooping flowers on the left were probably added later to enliven the composition. Their brushwork and color are both slightly different from the rest of the picture, whose symmetry and stiffness they alleviate. The strangely distorted vase and table perspective is a pictorial strategy possibly picked up from Paul Cézanne (1839–1906).

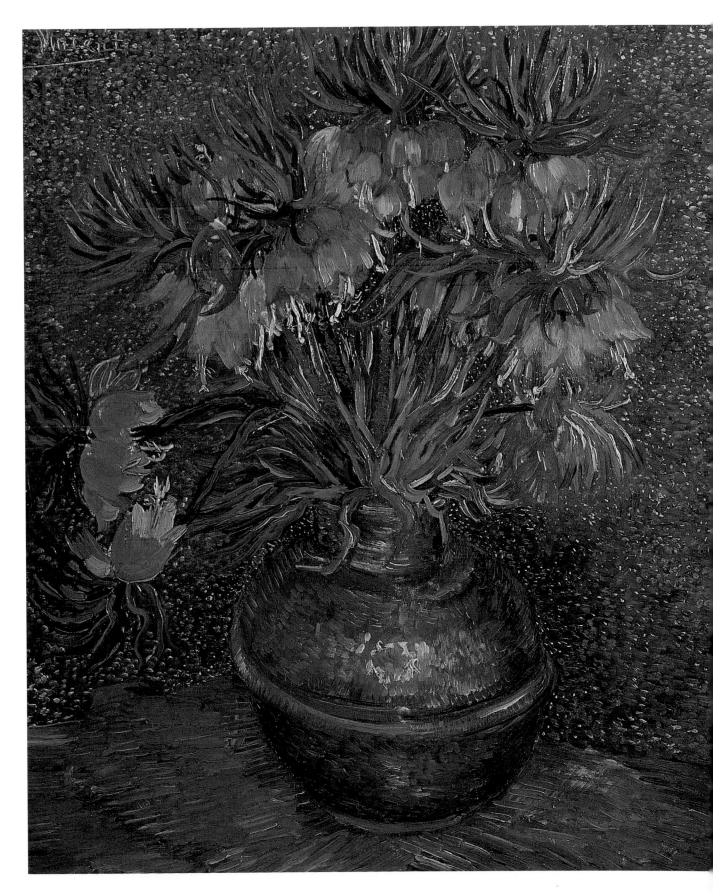

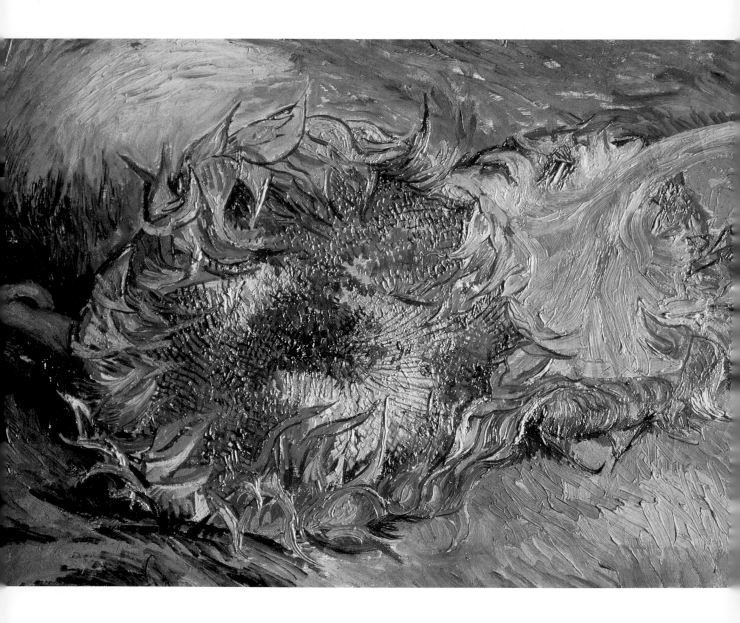

SUNFLOWERS (1887)

Metropolitan Museum of Modern Art, New York. Celimage.sa/Lessing Archive

*T*HIS painting is an intimate portrait of two flowers. Van Gogh's sensitivity toward the composition and color is clearly reflected in the detail with which *Sunflowers* has been painted. Each petal has been individually executed, and the lines at the heart of one of the flowers have been presented with great realism. Sunflowers are an important and common feature of Van Gogh's work, although, unlike in this particular piece, they are usually arranged together in a vase.

Another unusual aspect of this work is the blue backdrop. This cool contrast with the orange-yellow of the flowers enhances the impact of the flowers and their prevailing warmth and vibrancy. The juxtaposition of the two shades also gives a sense of depth to the image.

This particular *Sunflowers* was painted between August and September 1887, while Van Gogh was living in Paris. This is one of four sunflower paintings from this time, although people usually only remember those from his stay at Arles, from 1888 to 1889. While these earlier works are starkly different from the Arles series, they nevertheless represent an outstanding achievement in Vincent's artistic evolution.

THE ITALIAN WOMAN (1887)
Musée d'Orsay, Paris. Celimage.sa/Lessing Archive

VAN Gogh's difficulty in finding female models to pose for him lasted throughout his working life. However, his searches were not entirely motivated by artistic concerns. As he confessed: "The female figures I see among the people here leave a most marked impression on me; I should far rather be able to paint them than to have them, although I do indeed wish I could do both.".

With the figure represented here, Van Gogh may well have had his wish granted. *The Italian Woman* is generally considered to be Agostina Segatori, with whom Van Gogh was rumored to have had an affair. He wrote to his sister that whilst in Paris he had "he most impossible and rather unseemly love affairs from which I emerge, as a rule, damaged and shamed and little else." Whether this was the case with Segatori we simply cannot be sure. What we do know is that she ran a café that Van Gogh and his friends often frequented, and that he met her by dint of exchanging his pictures for her meals.

Stylistically, this painting is a curious mixture of two influences: the cheap color prints widely available at the time, and the rarer, more refined Japanese prints that had recently entered the country. The result is one of the brashest canvases that Van Gogh completed during his stay in Paris. The figure is framed on two sides by a border of complementary reds and greens, which adds to the picture's generally flat and decorative effect. The flower she clutches is a traditional symbol of hope and faith. Van Gogh's affair with Segatori did not last long, however, and it is possible that this portrait was in fact painted in reminiscence.

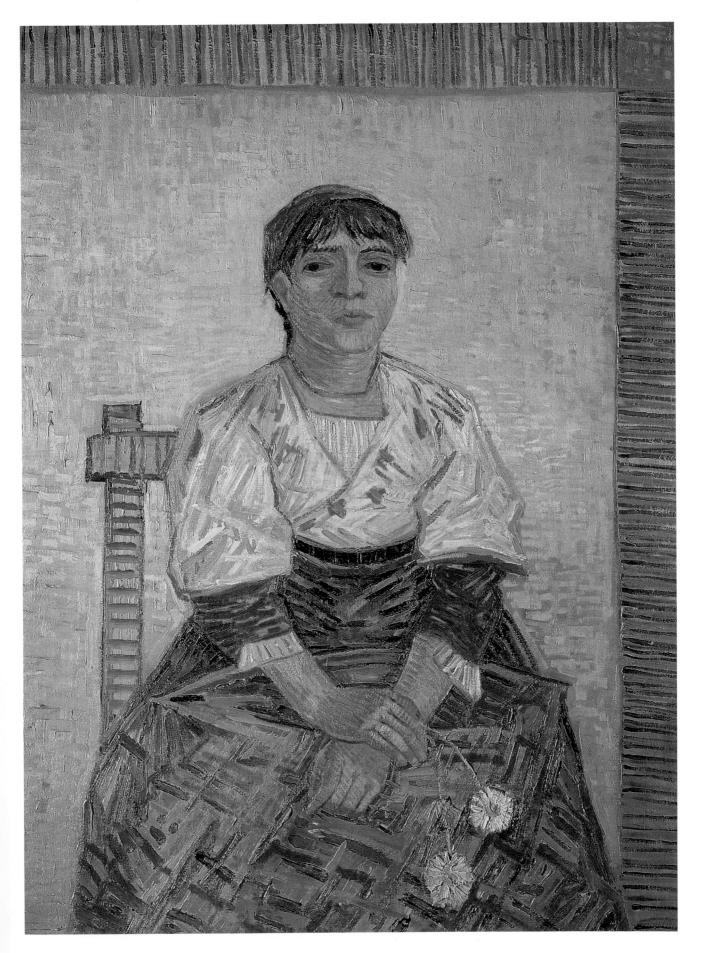

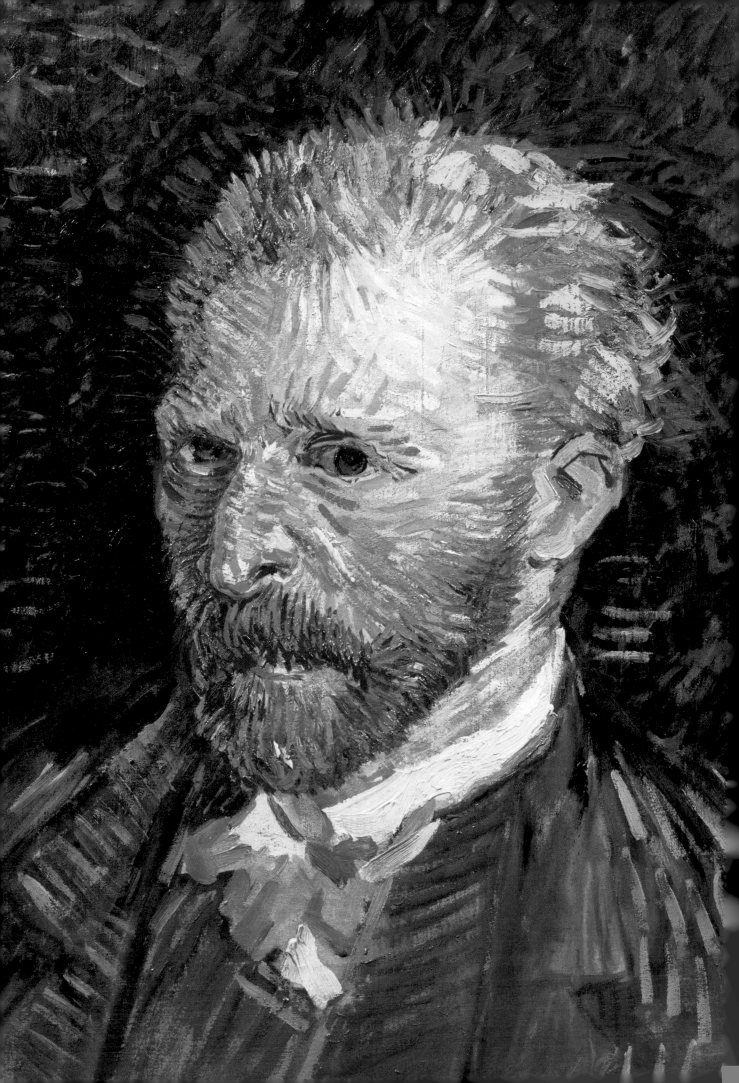

SELF-PORTRAIT (1887)

Musée d'Orsay, Paris. Celimage.sa/Lessing Archive

IN this self-portrait, Van Gogh's face has been treated with a brush and color technique similar to that used for his haystacks, in paintings such as *La Sieste* (1889–90). The same warm yellow vibrancy exudes from the contours of his skin, as in his landscapes. There is also an unmistakable Impressionist influence, reflected in the hasty, directional brushstrokes of Van Gogh's hair and jacket

Van Gogh painted himself so often partly because he could not afford to pay models to sit for him. Thus, this is one of numerous self-portraits.

The deep blue-black of the background accentuates the appearance of the artist's face, lifting it from the flat plane of the canvas. We are drawn to Vincent's expression—his eyes suggest a mood of deep self-reflection, providing a resonating contrast to the ecstasy of the surrounding brushstrokes.

The sprawling motion of paint across the surface of the canvas comes to life as an intense and violent example of Van Gogh's Impressionistic style. The two dark circles of his eyes penetrate the array of warm and bright color. Perhaps he tried to conceal his true expression through the application of the paint, but at the same time, he leaves a small window open so that we can see the internal strife that plagued him so greatly.

STUDY FOR PORTRAIT OF PÈRE TANGUY (1887)
Collection Stavros S. Niarchos. Celimage.sa/Scala Archives

A KEY feature of Van Gogh's new life in Paris was his greatly extended social circle. His varying styles during the period were perhaps due in no small part to this sudden glut of influences, among whose number Père Tanguy ranked highly. Tanguy owned a small store selling artist's materials, which he often exchanged for paintings, and particularly those by radical young artists. He considered Van Gogh to be just such a person, and actually once sold one of his paintings (pre-exchanged for paint) for 20 francs. The myth of Van Gogh never selling a painting in his lifetime can thus be dismissed—in fact Tanguy was only one of several purchasers.

As a study for the later portrait of Tanguy, this painting is particularly detailed. However, the later work was not just a more polished version of the former. Several features were dropped and new ones added. Here, for example, we can see one of Van Gogh's own still lifes, in the top left-hand corner, which was subsequently omitted. Also left out in the final tableau was the innovation of outlining the sitter in red.

It had been suggested that the frontal pose, clasped hands, and Japanese prints were all meant to give Tanguy connotations of a Japanese Buddhist priest. Van Gogh revered Japan as some sort of utopian paradise where art and life were in perfect synchrony. His desire to associate Tanguy with this society would therefore have been understandable. Considering the shop-keeper had never traded in Japanese prints, the inclusion of them here would seem strange if we did not interpret the whole picture as a eulogy to the East.

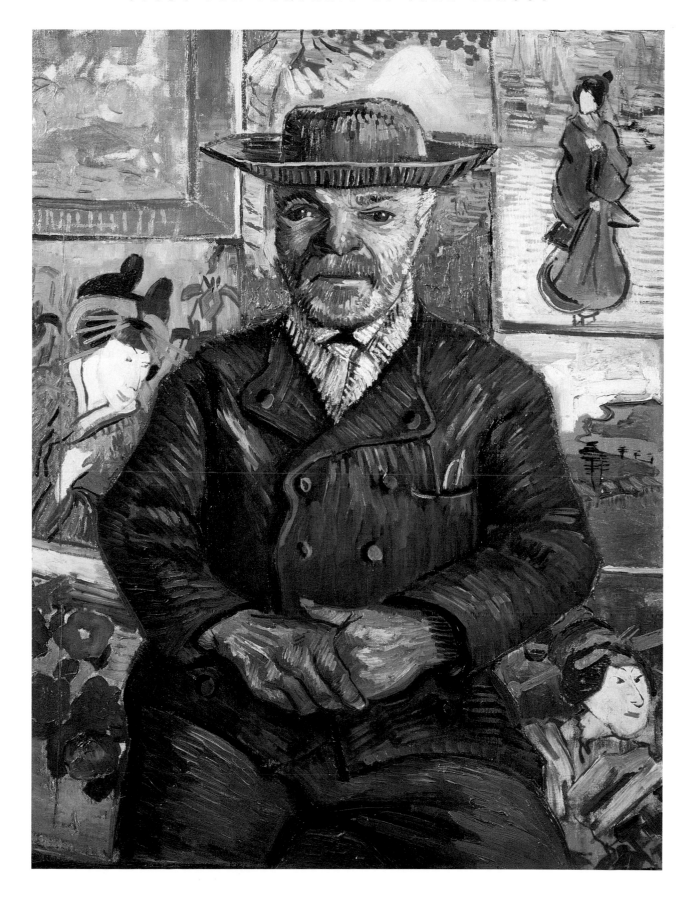

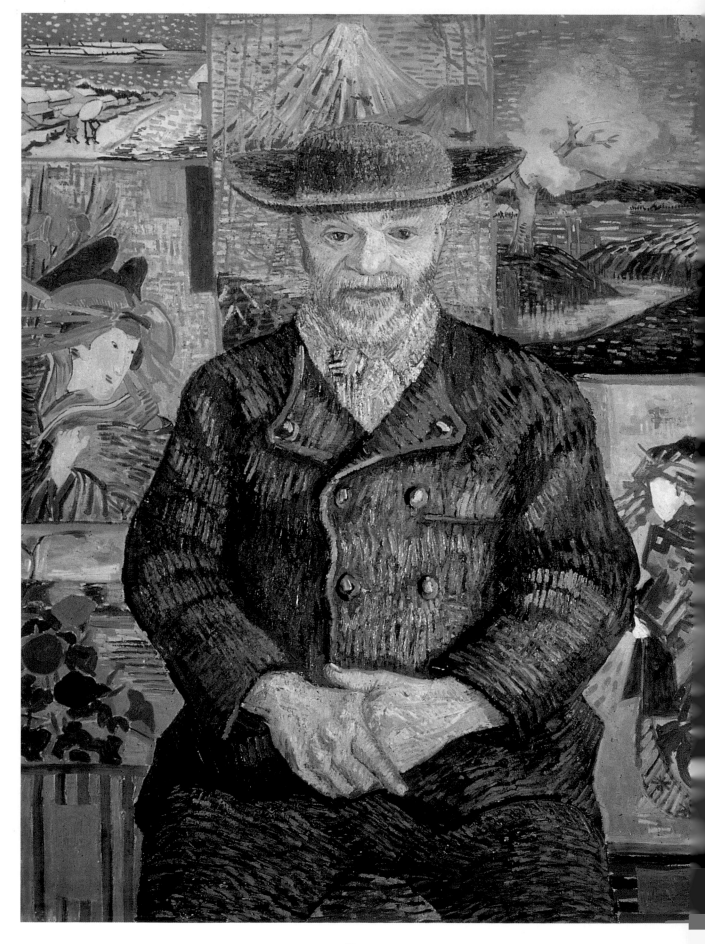

PORTRAIT OF PÈRE TANGUY (1887)

Musée Rodin, Paris. Celimage.sa/Lessing Archive

*V*AN Gogh painted three portraits of Tanguy, all of which deploy a much more intense palette than hitherto. The significant technical reason for his brighter canvases, as with those of every other artist around this time, was one which Tanguy himself would have been familiar with from professional experience. New developments in the manufacture of oil paints meant a whole range of ready-mixed pigments became available in easy-to-use squeezable tubes. Such an innovation was invaluable to Van Gogh.

Similarly influential to his career were Japanese prints, like those surrounding the sitter here as a decorative backdrop. He had originally seen and begun collecting them in Antwerp in the previous months, and admired them for their stylized design and sense of nature's clearcut beauty. Indeed the whole picture, with its deft brushwork and flat picture planes, has distinctly Japanese overtones. Above all, the emphasis is on Tanguy's working-class origins and straightforward, socialist principles. His forward pose, simple, naive expression, clasped hands, and straw hat are all signs that here is a man of the people.

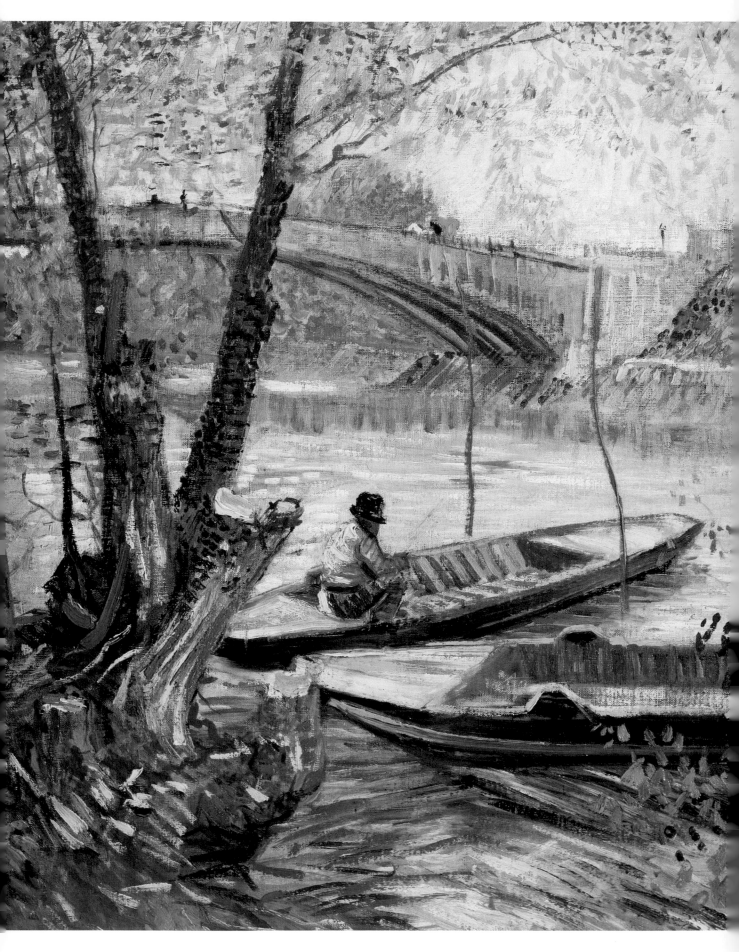

FISHING BOATS IN SPRING (1887)

The Chicago Art Institute, Chicago.
Celimage.sa/Lessing Archive

A MAN sits in a boat with his back to the onlooker. He is seemingly unaware that he is being depicted in this painting. The river and bridge are subtly framed by the leaves that gently creep in from both sides of the image. They are lightly dotted around the left and right of the canvas, emphasizing the Impressionist aspect to the painting. In this sense, *Fishing Boats in Spring* is one of Van Gogh's most eminent Impressionist paintings. After all, this painting was completed during his stay in Paris, where he was surrounded and influenced by the Impressionists, the most dominant art movement of the decade.

His style of painting, however, is intentional. The light and loose brush method reflect the season of spring, during which this work was painted. There is also a fantastic blend and balance of color as Van Gogh combines brown, blue, and green tones throughout the image. The overall effect is soft and subtle, like the season it is supposed to represent. As we look into the distance and beyond, toward the bridge in the left-hand corner of the canvas, we can see how the individual strokes become less defined. It is only as we look directly at the base of the canvas that we can see an element of what we consider to be Van Gogh's defining brush method. Here we can see a series of directional and opposing paint strokes, which mimic the course of the river and outline the bark at the base of the tree.

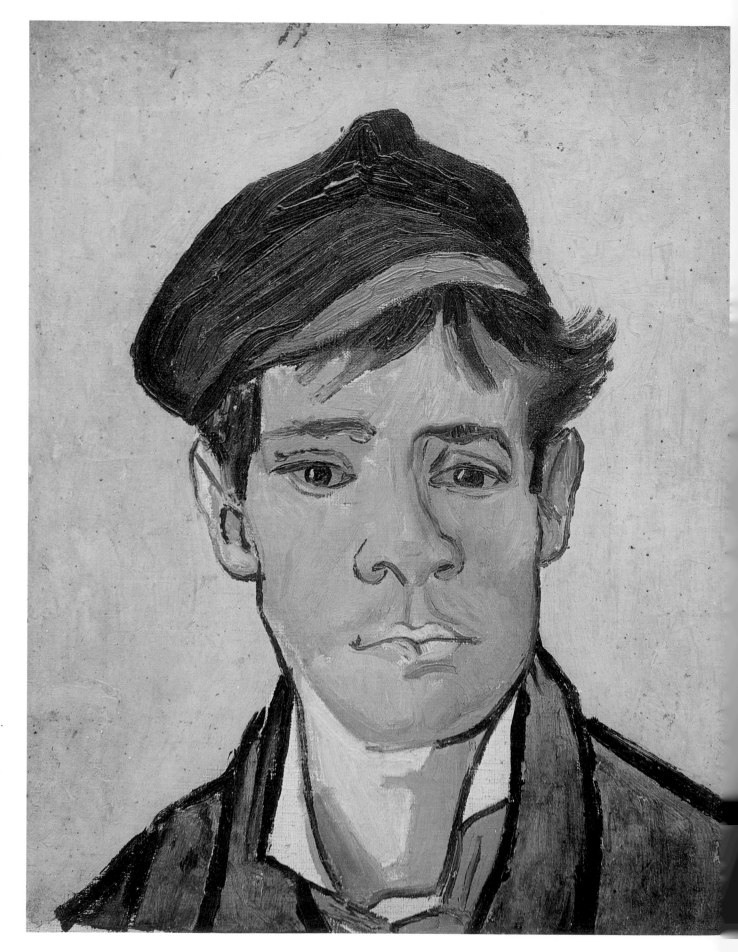

YOUNG MAN WITH CAP (1888)

Nathan Collection, Zurich. Celimage.sa/Scala Archives

AFTER two years of living in Paris, Van Gogh grew tired of city life and decided to travel south, where the climate was warmer and he could enjoy a more relaxed rural setting. In February 1888, he moved to the small town of Arles, in Provence, where he was to refine his stylistic genre. The paintings produced in Arles (some 200 artworks in the space of 15 months) had a more consistent method, quite unlike the experimental products of previous years. Here, Van Gogh began his exploration of the expressive nature of color.

Painted in December 1888, *Young Man with a Cap* deploys an overwhelming use of yellow. The portrait signifies part of a greater shift in the artist's palette, to warmer and brighter shades, a change that was the likely result of his move to Arles.

During this time, the artist sold no paintings, and lived in poverty. Van Gogh was beginning to suffer from visual hallucinations and severe depression. A quarrel with Paul Gauguin triggered Van Gogh's first nervous breakdown, and the infamous incident in which he mutilated his left ear.

APPLES (1888)

Van Gogh Museum, Amsterdam. Celimage.sa/Lessing Archive

THE emotional energy of this artwork seeps through the paint itself, which has been applied in surplus amounts to the canvas. Van Gogh has also created an intense and bright contrast through his use of an oppositional red–green palette.

The roots of the painting are unmistakably Impressionist, with Van Gogh's use of hasty, broken brushstrokes to form the backdrop and individual fruits. The palette is strong, as he persists with his intention to explore and master the full extent of the color spectrum. *Apples* was part of his venture into still life painting, so that he could "freshen his colors for later work," as he wrote in his letters to Theo.

This bold, novel approach obviously pleased Theo, who felt that this development in Vincent's work would allow it to sell.

Apples is a still life painting of considerable warmth and richness. Some of the fruits appear almost overripe, and it is evident through this work that Van Gogh was starting to improvize with his use of color, utilizing it expressionistically rather than as a tool of realism. However, the swift dashes of red, green, yellow, and blue surrounding the composition of apples, is also a sign of Van Gogh's increasing confidence with his medium.

The final result of this exploration into the effects of color culminated in works such as *The Sunflowers* (1888), in which Van Gogh's chromatic intensity peaked at an all-time high.

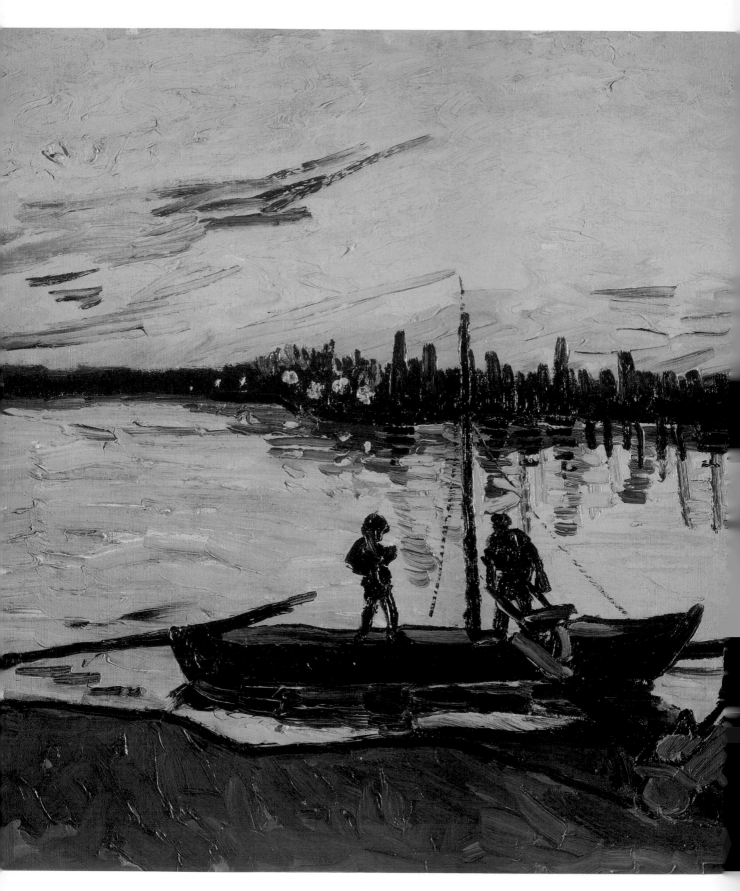

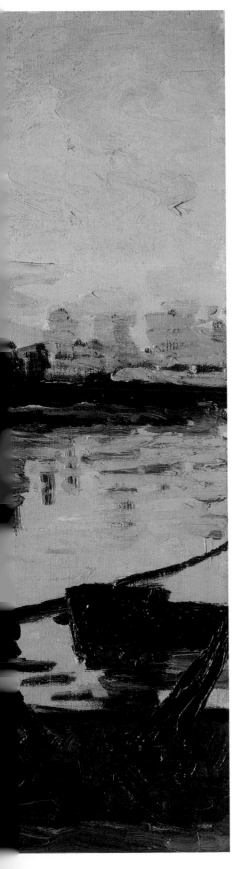

STEVEDORES IN ARLES (1888)

Thyssen-Bornemisza Museum, Madrid. Celimage.sa/Scala Archives

*V*AN Gogh received little formal artistic training, although he attended a small number of drawing classes. He found references and drew inspiration from prints and reproductions in the pursuit of his own artistic goals.

In *Stevedores in Arles*, we find a stark and powerful use of bright yellow, which reduces the foreground to a dark silhouette. This style can be compared to the works of William Mallord Turner and Claude Monet, with its Impressionistic connotations. Van Gogh utilizes this technique to create a violent color contrast. He achieves a wonderful blend of movement through a rich use of intense and juxtaposing shades.

A clear balance is struck as the dominant colors are applied within a series of alternative layers. The black shadow of the foreground is repeated along the horizon, and the yellow of the sky is reflected strongly in the water. The difference between the two shades is defined through the alternating brushstrokes used to map the presence of the river and the shore. Horizontal lines pattern the waves of the water, while vertical strokes are used to depict the buildings and the men on the boats.

Van Gogh's work had a wide range of subjects, from rural landscapes and still lifes, to portraits of the working peasants among whom he lived. All of these remain distinctly memorable, because of the profound passion with which they were executed.

SELF-PORTRAIT BEFORE EASEL (1888)
The Van Gogh Museum, Amsterdam. Courtesy of Edimedia

*V*AN Gogh's attitude toward the self-portrait has often been compared to that of his similarly illustrious compatriot, Rembrandt. Indeed, their almost obsessive urge toward self-investigation has been widely regarded as a quintessentially Dutch trait. However, whereas Rembrandt's prolific numbers of self-portraits were relatively normal for his time, Van Gogh belonged to a small, loose group of artists for whom concerns with the interior world were primary. His fellow Post-Impressionists, Paul Cézanne and Paul Gaugin, for example, also painted dozens. Whereas the Impressionists had been predominantly interested in charting social or public life, the Post-Impressionists turned inward to ask why we are here in the first place.

Painted just prior to leaving for Arles, this is one of many self-portraits Van Gogh produced during his time in Paris. Toward the end of his stay, each successive canvas seemed to reflect an increasing depression with life in the capital. The current thinking on Van Gogh's emotional condition is that he almost certainly suffered from chronic clinical depression. Analyzing this particular period of his life reveals several specific factors which surely contributed to, or sparked off, this condition. Gaugin, with whom he had struck up a close friendship less than a year previously, left Paris for Brittany. Then his lover, Agostina Segatori, who owned a café where he exchanged paintings for food, also left him. Despairing of ever starting a family, he confessed to Theo that "the love of art makes one lose real love." Whether Theo concurred with these pronouncements is unclear, but their quarrels over other matters during this period, particularly money, are well documented. Van Gogh's acute awareness of the financial burden he was imposing on his brother is yet another potential reason for his melancholic moods.

Staring ahead, playing the part of the artist who suffers for his art, this portrait reflects the emotions of a man whose personal relationships were in some turmoil.

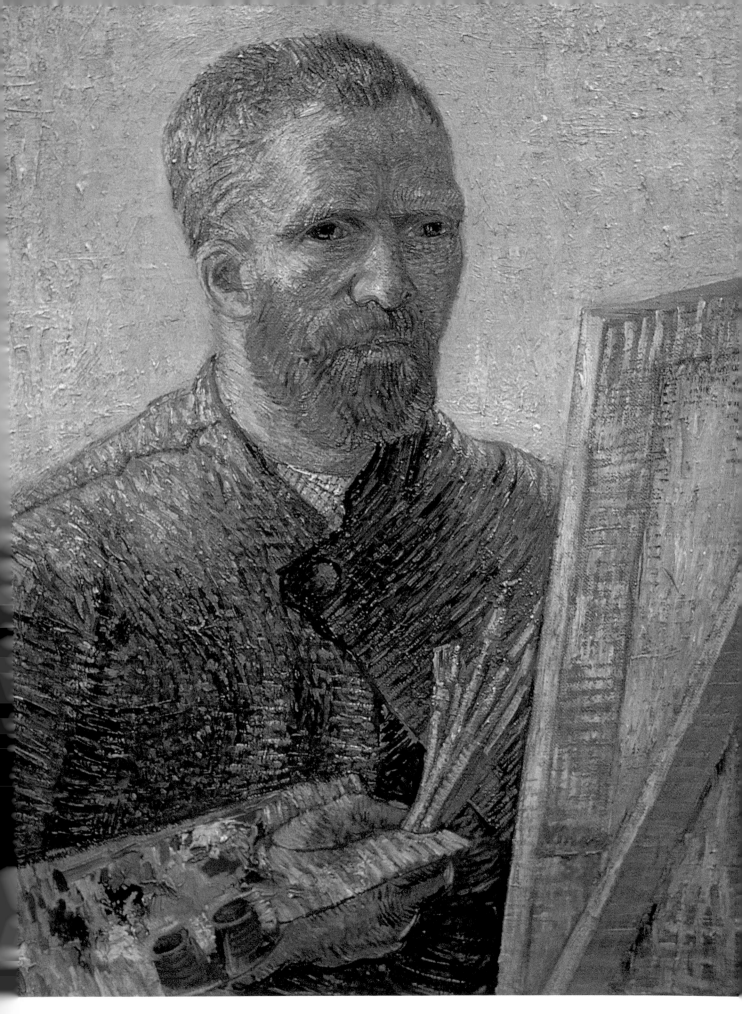

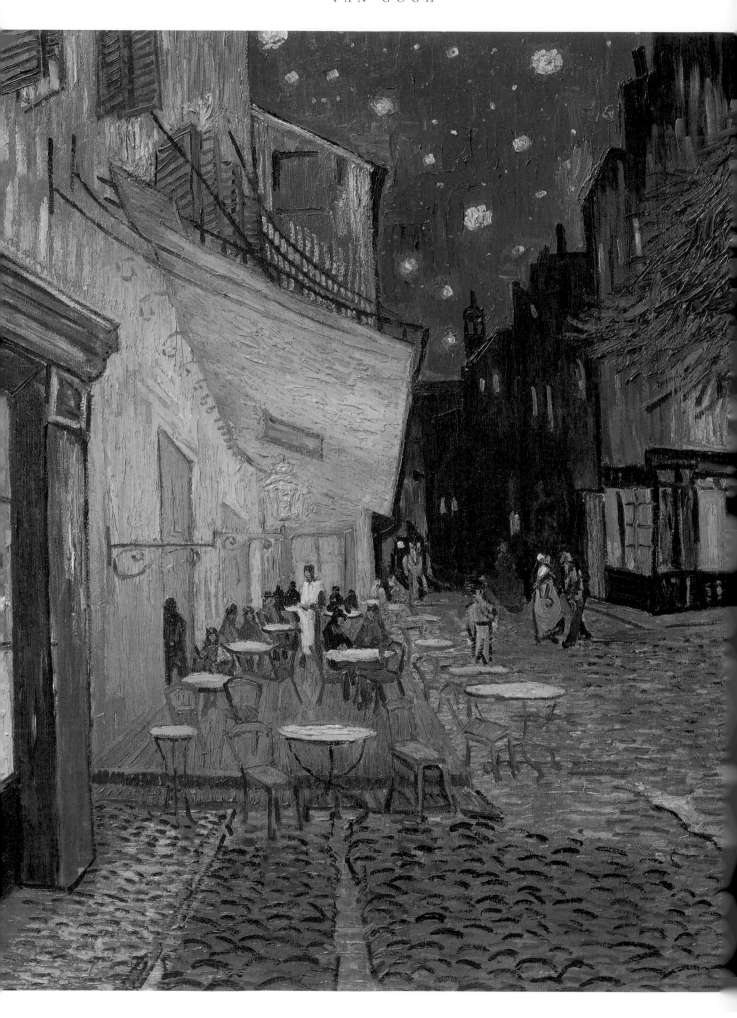

CAFÉ TERRACE ON THE PLACE DU FORUM (1888)

Rijksmuseum Kröller-Müller, Otterlo. Celimage.sa/Lessing Archive

ONE of the first scenes Van Gogh decided to paint during his stay at Arles, this is a work that heralded what was to become one of the most prolific periods in his career. In a single year, Van Gogh completed a staggering 200 canvases as well as writing some 200 letters. Considering the sheer quantity of his correspondence, it is surprising perhaps that the precise reasons for his move to Arles remain unclear. Perhaps he chose Arles for the legendary beauty of its women; the famous Arlesiennes raved about in the contemporary guidebooks and novels. Despite the warm and welcoming atmosphere that led Van Gogh to make confident pronouncements about his hopes for building an artistic community in Arles, his overall response to the place was ambivalent. He once called it "a filthy town."

Café Terrace on the Place du Forum was presumably situated in a more salubrious arrondissement, although cafés were a favorite meeting place for prostitutes and their clients; the couple who stop to talk in the middle of the road could be far from innocent and the empty seats in the foreground may indeed be welcoming us to participate in just this type of exchange. Alternatively, what we witness is "simply" a scene of calm and stability—still rendered with an expressionistic use of paint, but with no sign of the frenetic activity that surrounded Van Gogh's later works.

THE NIGHT CAFÉ (1888)

Collection Hahnloser, Berne. Courtesy of Edimedia

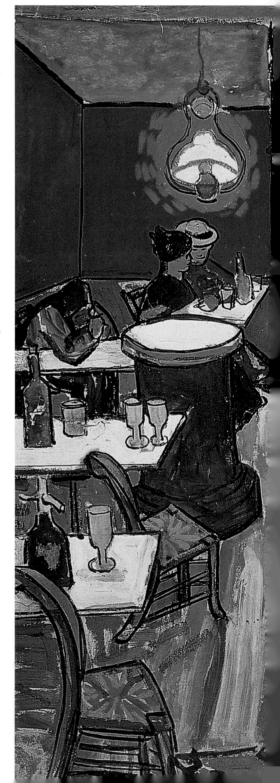

AN Gogh ignored the Roman ruins for which Arles is internationally renowned, and did not even mention them in his letters to Theo. What he did feel warranted writing about—and painting—was the Provençal countryside of the "Midi" and his beloved cafés. Compared with chic Paris, café life in Arles offered far worse company, but in many ways that was precisely the point. Considering himself to be an isolated figure operating on the margins of society, Van Gogh felt naturally attracted to cafés for their seedy, underground reputation. With alcoholics, prostitutes, and the homeless numbering amongst their "socially excluded" low-life denizens, Van Gogh, the poor struggling artist, felt quite at home.

The Night Café was just such a site of urban alienation. By choosing to frequent and represent this kind of scene, Van Gogh was curiously returning to *The Potato Eaters* (1885) territory. Certainly neither painting has the light, detached air that characterized his more Impressionist works of the interim period. Instead of using color to define spatial forms, for example, here it is deployed entirely as a means of expression. The picture's large blocks of pure, flat color anticipate the later German movement of Expressionism in many ways. Likewise, the steep perspective that throws us into the room makes for a strange and oppressive disorientation. The lamps that give off an almost tangible, luminous energy add to the overall sense that, as Van Gogh himself so aptly put it: "it is the *delirium tremens* in full swing."

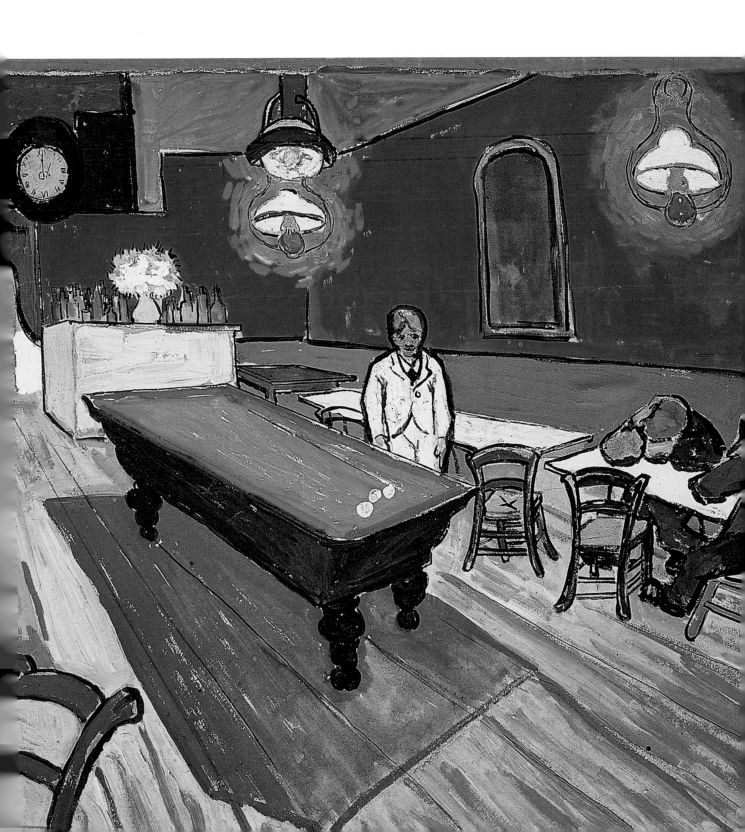

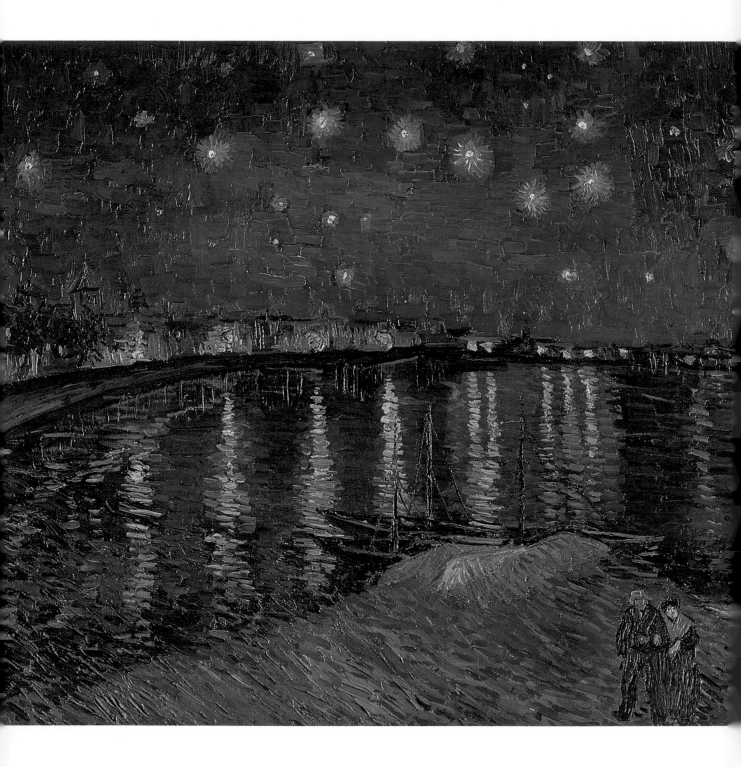

STARRY NIGHT OVER THE RHÔNE (1888)

Musée d'Orsay, Paris. Celimage.sa/Lessing Archive

PAINTED a couple of months after his arrival in the south of France, this is perhaps the lesser known of Van Gogh's two "starry night" scenes. It is also a significantly calmer, more harmonious painting than the one completed a year later, while still retaining its creator's typically manic edge. Inspired by a walk at night, Van Gogh seems to have experienced a kind of hyper-reality when confronted by grass, water, and sky in close combination. It is certainly striking how these three elements fuse into one dynamic whole. For once Van Gogh also felt confident that he had rendered nature's beauty in paint successfully. Such pleasure with his own efforts was not always evident. He once confessed to Theo that "what often vexes me is that painting is like having a bad mistress who spends and spends and it's never enough, and I tell myself that even if a tolerable study comes out of it from time to time, it would have been much cheaper to buy it from someone else." Whether this quote was meant as self-deprecating rhetoric or an indication of genuine self-disgust, Van Gogh's desire to paint never really waned. Although he only took up painting at the relatively late age of 28, from then on it was a vital part of his life with a distinctly therapeutic value. A canvas like this in fact epitomizes the joy that painting inspired in him. Like the silhouetted couple in the foreground, it seems to revel in the romantic, celebratory nature of starlight.

Portrait of Eugène Boch (1888)

Musée d'Orsay, Paris. Celimage.sa/Lessing Archive

RUMOR has it that not only did Van Gogh attach candles to his easel whilst painting at night, but also placed them in the brim of his hat. Such stories, which fuelled speculation about his madness, may, however, have actually been true. He certainly took the Impressionist's edict to paint *en plein air* seriously, and was attracted by night scenes in Arles from first moving there.

It was in the absence of Gauguin, who had not yet arrived in Arles, that Van Gogh chose to paint another friend, the young Belgian poet, Eugène Boch. Although this particular work was not painted at night, the choice of a starry-night backdrop was certainly unusual for a portrait, and virtually unique in Van Gogh's portraits. Van Gogh believed that Boch bore a resemblance to the great Italian poet, Danté, about whom he had recently read a romantic biography. This, together with the letter that he wrote about the portrait to Theo before its execution, are significant facts. They go some way to countering the widespread myth of Van Gogh's work being entirely spontaneous and unplanned. They also reveal him as a man fixated on a fantasy world of stereotypes and sentimentalized genius. In his mind's eye, Eugène Boch was the universal poet and the starry backdrop represented the infinity of Boch's poetic dreams.

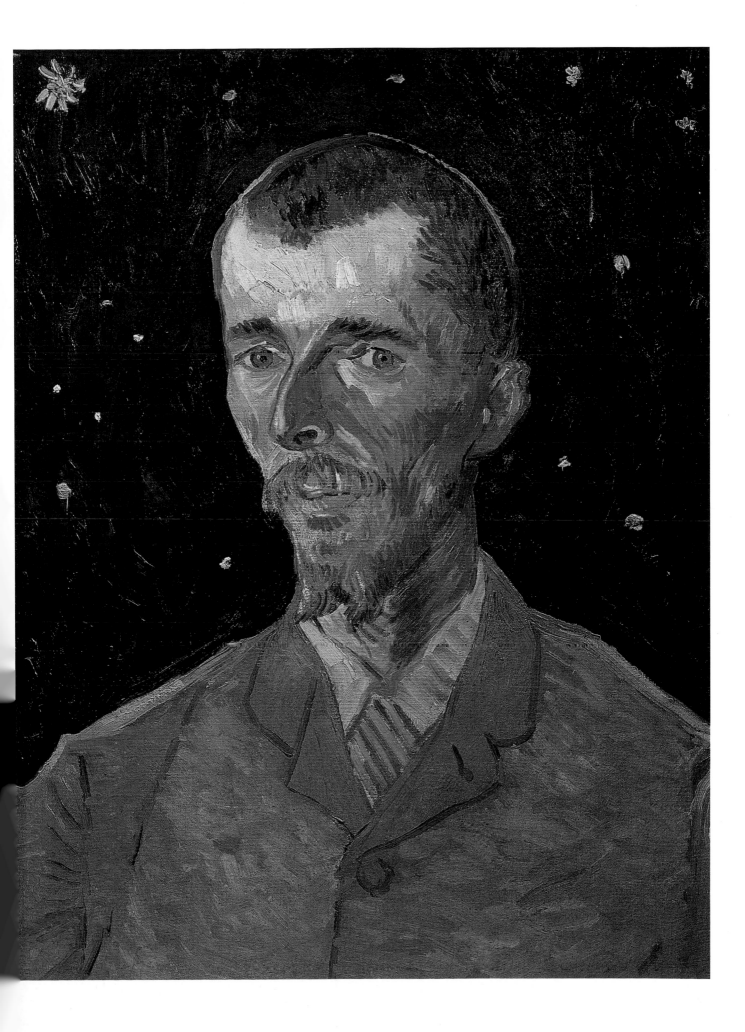

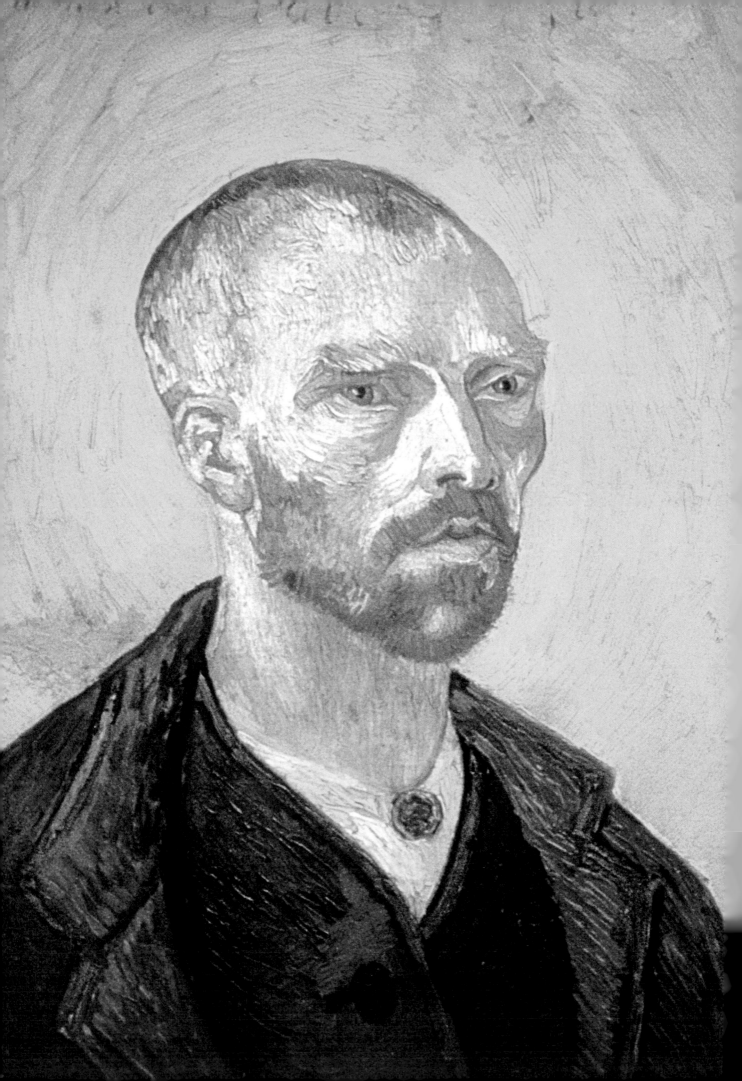

SELF–PORTRAIT (1888)

Fogg Art Museum, Harvard University, Massachusetts. Courtesy of Edimedia

THIS self-portrait, completed by Van Gogh in 1888, was dedicated to fellow artist, Paul Gauguin. The two worked together for two months in 1888 at Van Gogh's house in Arles. Occasionally, they worked side by side, although conflicts that arose between the two precipitated Van Gogh's first breakdown.

Each of Vincent's visual discoveries is highly individualistic. Collectively, they all have a mutual intensity of expression that is unveiled by the artist's eyes, and yet in terms of their palette and brush technique, they vary quite considerably.

These self-depictions map Van Gogh's exploration and altering interpretations of the Impressionist and Neo-Impressionist styles. Over the range of some 30 self-portraits, we can follow changes in the way that he has applied his colors with varying measures of thickness and direction. Each one is presented as a different experience and window into the life of the artist.

This series has often been compared to those painted by Rembrandt Van Rijn (1606–69). Both artists produced a similar number of self-portraits, each of which has an intrinsic power of expression. However, Rembrandt's self-portraits were produced throughout his lifetime, whereas Van Gogh painted all of his within the space of five years. These were completed within the period from the end of the Brabant period, in 1885, to the last year of his life, at St Rémy and Auvers.

DETAIL FROM THE YELLOW HOUSE (1888)

Van Gogh Museum, Amsterdam. Courtesy of Edimedia

THE exuberant, vibrant color coming off the surface of this canvas is terrific. Although the palette is limited to just blue and yellow, the warmth of these two shades is luminous. This warmth of color seems to reflect a period of content for Van Gogh during his time at Arles. The colors are applied in flat planes, which are only slightly etched by the movement of his brush. The yellow buildings, especially, consist of smooth thickness of color against a midnight sky. The two shades contrast only in the way that one suggests the heat of day, and the other the cool of night. Yet, this traditional combination of shades, in an overtly contradictory manner, gives *The Yellow House* its unique hallucinatory quality. Viewing this detail of the painting only enhances the effect of this technique.

The house is recorded in a fairly attentive manner. The green shutters, the window frames, and the individual windowpanes are described with a complementary brush of color. There is also a subtle balance drawn between the use of green and yellow, which is suggested by the amalgamation of the two shades in the short strokes of color that form the leaves of the tree to the left of the image.

Another unusual aspect of this painting is that it features a building. Van Gogh displayed little interest in architecture, which makes *The Yellow House* a painting that is uncharacteristic of the artist and his style, but one that still reveals a window into the history of his life.

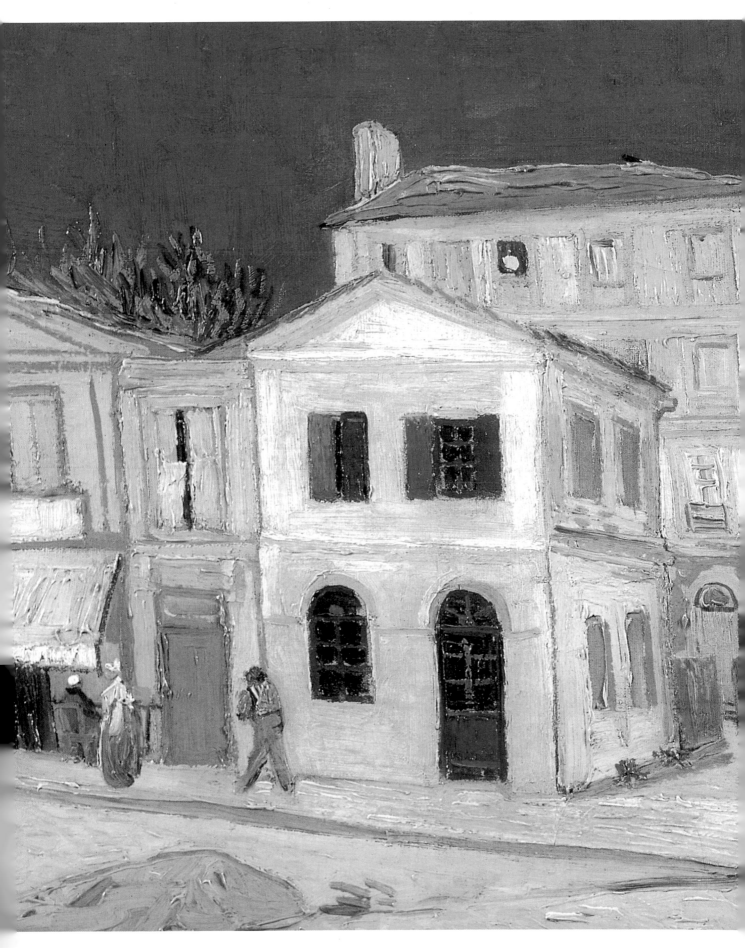

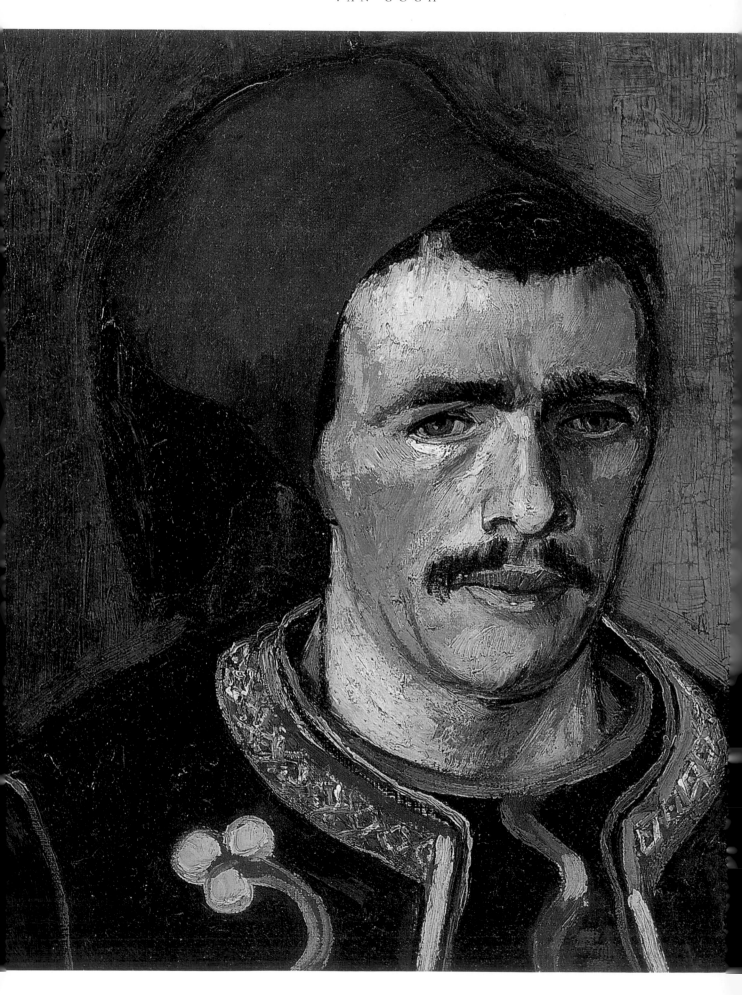

DETAIL FROM THE ZOUAVE (1888)

Van Gogh Museum, Amsterdam. Courtesy of Edimedia

THE Zouaves were a division of the French-Algerian troops based at Arles. They were renowned for their ferociousness in combat and their equally ferocious way of life. This portrait was painted as part of Van Gogh's attempt to record the varying social cultures of his context at this time. The man in this painting is depicted in his traditional attire and set against the simplicity of a pale backdrop.

In this detail, the bleak gray-white color of the background is cleverly chosen to contrast with the rich red, blue, and green tones of the soldier's dress. His jacket has a decorative collar, and there are two flowers, one on either side of the jacket, rising toward both shoulders. The richness of the tones of the subject's face and garments provides an interesting interpretation of his mood.

This is certainly a unique and evocative work. The sitter's eyes and features are treated with considerable detail, and each aspect of his face is described with an element of his emotion. The depth of color in his eyes suggests a mood of sadness, or perhaps pensive reflection.

THE LANGLOIS BRIDGE (1888)
Rijksmuseum Kröller-Müller, Otterlo. Courtesy of Edimedia

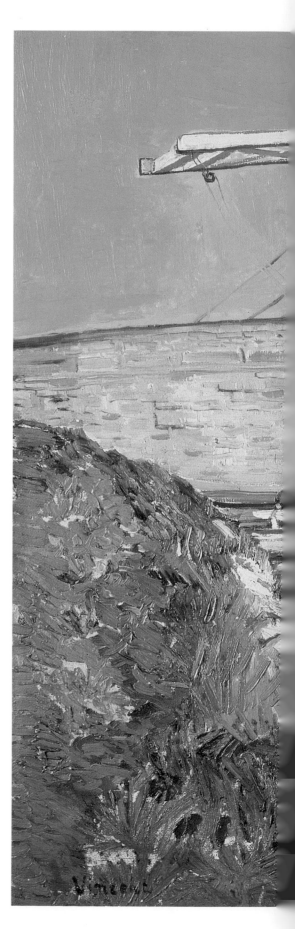

LIKE his Impressionist predecessors, Van Gogh was fascinated with man's increasing impact on nature during the 19th century. Modern interventions in the natural world were at an unprecedented high when this painting was completed in 1888. Significantly, however, Van Gogh chose a scene whose central technical features—the Arles de Bouc Canal and the Langlois Bridge—had actually been built many decades earlier. Their modernity had therefore, by the time of his depiction, been severely tempered. They had fused with their surroundings to become almost like organic outcrops. The same could perhaps be said of the riverbank washerwomen, whose busy labor is very much subsumed within the whole image. The entire scene must have appealed to Van Gogh's idea of the picturesque "Midi," since he painted it four times and made numerous pen drawings.

Stylistically, the painting is something of a mix. Although retaining some Impressionist influences, its blocks of color and energetic style owe more to the increasing impact of Japanese prints. The bridge itself is particularly redolent of similar structures as painted by the Japanese artist Hokusai 50 or so years earlier.

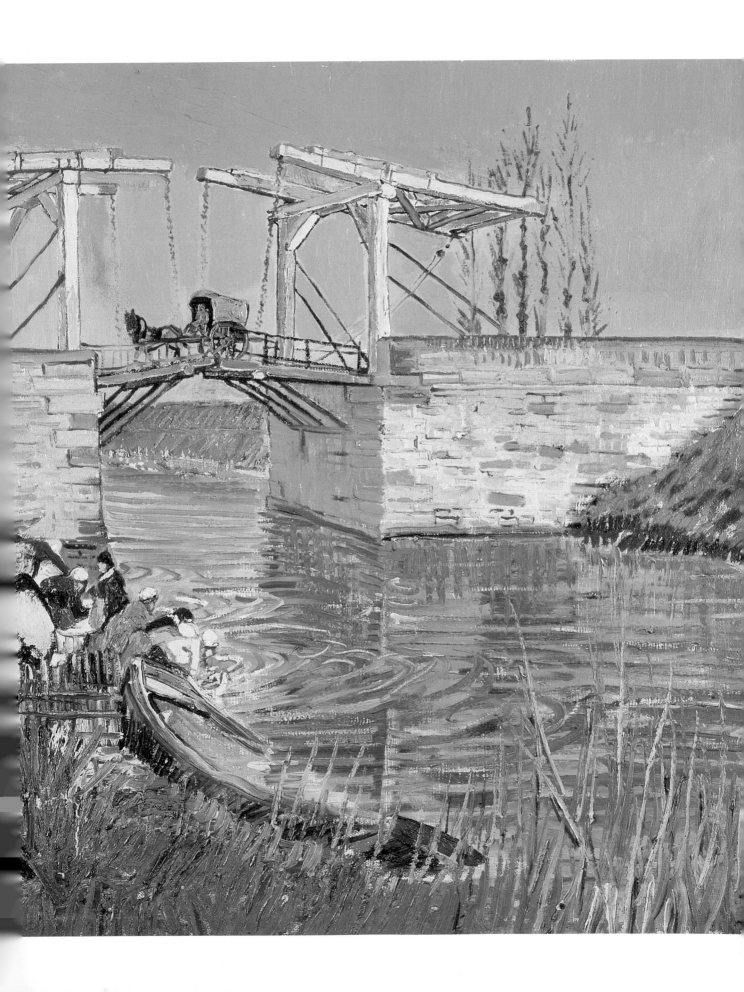

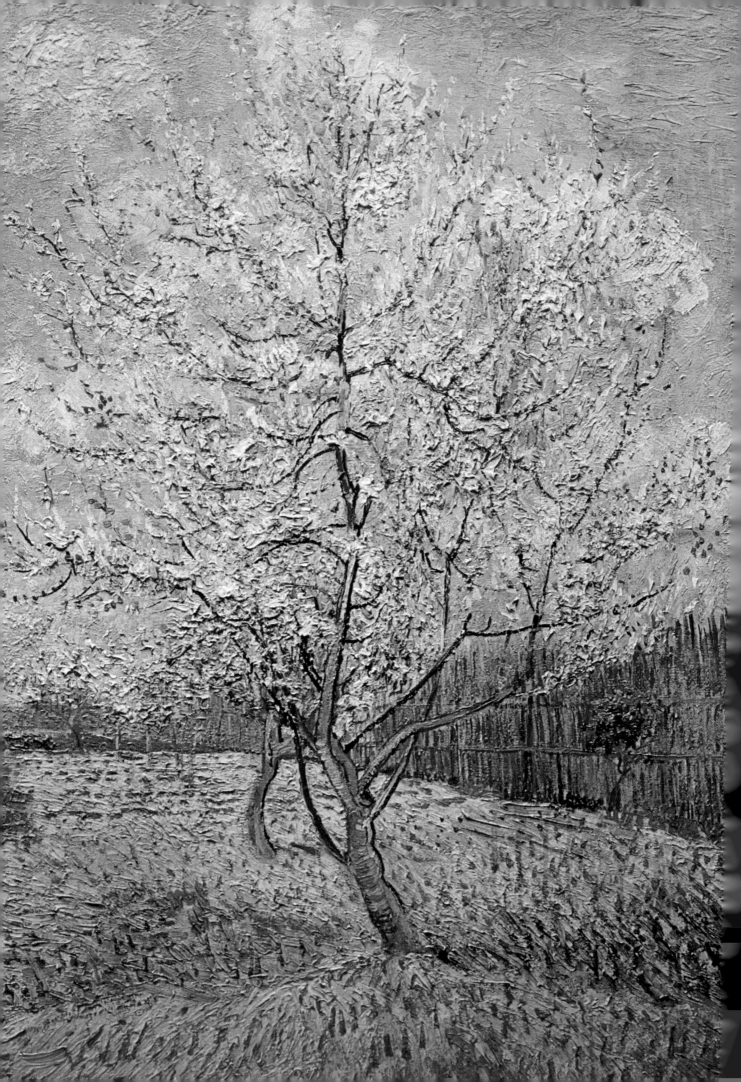

PEACH TREES IN BLOSSOM
(SOUVENIR OF MAUVE) (1888)

Rijksmuseum Kröller-Müller, Otterlo. Courtesy of Edimedia

THIS beautiful image was one of the few pictures Van Gogh signed, a clear indication of his satisfaction with the piece. It was painted in March as a response to the death of his cousin, the well-respected Dutch painter Anton Mauve (1838–88). Apart from the short period of time Van Gogh spent studying at the Antwerp Academy of Fine Art and Cormon's studio in Paris, Mauve had been his only teacher, and was therefore someone he came to feel a profound affection for. Van Gogh decided to paint the picture as a gift for Mauve's widow and wrote on it in the bottom left-hand corner: "Souvenir of Mauve, Vincent and Theo." His brother's name was subsequently deleted from the canvas, although the reason why Theo would have wished to dissociate himself from such a successful work remains unclear. The recipient was reported to have been very touched by the gift commemorating her late husband.

However, Van Gogh's motives were not altogether altruistic; he secretly hoped the painting would be seen by Mauve's close friend, the influential art dealer, Terstoeg. As he confessed to Theo: "It seems to me [*Souvenir of Mauve*] might really break the ice in Holland." Nevertheless, there is also little doubt that *Peach Trees in Blossom* was sincerely meant as a heartfelt tribute. He further wrote to Theo: "Mauve's death was a terrible blow to me. You will see that the rose colored peach trees were painted with a certain passion."

VIEW OF ARLES WITH IRISES (1888)
Van Gogh Museum, Amsterdam. Courtesy of Edimedia

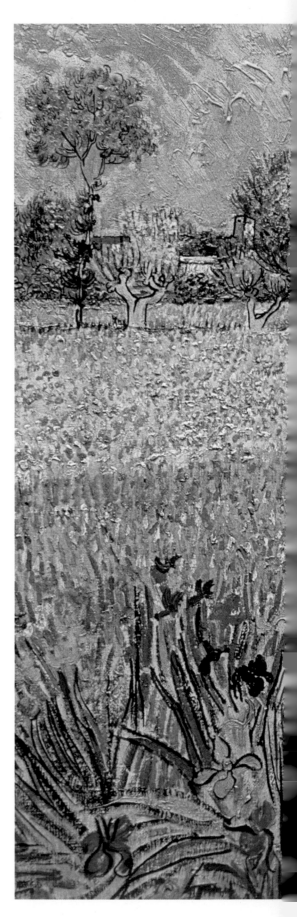

*I*RISES are a significant motif and recurrent theme in Van Gogh's work from Arles. He discovered these flowers during the early part of his stay there. In this landscape, an entire stretch of irises runs across the field along the foreground of the painting.

Technically and stylistically, this work has been thoughtfully designed. The warm yellow field running between the blue flowers and green trees contrasts well, but not overwhelmingly, with other elements. It also provides a fantastic perspective across the fields, which lead up to the horizon of trees and buildings. *View of Arles with Irises* displays a variety of Van Gogh's techniques, from the wild strokes of the irises in the foreground, to the smaller lines of the yellow field and the erratic hasty brushstrokes of blue in the sky. The painting is rich in technical proficiency.

In terms of color, the palette is quite limited, yet the complementary shades of yellow and purple-blue combine to create an inviting effect. The colors are executed in their purest forms, untainted by the heavy shadow and accentuated lines of some of Van Gogh's other landscapes, with the result that the effects in this piece are far more subtle.

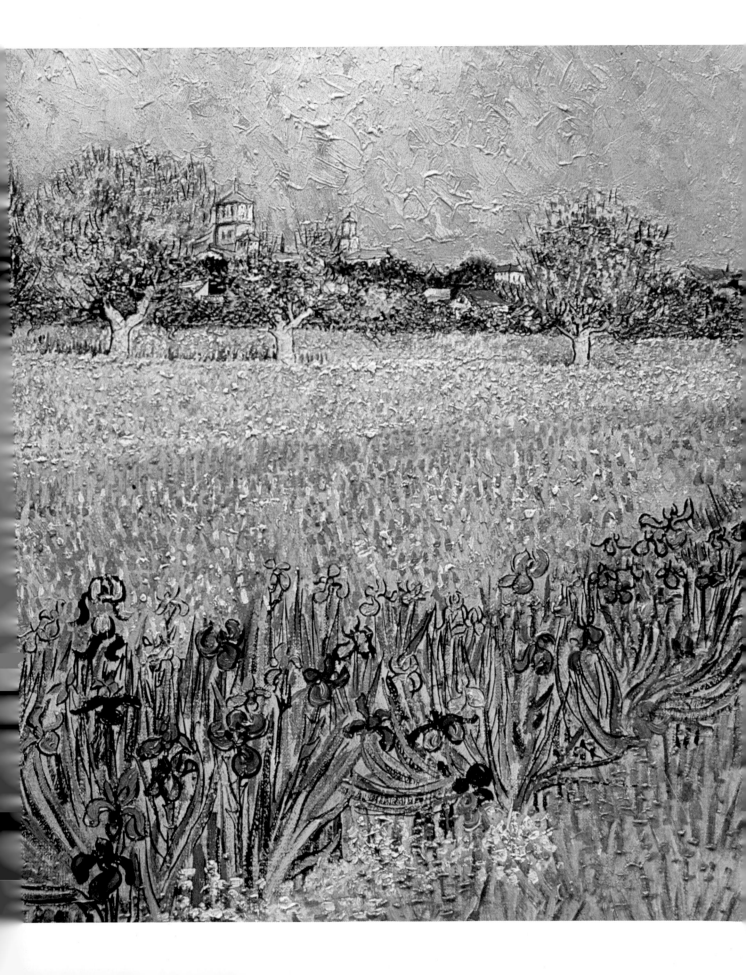

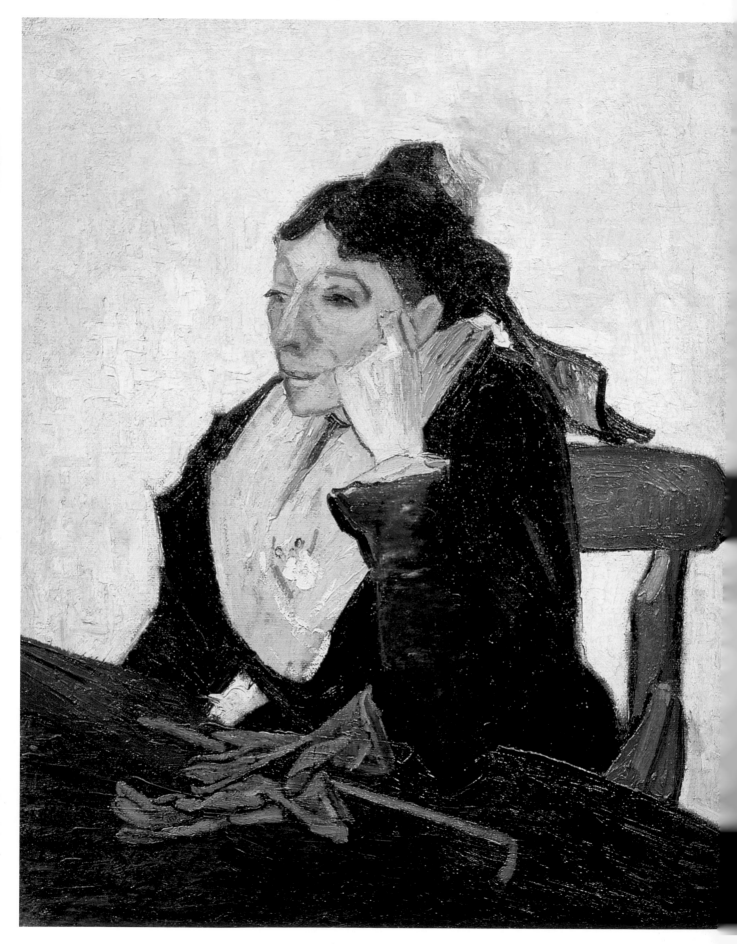

L'ARLESIENNE (1888)

Musée d'Orsay, Paris. Celimage.sa / Lessing Archive

*T*RANSLATED, "l'Arlesienne" literally means "the woman of Arles," which might suggest that Van Gogh's motivation for choosing this subject was a desire to represent another "type" just as he had done with *Woman Digging* (1885). However, this particular Arlesienne was well-known to him as the wife of café proprietor, Joseph Ginoux, from whom he rented a room. After financial disputes with previous landlords, Van Gogh was wary of being overcharged, but the couple's friendliness soon assuaged any lingering anxieties.

Describing his latest effort to Theo, Van Gogh had this to say: "... the background is pale citron, the face gray, the clothes black, black, black of raw Prussian blue. She is leaning upon a green table and seated on an armchair of orange colored wood." Van Gogh's preoccupation with colors was not so much a concern over the colors themselves, but rather their interrelationships as part of a whole. The same sensibility is at work in *Irises in a Vase* (1890). His description, incidentally, could also apply to another version of the picture, which features books instead of an umbrella and gloves. The status of these objects as "props" could have suggested itself to Van Gogh by a well-known contemporary play, also entitled *L'Arlesienne*. The heroine's beauty and vigor, visible here, were known to be characteristics of "les Arlesiennes" and led Van Gogh to remark of a lieutenant friend: "he is lucky, he has as many Arlesiennes as he wants, but then he cannot paint them, and if he were a painter he would not be able to get them."

GYPSY CAMP WITH HORSE AND CART (1888)

Galerie du Jeu de Paume, Louvre, Paris. Celimage.sa/Lessing Archive

THIS painting represents the memory of a big trip Van Gogh decided to make at the end of May 1888. Perhaps because of financial constraints, he rarely journeyed outside Arles to see the surrounding environs, but made an exception in this case. Along with thousands of others, he was drawn to Les Saintes-Maries de la Mer, 30 miles from Arles, by a religious festival held there from May 24 to 25 each year. It was on these dates in AD 45 that the small seaside town had been the reputed landing site of Mary Magdalene, her sister Mary Cleophas, and Mary Salomé. All three had allegedly come to convert the region to Christianity. Their cult proved particularly popular amongst local gypsies, and it was a group of these that Van Gogh chose to paint on his return home. This approach was unusual for Van Gogh, who almost always worked from life. However, unlike other exceptions to this rule, such as *Souvenir of the Garden at Etten* (1888), the image here does not represent a symbolic dream reality, but rather an actual event, as visibly recollected in the tranquillity of the studio. The subjects' socially marginalized status would surely have attracted Van Gogh, whose empathy with such characters can only have been heightened by their itinerant lifestyles.

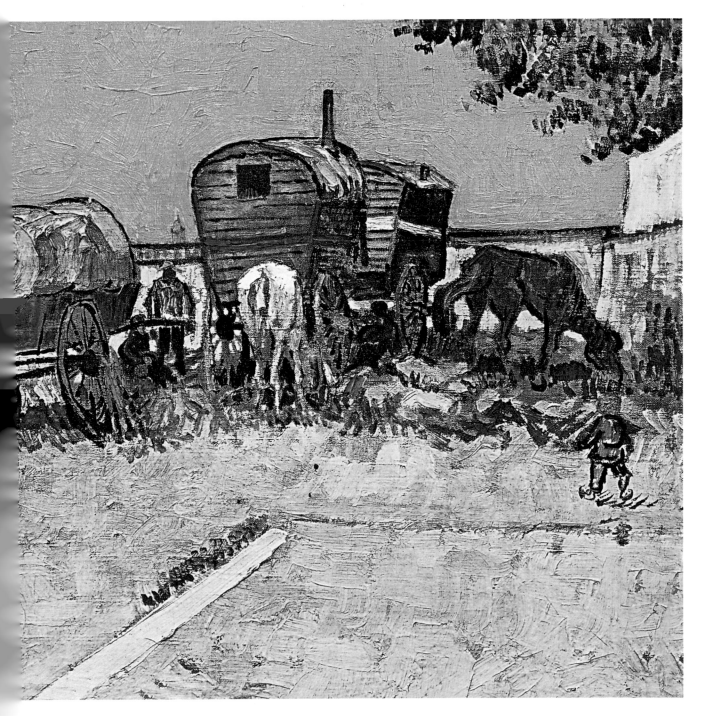

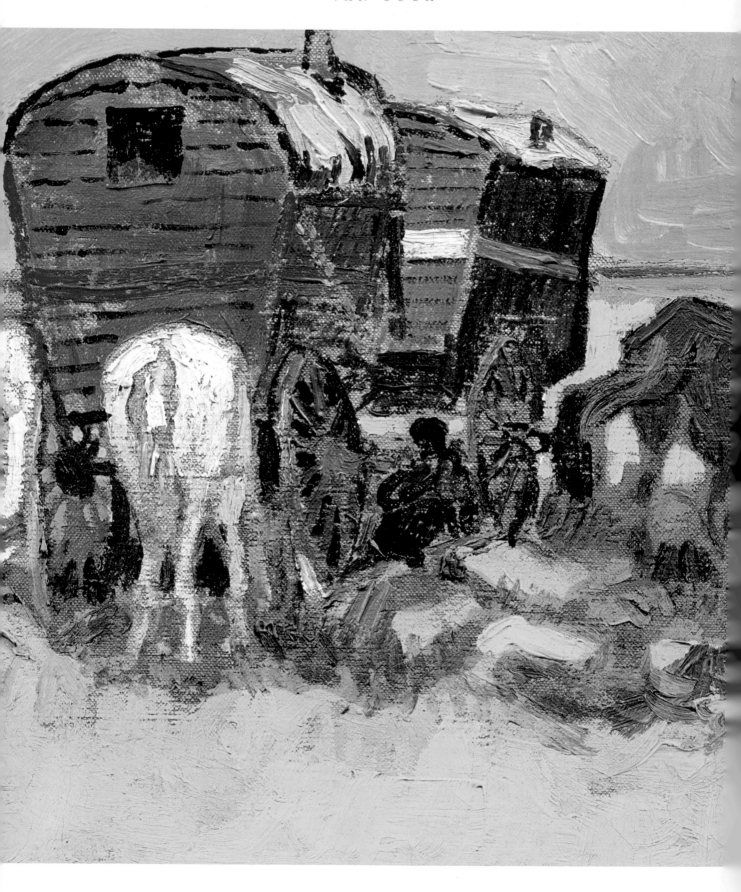

DETAIL FROM GYPSY CAMP WITH HORSE AND CART (1888)

Musée d'Orsay, Paris. Courtesy of Edimedia

WE know this painting holds significant value, not only for what it reveals about Van Gogh as an artist, but also for what is says about him on a personal level.

This particular detail from *Gypsy Camp with Horse and Cart*, shows the back of a white horse and blue cart. This section of the painting does not show a particularly detailed treatment of the subject matter.

Flickers of orange color can be seen around the wheels of the cart and running through the hair of the animal, suggesting the heat of a summer's day. Along the ground and in the sky, color has been applied thickly to the surface of the canvas, in light shades of yellow and blue respectively. These subtle hues further encourage the image of a hot afternoon spent in the sunshine on the coast of the Mediterranean.

The painting is a personal achievement for the artist, who rarely ventured from Arles. Also, the relaxed pace of his surroundings, shows a clear influence over the manner in which this work was executed. The effect of the warmth and tranquility in Les-Saintes-Maries-de-la-Mer manifests itself in Van Gogh's use of warm, soft, gentle planes of color, a method that reflects the artist's contentment at this time.

SAINTES-MARIES (1888)
Courtesy of Edimedia

ALTHOUGH Van Gogh spent only four days in Les-Saintes-Maries-de-la-Mer, he was clearly impressed with the location and painted a number of scenes from the area. The southern climate had a great impact on his use of color, this change in scenery leading to a liberation of his palette. This and other works completed during his time at Saintes-Maries illustrate his growing commitment to the expressive values of color.

Les Saintes-Maries-de-la-Mer was built as a fishing village in the Camargue region of France. It was built on an island in the heart of the Camargue, where the Petit Rhône joins the sea. The village was established around the Notre-Dame-de-la-Mer church, and spread out as it grew.

We can identify the large dominant church in Van Gogh's Saintes-Maries, as it rises above a jigsaw collection of rooftops and cottages. Although the town was not considered picturesque in terms of a medieval village, Van Gogh bathes his canvas in a warm light, depicting this part of France with an element of personal adornment.

In this painting, Van Gogh further explores his passion for color contrasts, but in quite a subtle manner. His use of red and green, and blue and orange is still apparent, yet they are not placed in juxtaposition, as they are in similar works, such as *Street in Saintes-Maries* (1888).

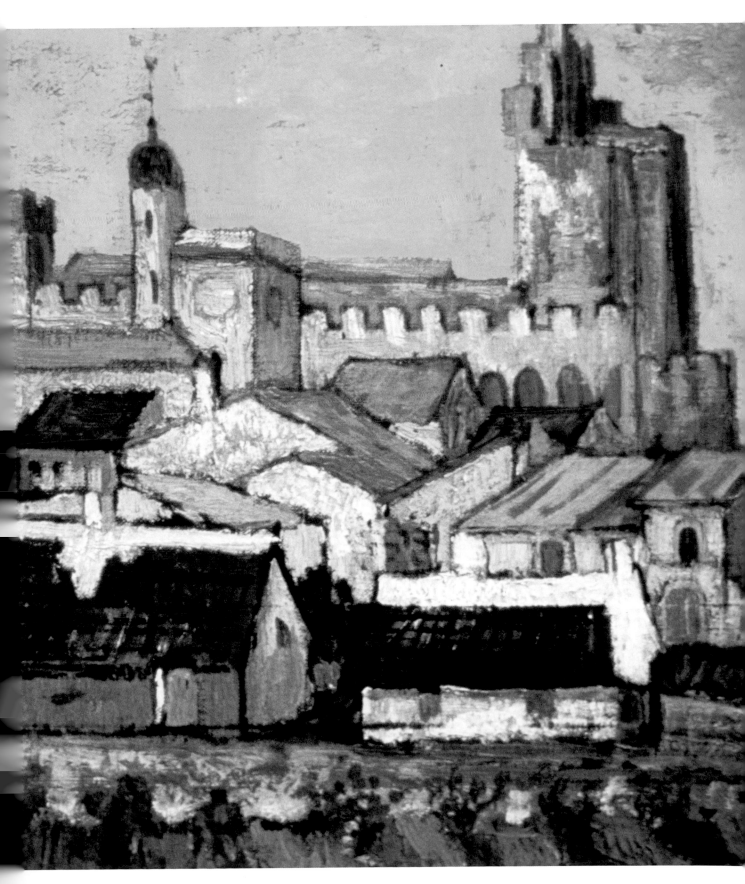

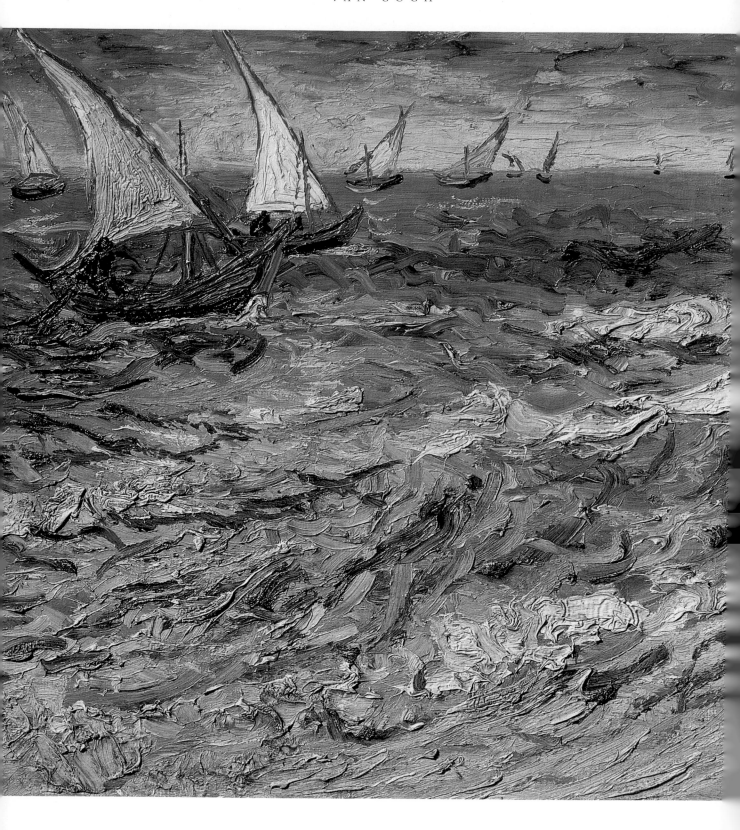

SEASCAPE (1888)

Pushkin Museum, Moscow. Celimage.sa/Scala Archives

WHILE still in Holland in 1885 Van Gogh wrote: "Sand-sea-sky—I would like so much to express these at some point in my life." At Les-Saintes-Maries-de-la-Mer, he at last had the opportunity to do so. He spent only four days at the seaside town in late May, but was sufficiently enamored to make nine drawings and three paintings of it on his return. Of the paintings, two were seascapes and this is the better of the two. In fact Van Gogh was so pleased with it that he produced three copies in August. At the time of the original, Van Gogh was aspiring to a more assured way of working; the broader strokes, called for in painting the sea, freed him from his previous precision. Added to this, the Mediterranean proved more colorful than he had expected it to be and strengthened his belief that "color must be exaggerated even more." In a letter describing the scene to Theo, he outlined his further surprise that: "The deep blue sky was flecked with clouds of a blue deeper than the fundamental blue of intense cobalt, and others of a clearer blue, like the blue whiteness of the milky way."

Indeed, it is the blues of the waves which seem to be the painting's real subject, with the boats relegated to background add-ins. The foreground waves, which have a curious grass-like quality, are painted in a particularly thick impasto that makes them appear to splash off the canvas.

THE SOWER AT SUNSET (1888)
Rijksmuseum Kröller-Müller, Otterlo.
Celimage.sa/Lessing Archive

VAN Gogh painted several images of the sower, but this particular version was especially significant to him. He began making plans for the picture long in advance of its final execution, and described the completed work to Theo in no less than four letters. It was again inspired by Jean-François Millet's painting of the same scene, finished 30 years earlier. However, whereas Millet always deployed a dark, somber palette, Van Gogh's use of color showed that he had also learnt the lessons of Impressionism. Indeed, he conceived this painting as being one that would represent "a symbolic language through color alone." The complementary yellows and violets speak eloquently of a new art and a new age: their resonance is thoroughly modern.

Comparing his efforts to those of his hero, Millet, perhaps it was inevitable that Van Gogh was displeased with the result. As a consequence, he made some changes to the original, among which included toning down the colors and changing the peasant's trousers from their original white to a more integrated blue. He also painted over the trees that had originally appeared to the right of the sun, and moved the sower himself further from the center. Even these changes, though, didn't satisfy him. He wrote to Theo deriding it as a "glorified study."

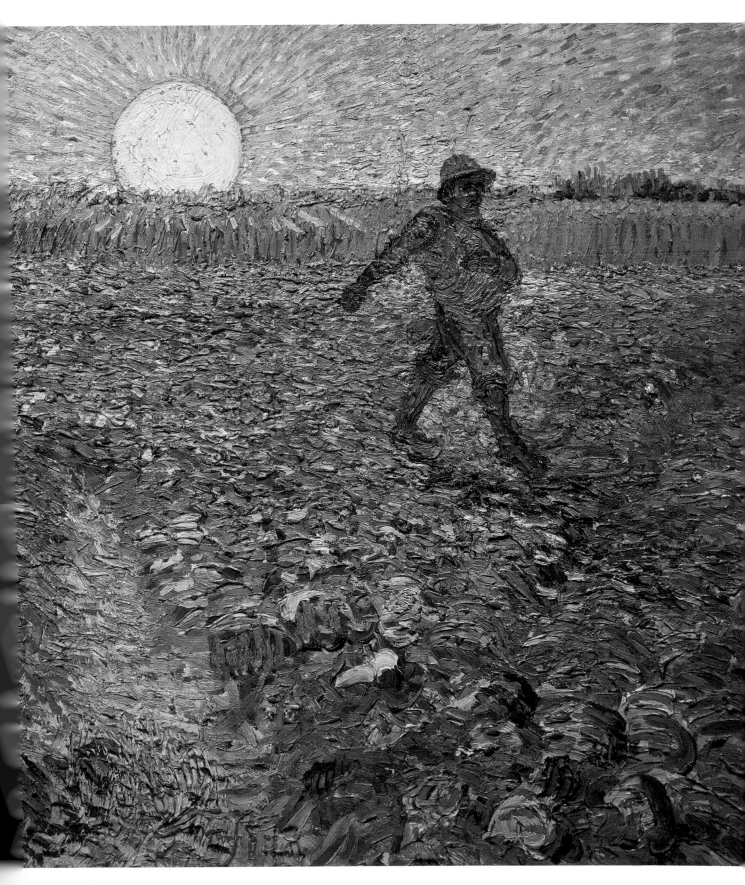

THE SOWER AT SUNSET

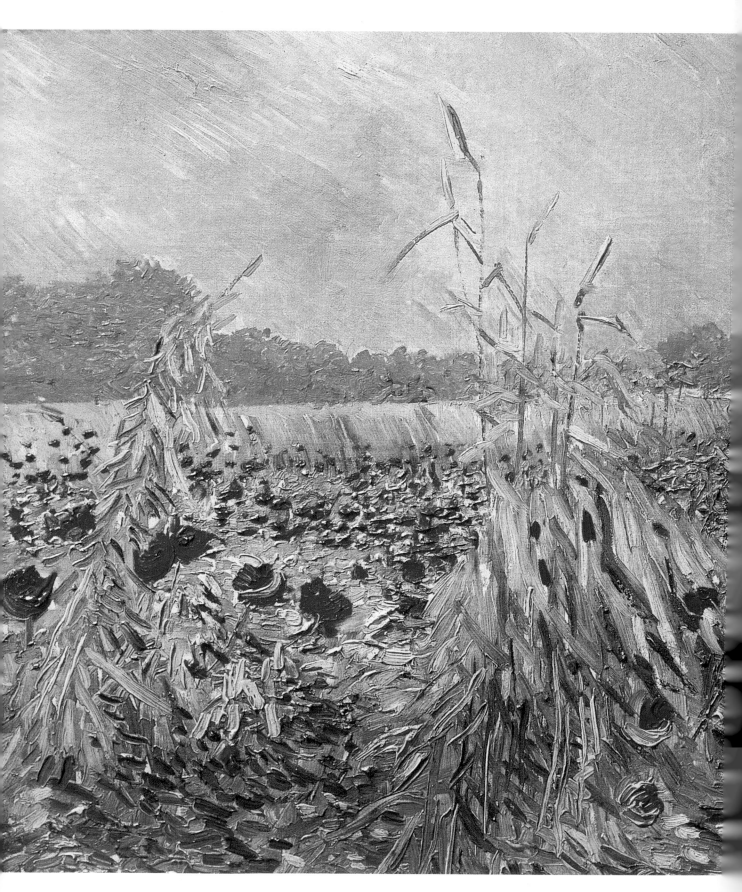

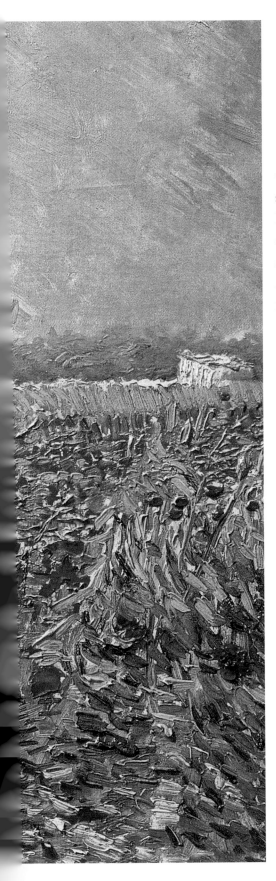

GREEN CORN STALKS (POPPY FIELD) (1888)

Israel Museum, Jerusalem. Celimage.sa/Lessing Archive

WHEREAS Claude Monet's (1840–1926) famous poppy fields are delicate and light, Van Gogh's treatment of the same subject is stronger, denser, and more expressive. The Impressionist's sketchy brushwork is retained to a certain extent, but developed in a more abrupt, almost violent direction, and the colors are purer and more intense. Complementary reds and greens play off each other to startling effect. Since leaving Paris, Van Gogh had gained much confidence in his artistic ability. Inspired by such artists as Monet, he resolved to integrate their working practices into his own. One such method was to reject the use of traditional preliminaries, such as sketches and oil studies, in favor of painting *en plein air* directly onto the canvas. This is not to say that his work was entirely spontaneous—calculation and premeditation were always present in the final works—but experimentation was allowed to take place right up to the last brushstroke. Sometimes paint was even applied straight from the tube. This may in fact have been the case here; the impasto technique has certainly been applied in the foreground with some gusto.

ROAD AT SAINTES-MARIES (1888)
Courtesy of Edimedia

THE Museum of Modern Art in New York recently had to give away four Impressionist artworks, because the patron who had bequeathed them in 1948 believed they would lose their sense of modernity within 50 years.

Two of these works were by Vincent van Gogh. One was a pen-and-ink sketch, titled *Road at Saintes-Maries* (1888), and the other was a gouache painting, completed in 1889. The two works were valued at an amount exceeding $40 million.

Road at Saintes-Maries is a pen and ink drawing. Unusually, it lacks the rich intensity and flow of color that we see in other depictions of the town, such as *Street in Saintes-Maries*, painted by Van Gogh in the same year. Instead, this work has an authenticity that is conveyed by its faintly browned paper and absence of color.

The fine lines used to craft this scene remain mostly long and smooth throughout, even though they have been hastily applied to the surface. The brush technique in some of Van Gogh's other Impressionist ink sketches was to become quite fierce and broken, and in others, was straight and precise. In several of these works, the artist introduced light washes of color, a method inspired by the Japanese prints that were so popular at this time.

The subject matter of *Road at Saintes-Maries* may be derived from the artist's past, but its treatment is quite unique. What was once grounded in gritty realism, has now become a simplistic and minimal representation.

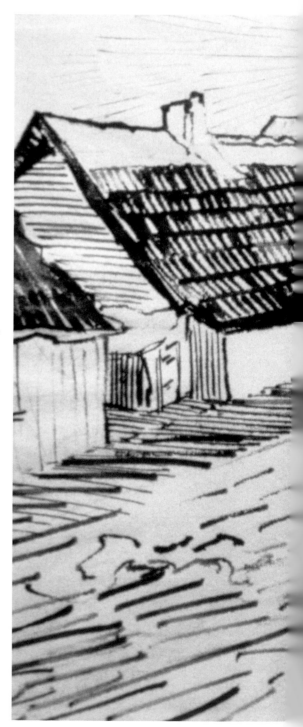

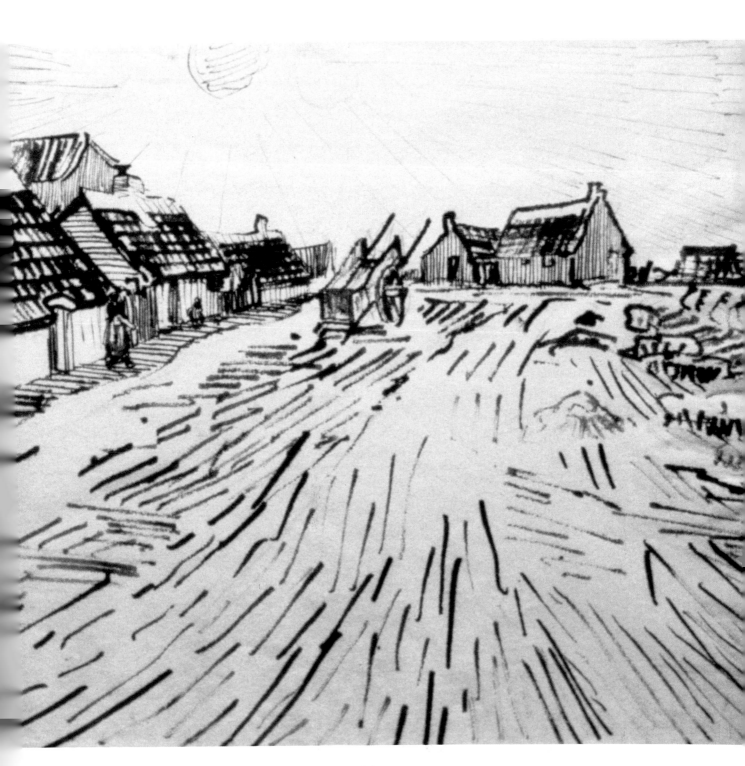

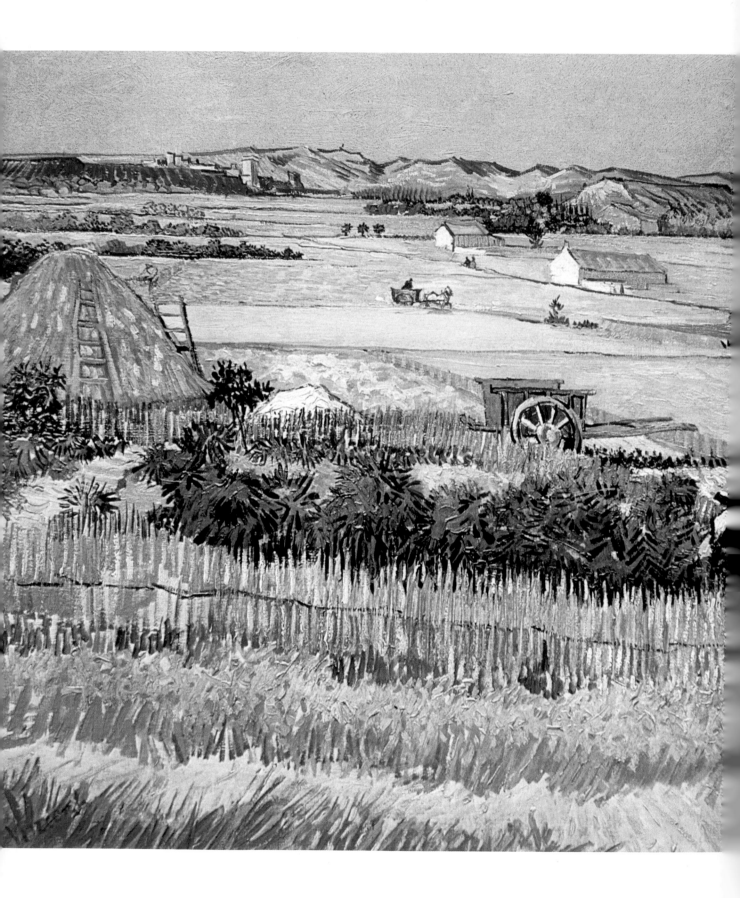

THE HARVEST (1888)
The Van Gogh Museum, Amsterdam. Courtesy of Edimedia

HAVING completed an almost identical version of this scene in his detailed drawing of *The Harvest* (1888), Van Gogh felt confident enough to finish this painting in one long sitting. He was sufficiently pleased with the end result to give it a French title—*La Moisson*—a rarity for Van Gogh, most of whose work has been titled by subsequent dealers, critics, and art historians. At the time he considered the image to be such a success that he even wanted to show it at the annual Indépendants Exhibition in Paris. Comparing it with his other work up to this point, Van Gogh's praise was unusually emphatic. He wrote to Theo: "The [...] canvas absolutely diminishes all the rest."

Previously in Holland, Van Gogh had been unable to attempt such panoramas, partly due to a certain technical immaturity, but mainly for straightforward topographical reasons. Quite simply, Holland was too flat. The Provençal countryside, compared to its Dutch equivalent, was the source of a far greater variety of cultivation and associated agricultural activities; many feature here. It is not hard to see why Van Gogh was so happy with his efforts. It is a truly stunning view, a landscape of unprecedented clarity and a rich evocation of an area in France that he came to love.

HARVEST IN PROVENCE (1888)

Jerusalem Museum, Israel. Celimage.sa/Lessing Archive

URING his time in Arles, Van Gogh's long apprenticeship and period of stylistic experimentation came to an end. He had always felt naturally drawn to peasant subjects, but in the south of France his canvases became larger and his already fast pace of work increased considerably. Indeed, Van Gogh himself explained to Theo that the paint flowed as naturally from his brush as sentences from his lips. At times he felt he was incapable of distinguishing between good work and bad, and hardly felt in control of his movements. This was not, as has been suggested, because he was mad—this is hardly the work of someone who is mentally unstable—but it is more likely to have been a result of working many hours on end in wheat fields such as this under the blazing Provençal sun.

This is one of the canvases executed under such conditions. It was painted quickly and instinctively, but quite purposefully. The subject was chosen beforehand and he wrote to Theo that he had hit a "high yellow note" in the summer of 1888. Although it would be puerile to suggest Van Gogh had an absolute "favorite color," yellow was the one that dominated his palette in Arles.

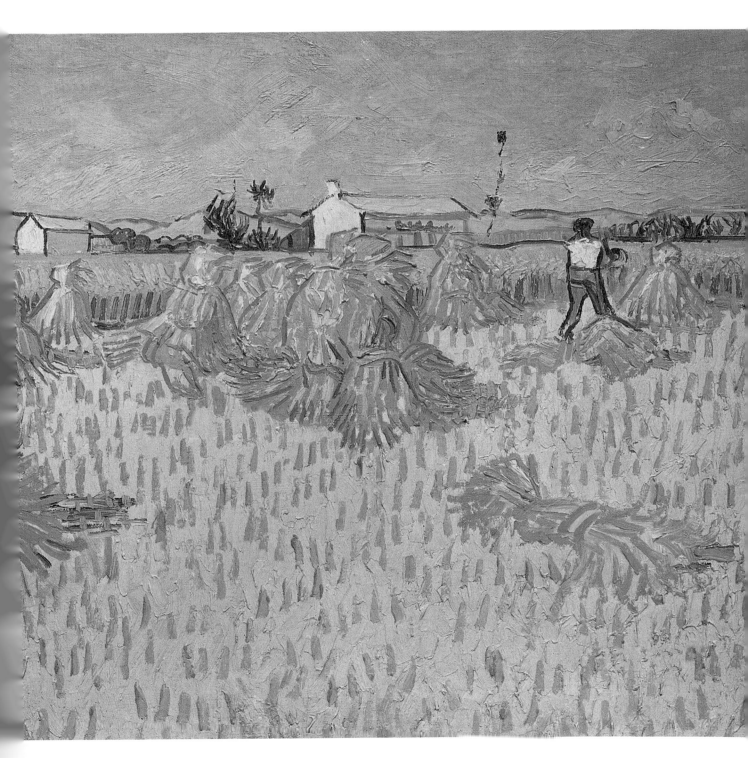

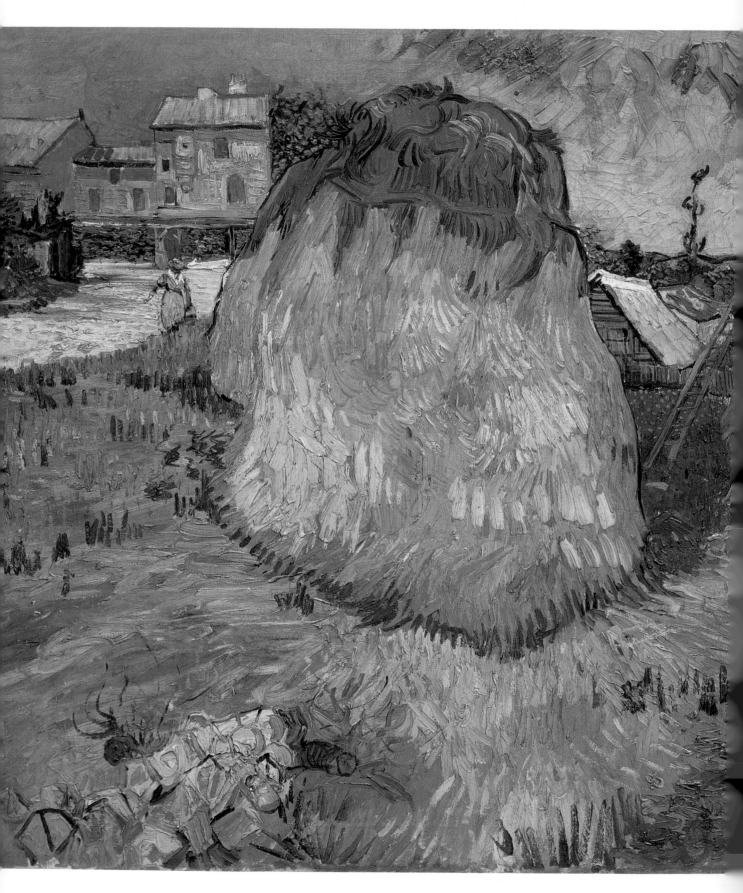

HAYSTACKS IN PROVENCE (1888)

Rijksmuseum Kröller-Müller, Otterlo.
Celimage.sa/Lessing Archive

HAYSTACKS have been a ubiquitous feature of the French countryside since the days it was first cultivated. Their representation in art, though, was never so common as during the 19th century. Most famously, perhaps, Monet chose them as a perfect device for revealing the protean effects of light throughout any given day. Later, Symbolists like Gauguin used them to stand in for things outside physical reality: representations of the "Idea." Van Gogh was attracted to both these artists, and so his haystacks draw in many ways from their approaches to the subject. This image, for example, while being emphatically rooted in reality, concerns itself with more than mere verisimilitude. It also is about an idea: namely Van Gogh's belief that interacting with nature necessarily aroused strong religious feelings in the viewer. Although his father was a pastor, Van Gogh did not actually belong to any organized religion at this time in his life. Instead, he developed his own brand of pantheism (the doctrine that God is the transcendent reality, of which man, nature, and the natural universe are manifestations) with a wry twist. As he once admitted to Theo: "I feel more and more that we cannot judge of God from this world; it's just a study that didn't come off."

Van Gogh's criteria for whether his own paintings had "come off" also had religious parallels. To be successful, they had to soothe and console, like music, or, indeed, religion. The warm familiarity imparted by this painting does just that.

OLIVE GROVE AT MONTMAJOUR (UNDATED)

Musée des Beaux-Arts, Tournai. Celimage.sa/Scala Archives

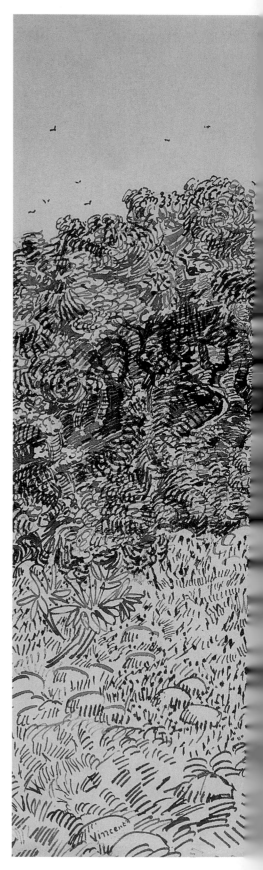

THIS piece, although not as well known as his other works, demonstrates Van Gogh's ability to use line expressively. His dexterity and artistic innovation were to influence nearly every artistic movement that came after him.

Olive Grove at Montmajour is an example of many delicate drawings that Van Gogh completed using inks or pencil. He continued with his Post-Impressionist landscape theme, depicting each of these wonderful scenes, or details, with an elegant and realistic precision. In some, there is an obvious Japanese or oriental influence, especially in works such as *The Tree* (1888) and, particularly, *Peach Trees in Blossom* (1888), in which he has added light washes of pale pink or blue color to subtly establish certain features of the image.

Van Gogh's ink works from Montmajour were completed during his stay at the abbey located there. The abbey was founded in the twelfth century, and it was where Van Gogh liked to come to paint and meditate. The abbey featured as a motif in several paintings.

The most renowned series of these ink works recorded the harvest, which was just beginning in Arles at around this time. Van Gogh finished quite a number of these drawings during this period, to help finance Gauguin's train ticket to his house in Arles.

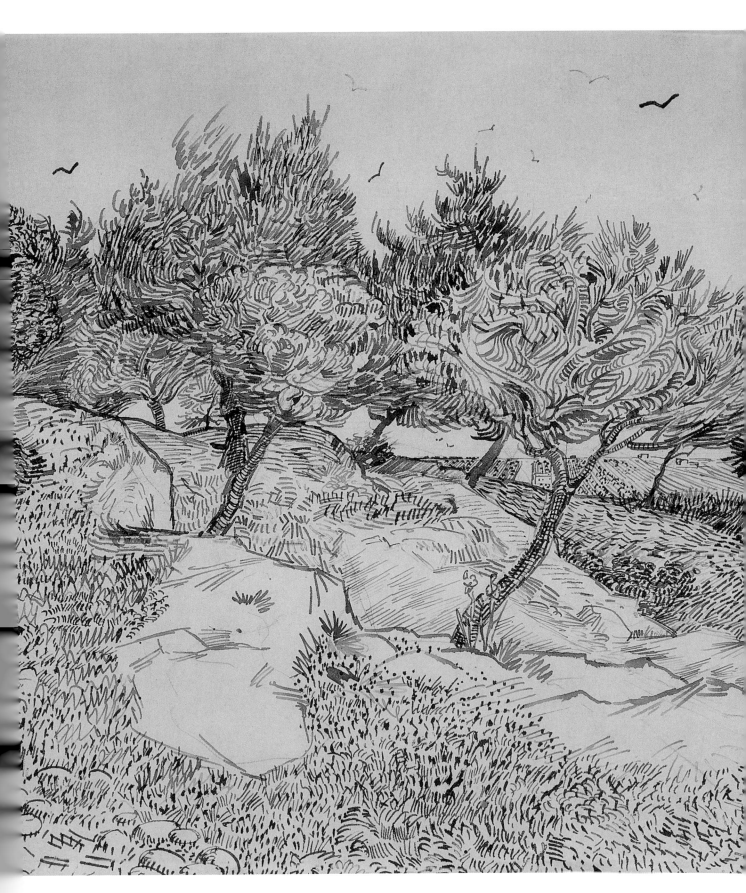

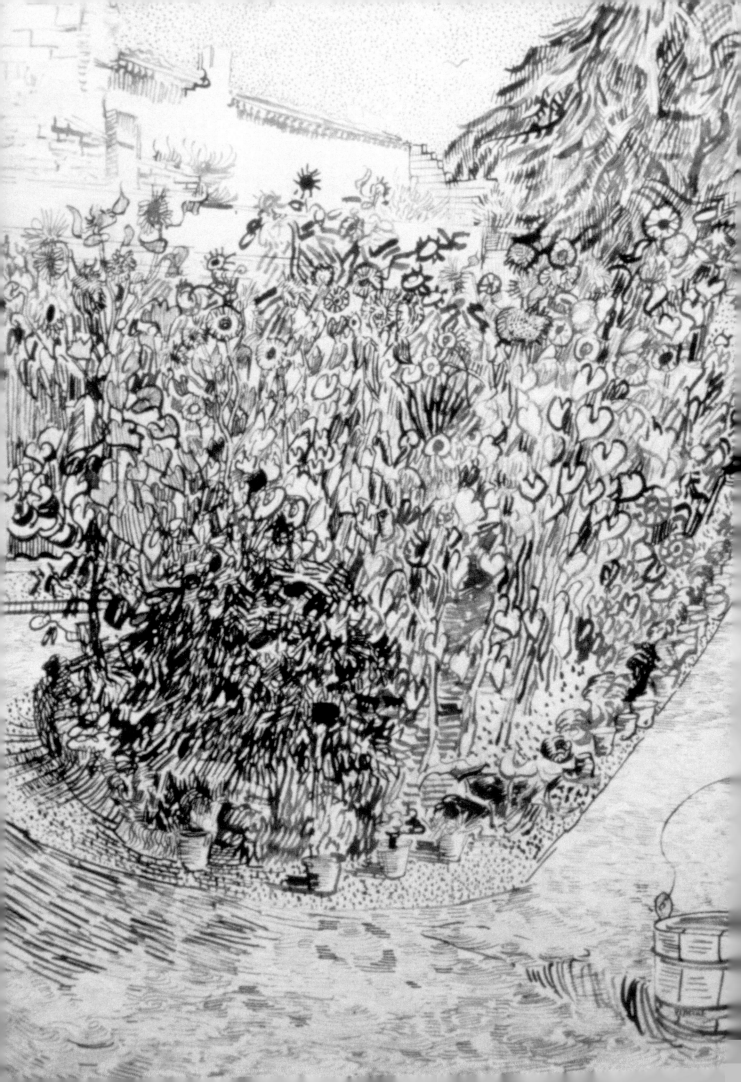

FLOWERBED WITH SUNFLOWERS (1888)

Courtesy of Edimedia

DRAWN using a quill and reed pen, in brown and black ink on paper, *Flowerbed with Sunflowers* is a work in which Van Gogh has exploited his medium to its fullest potential. In an effort to economize during the summer of 1888, Van Gogh found himself drawing more than ever before. As a result, he had more time to experiment with the different marks and strokes made by a pen as opposed to a brush. In *Flowerbed with Sunflowers* we can identify the drawing style that is his trademark. In this work Van Gogh has taken his decorative style one step further to cover the sky with a multitude of dots. Some have suggested that these were drawn in an attempt to depict the heat of a Provençal summer. Others point to external influences, notably those of Pointillism and Japanese prints. Van Gogh himself considered this method to be rather severe, for reasons he explained to Theo in one of his letters: "If the drawings I send you are too hard, it is because I have done it in such a way as to be able to use it as a guide for painting."

Van Gogh produced several similar scenes using this technique, in works such as *Flower Garden* (1888) and *The Harvest* (1888).

THE RED VINEYARD (1888)
Pushkin Museum, Moscow. Celimage.sa/Lessing Archive

PAINTED in the fall of 1888, *The Red Vineyard* depicts an event that took place annually around this time of year: the grape harvest, or "vendange." As a northern European, unfamiliar with such rituals, Van Gogh had certain preconceptions about what they were like. It is these ideas and opinions, formed beforehand in Holland, that manifest themselves in this idyllic scene. Also significant, as always with work of this period, was the influence of the Japanese prints he had admired in the exhibition halls of Paris. Van Gogh convinced himself that southern France would closely resemble the Eastern landscapes he had seen in the capital. In actuality it more than lived up to his expectations.

These grape harvesters were people Van Gogh felt he could relate to by the fact they were working with nature and its rhythms and not against it. Accordingly the picture has a romanticized "Japoniserie" about it. "If we study Japanese art," Van Gogh noted, "we see a man who is undoubtedly wise, philosophic, and intelligent, who spends his time doing what? In studying the distance between the earth and the moon? No. In studying Bismark's policy? No. He studies a single blade of grass." Indeed, this obsessive concern with minutiae of the natural world at the expense of science and politics is significant. There is no sign here of aching backs or tired and weary faces, prematurely aged by years of exploitation and drudgery. Instead Van Gogh's harvesters are bathed in the warm and sentimental glow of late afternoon sunshine.

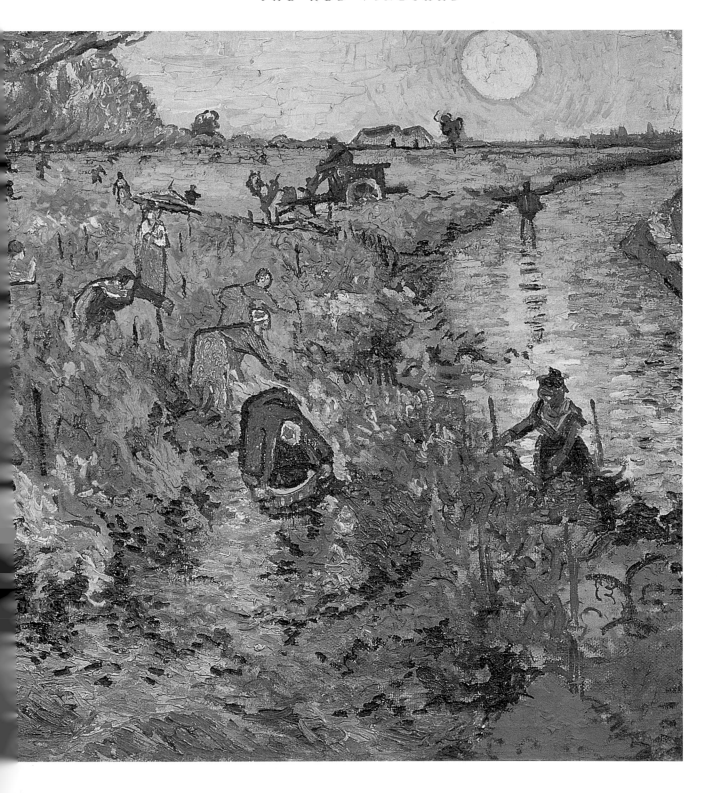

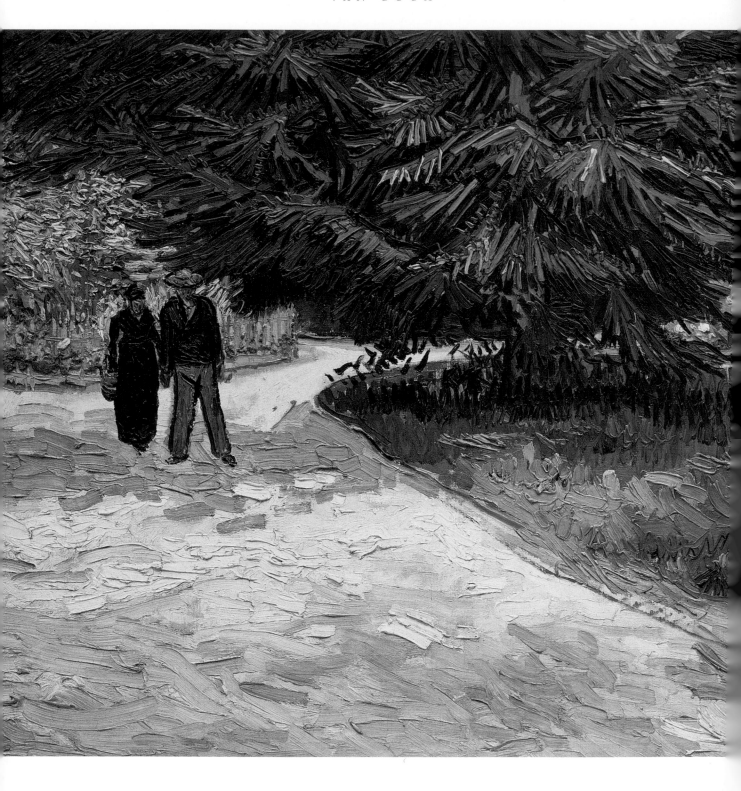

THE POET'S GARDEN
(PUBLIC GARDEN WITH COUPLE
AND BLUE FIR TREE) (1888)
Private Collection. Celimage.sa/Lessing Archive

ALONG with *The Sunflowers* (1888), Van Gogh created this image to decorate Gauguin's room. It is the third in a series of four paintings, all entitled *The Poet's Garden*, based on the public gardens near the Place Lamartine in Arles. For the first time since arriving in Arles, green dominated Van Gogh's palette. The move was quite deliberate. After completing paintings of wheat fields in July, he made this future intention quite clear to Theo: "Perhaps I will look for green now," he said. Various critics have described the picture as "pleasant" and "unpretentious," which seems about right. The composition is rather interesting, featuring the device of a triangular path that naturally draws our eye to the distant figures who are framed by trees and foliage. Broad, loose brushstrokes are used economically to portray light and shadow, but also lend the scene a relaxed, carefree air. Van Gogh referred to the couple as "lovers," although their black clothes and faceless anonymity mean that the idyll in which they casually stroll is also tinged with a certain melancholy.

THE POET'S GARDEN
(THE PUBLIC PARK AT ARLES) (1888)

Private Collection. Celimage.sa/Lessing Archive

THIS is another of the scenes titled *The Poet's Garden* which were intended to decorate Gauguin's room in the Yellow House. In many ways they represented an attempt by Van Gogh to stamp his own personality on the house before his friend arrived. For all his desire to live communally, he was not quite prepared or willing to give everything up. As he confessed to Theo beforehand: "[Gauguin's] coming will influence my way of painting, I believe to the good, but I am nevertheless rather attached to the way I decorate my house ..." It was a gift, therefore, with a double edge. By placing the picture in Gauguin's room, he tried to retain a sense of his own identity, despite claiming that this was precisely what he wanted to efface by opening himself up to new influence.

The actual place depicted in this painting was rather romanticized by Van Gogh, who said: "Isn't it true there is not something curious about this garden, cannot one imagine the Renaissance poets Danté, Petrarch, and Boccaccio walking amongst the bushes ...?" Van Gogh hoped his representation would prove similarly evocative to Gauguin, although in reality the park was inhabited by the typically Mediterranean old men sitting around on benches. Their presence here, along with the approaching woman dressed in dark clothing, speaks more of 19th-century France than 16th-century Tuscany.

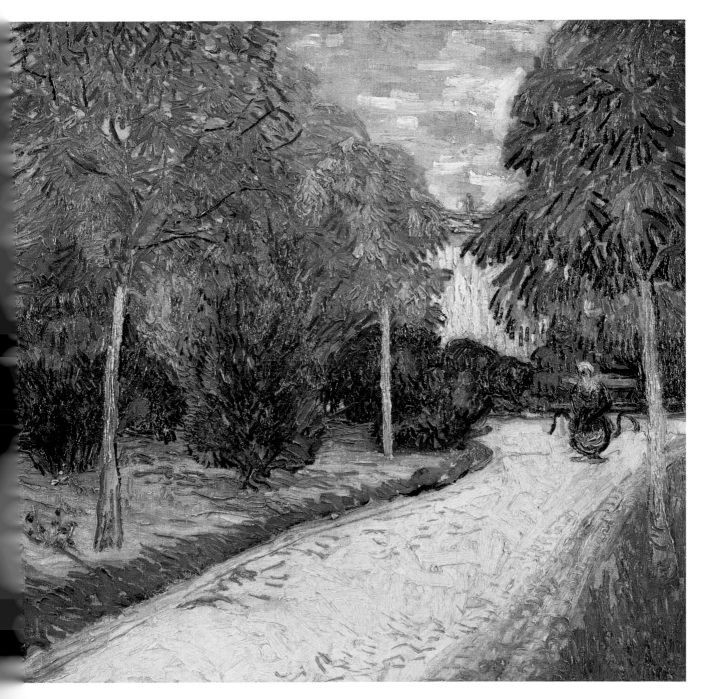

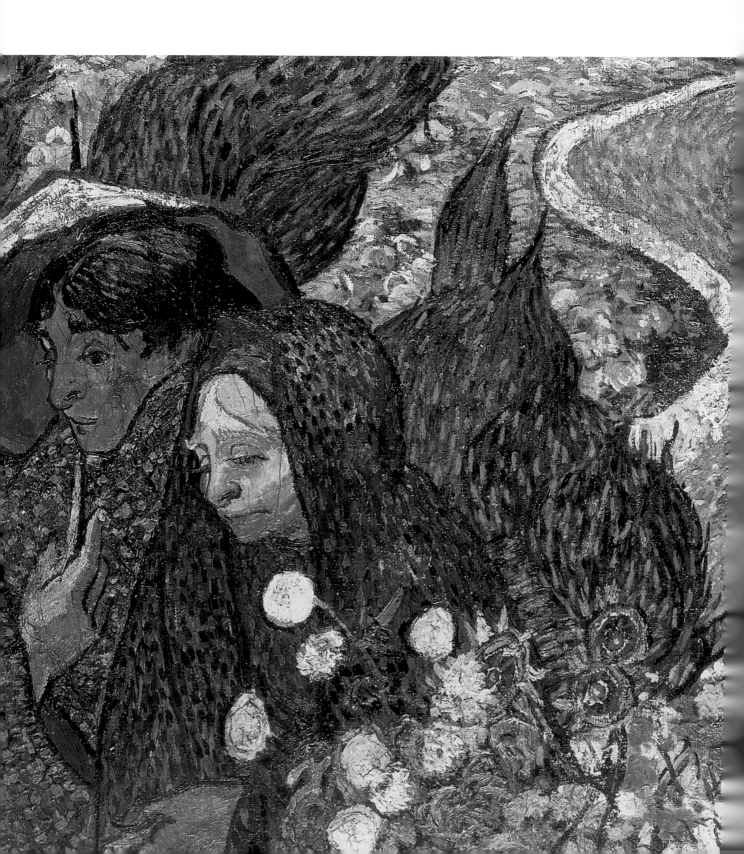

SOUVENIR OF THE GARDEN AT ETTEN (1888)

The Hermitage, St Petersburg. Celimage.sa/Scala Archives

GAUGUIN stayed with Van Gogh in Arles from October to December 1888. During that time the artists' healthy rivalry flourished, but it was probably Van Gogh who benefitted most from their competitive spirit. The theories that Gaugin taught him about working from memory were applied to a number of works of this period, but never more explicitly so than here. As he explained to his sister, Willemena: "The garden is not how it appeared in reality, but as it might look in a dream." In many ways none of Van Gogh's paintings were realistic representations of the visible world—they were always mediated through religious, cultural, or emotional experience—but with *Souvenir of the Garden at Etten*, any pretense at realism was openly denied. The inventing, manipulating, and stylizing of his images, which went on throughout his career, was now freely admitted. A good example of the way in which Van Gogh distorted reality, before, during, and after his brief Symbolist phase, was his outlining of shapes. The effect it achieves is to flatten the enclosed objects so that they become schematic components of an abstract whole. The blue shawl, green cypresses, and yellow path in the picture's foreground serve to take the viewer farther into the fictionally imagined space, but visually they remain on the same surface plane.

Despite the qualified success of this technique, Van Gogh felt uncomfortable with it, and the resulting differences in artistic approaches between himself and Gauguin ultimately led to his mental breakdown.

DANCE HALL AT ARLES (1888)
Musée d'Orsay, Paris. Celimage.sa/Lessing Archive

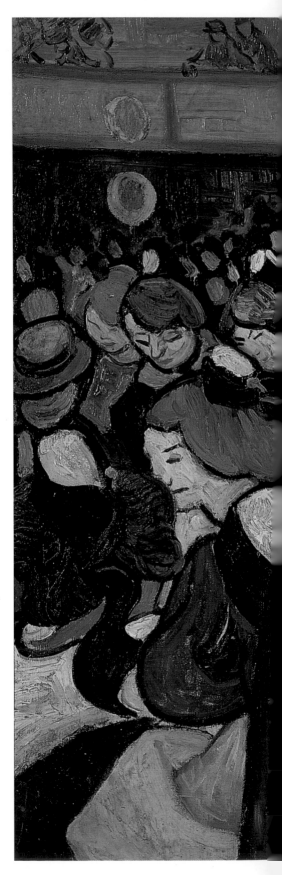

IN early 1888 Paul Gauguin and Emile Bernard had established an avant-garde community in the village of Pont-Aven in Brittany. The new style of painting that emerged from their joint venture was to have a profound influence on Van Gogh, especially when Gauguin came to Arles later that year. Although the images of Breton women that all three artists created featured the same subject popular with Salon painters, their technique was radically different. Taking their cues from Japanese prints and medieval art, the "Cloissonists"—as the Pont-Aven group came to be known – rejected traditional composition in favor of achieving unity through color and style alone.

Van Gogh's *Dance Hall at Arles* demonstrates this synthesis perfectly. Its simplified forms and elimination of detail were hallmarks of the new school, as was the systematic use of complementary colors. The red and green balcony in the distance, the blue and orange crowds at the back, and the yellow and violet of the foreground figures are all drawn from imagination, as mediated through color theory. The purpose they serve is to make each color resonate with an intensity that simply could not be achieved if they stood alone.

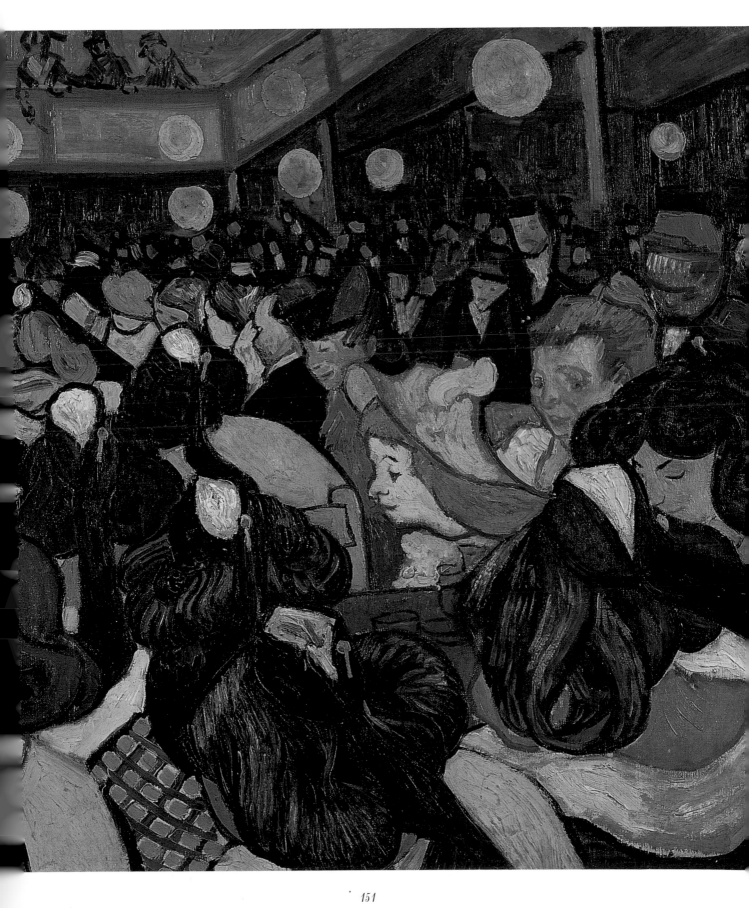

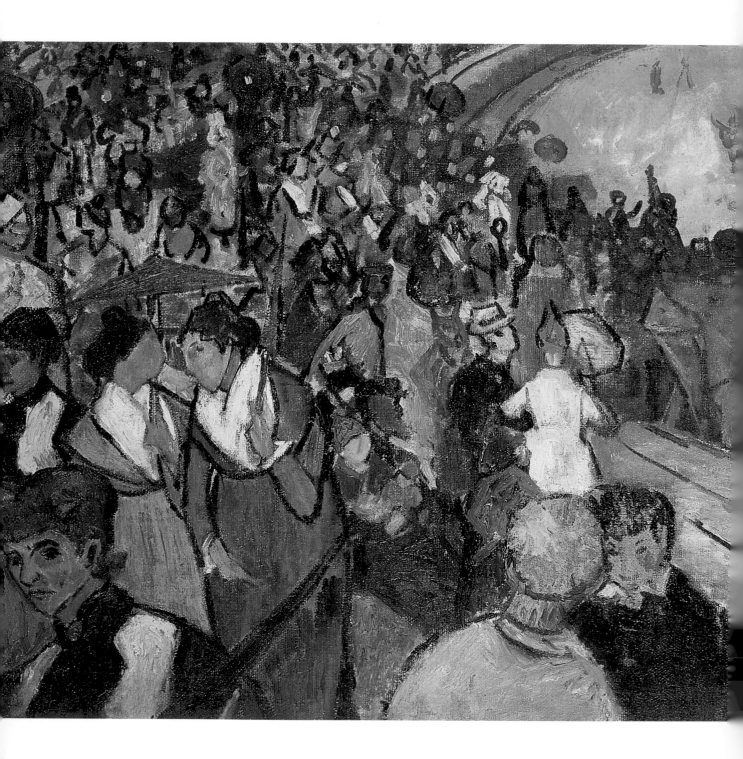

ARENA AT ARLES (1888)

The Hermitage, St Petersburg. Celimage.sa/Scala Archives

VAN Gogh's preoccupation with his health, and that of others, was a constant theme in his letters to Theo. "My God!" he speculated in one, "will we ever see a generation of artists with healthy bodies? ... the ideal would be a constitution tough enough to live till eighty." Van Gogh's own constitution of course was anything but tough; his tragic demise may have been self-inflicted, but when he died he was a far from healthy man. His prolific output was achieved very much in spite of his poor physical and mental condition.

Arena at Arles is a painting that features all the energy and vigor that Van Gogh was so obsessed with. Its ostensible theme of the bull-fight constituted a new and exciting cultural event to the Dutch artist, and one that he was immediately keen to represent. "The arenas are a fine sight when there's sunshine and a crowd," he enthused to Theo. Indeed, it is these last two aspects of the spectacle that appear to have fascinated Van Gogh; the bullring itself barely appears in the top right-hand corner. Unlike Picasso, painting only a few years later, the drama of "la corrida" was to be found not in its bloody action, center stage, but among the lively, thronging crowds.

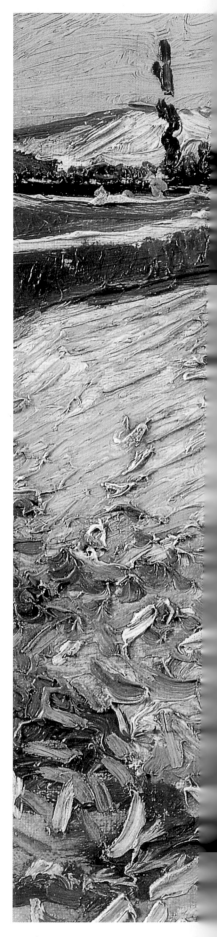

DETAIL FROM WHEAT FIELD (1888)

Van Gogh Museum, Amsterdam. Courtesy of Edimedia

IN this section of *Wheat Field* we are launched directly into an exciting and erratic coarse flaunting of color, which flirts ecstatically across the canvas. The painting is instantly recognizable as a work by Van Gogh. It eloquently voices the uniquely impressionistic and hasty style of the artist.

A swathe of pale blue stretches across the distance, and is divided by vertical flames of green, which are the trees. The heat of a summer's day can be felt through the mirage effect achieved by the wavering of form along the horizon. As we move our eyes toward the foreground, the brushstrokes become bolder and more scattered across a wealth of thick and vibrant yellow wheat. Looking at the painting from this close perspective does justice to the varying techniques that have been used to create the work. It is only on such an intimate scale that we can appreciate these methods.

Bright and thick patches of contrasting and complementary colors expose no areas of shadow. Van Gogh felt that each color bestowed individual meaning and possessed a unique value. Such a view was applied to his Arles paintings.

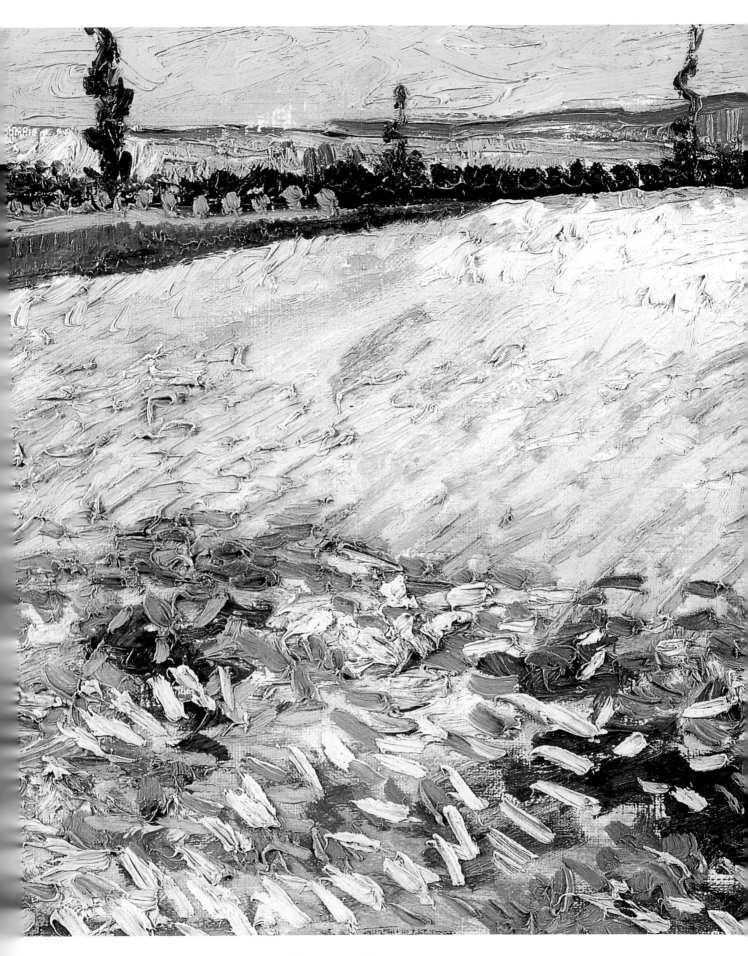

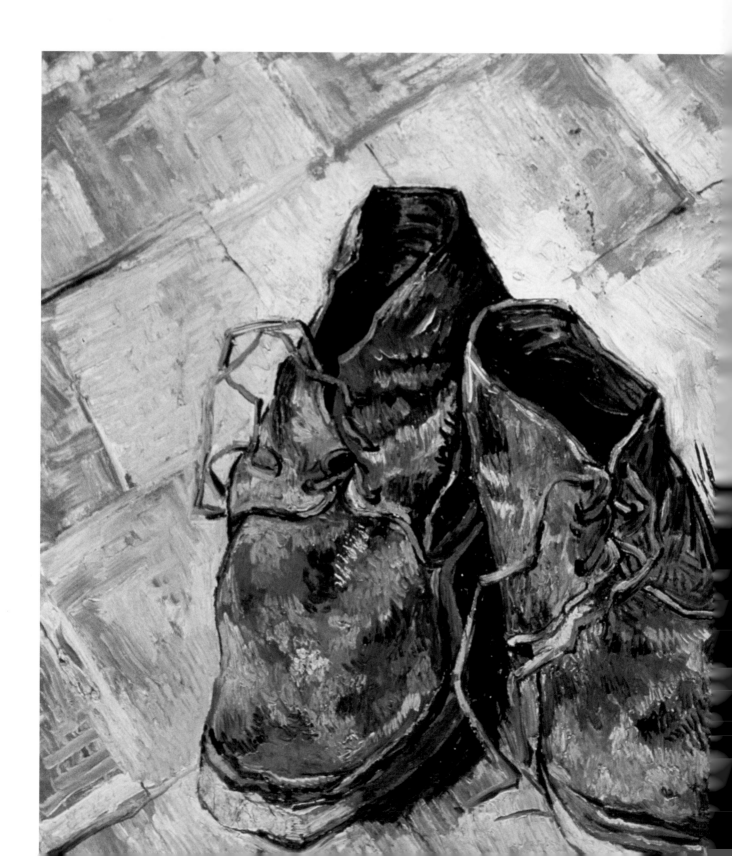

SHOES (1888)

The Metropolitan Museum of Art, New York. Courtesy of Edimedia

VAN Gogh painted an entire series of shoe paintings, through which we can map changes in his artistic styles and methods. Some emphasize the dark and monochromatic tones of his Dutch Period. Other versions, including this work, show the influence of the artist's sojourn in Paris and his exposure to the modern Impressionist and Post-Impressionist palette. In some instances, Van Gogh's images of shoes were painted over previously-painted canvases. He often faced financial difficulties, and had to improvize in order to afford his artistic development.

Van Gogh often revisited favorite themes and motifs from his earlier works, in order to appreciate their forms from a new stylistic perspective. *Shoes* refers to the last year during which Van Gogh lived in Paris, and illustrates the assimilation of what he learned from the Impressionist movement. We can see this change in the use of static lines and hasty brushstrokes to outline the shoes, coupled with the exploitation of a new, lighter palette.

DETAIL FROM VINCENT'S BEDROOM AT ARLES (1888)
Courtesy of Edimedia

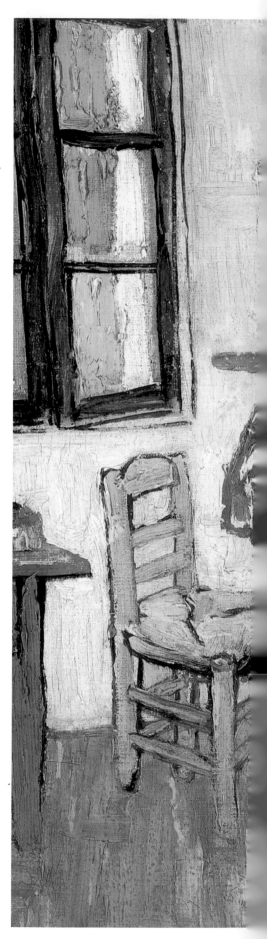

THE painting shown here is actually one of five different versions on the theme of the artist's bedroom. These included three oils and two sketches of the room. This particular series is one of Van Gogh's best known.

Probably the most obvious feature that differentiates the oil works from one another is the small landscape painting hanging above the bed. Another difference is the two portraits along the right-hand wall. All the versions of *Bedroom at Arles* have some subtle differences.

Yet, probably the most striking and memorable aspect of *Vincent's Bedroom at Arles* is Van Gogh's peculiar viewpoint. The painting appears unrealistic, with its diagonally warped portrayal of the objects in the bedroom. This approach seems extreme, but later in his career, Van Gogh rebelled against the muted colors of the Dutch Old Masters and the restrictions of a realistic perspective.

However, a more obvious theme linking these works is their striking palette, unusual perspective, and familiar subject matter. The colors of each scene display the typical vibrancy of many of Van Gogh's works from the Paris period. Yellow, his favorite color, is used expressively in this detail. However, this bedroom painting is noteworthy not only for its intimate association with the artist, but also for the pride that Van Gogh felt upon its completion.

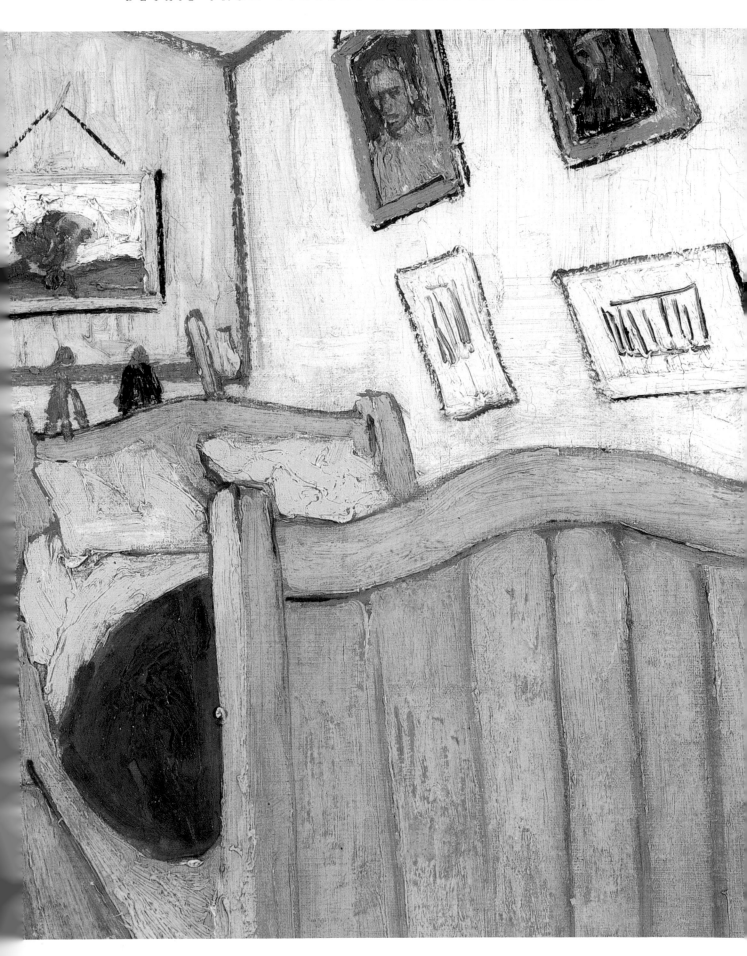

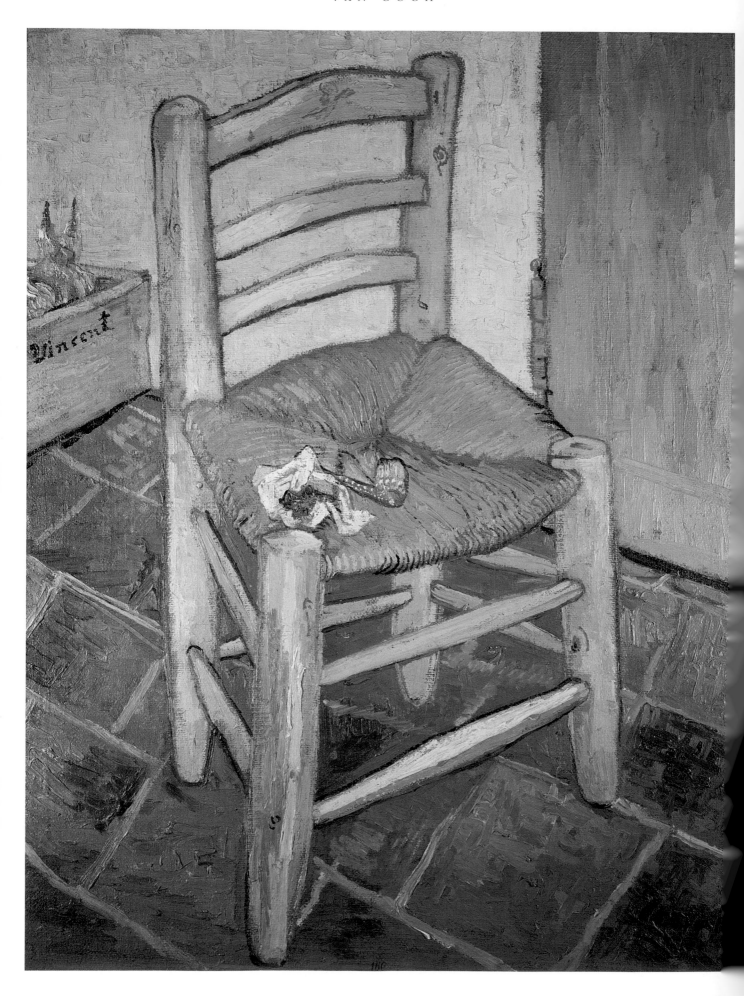

VINCENT'S CHAIR (1888)

National Gallery, London. Celimage.sa/Lessing Archive

EMPTY chairs had a very personal significance for Van Gogh, who appears to have associated objects strongly with people. Legend has it that the young Van Gogh cried out at the sight of an empty chair vacated earlier by his father who had been visiting him at the Hague. This image of his own empty chair resounds with a similarly plaintive call.

Gauguin's arrival in Arles a few months earlier had heralded an initial period of calm and joy in both men's lives. However, tensions soon surfaced. More at home in the city, Gauguin found Arles rather dull and ordinary. Furthermore, Van Gogh wanted more companionship than Gauguin could realistically offer and, as a consequence, he became worried that his friend would leave the Yellow House. This eventuality was made more likely by Van Gogh's notorious temperament. His violent mood swings and Gauguin's rampant egoism meant clashes became inevitable. Added to this heady brew, they also began to disagree about art. Van Gogh expressed his fears about the possibility of Gauguin's imminent departure in two famous paintings, of which this is one. The steep perspective of the painting throws us violently into the picture, creating a disorientating dynamic. The other painting, featuring Gauguin's chair, is equally fraught with tension.

BRETON WOMEN (1888)
Galleria d'Arte Moderna, Milan.
Celimage.sa / Scala Archives

*T*HIS is one of many scenes that were painted of female Breton peasants. Paul Gauguin painted several. His *Breton Peasant Woman* and *Four Breton Women* have similarities to Van Gogh's *Breton Women*. Vincent considered Gauguin's work to be a masterpiece, and was particularly impressed by the way he was able to create the flesh tones on the faces.

In *Breton Women* Van Gogh relinquishes his traditional style of painting in favor of a more unusual perspective and palette. Many artists were drawn to the Breton women because they made intriguing subjects, especially with their distinct headdress. Van Gogh had a passion for peasant life and was greatly attracted to the rich heritage and folklore with which it was imbued.

Both Van Gogh and Gauguin embraced a new and popular artistic style, inspired by Emile Bernard in works such as *Buckwheat Harvest* (1888). They began using flat areas of color and bold outlines to determine shapes and forms. This method is prevalent in *Breton Women*, and it achieves a novel and stark effect, with an element of abstraction. The forced determination of shapes and areas in the work provides them with individual status, and the result is a one-dimensional image.

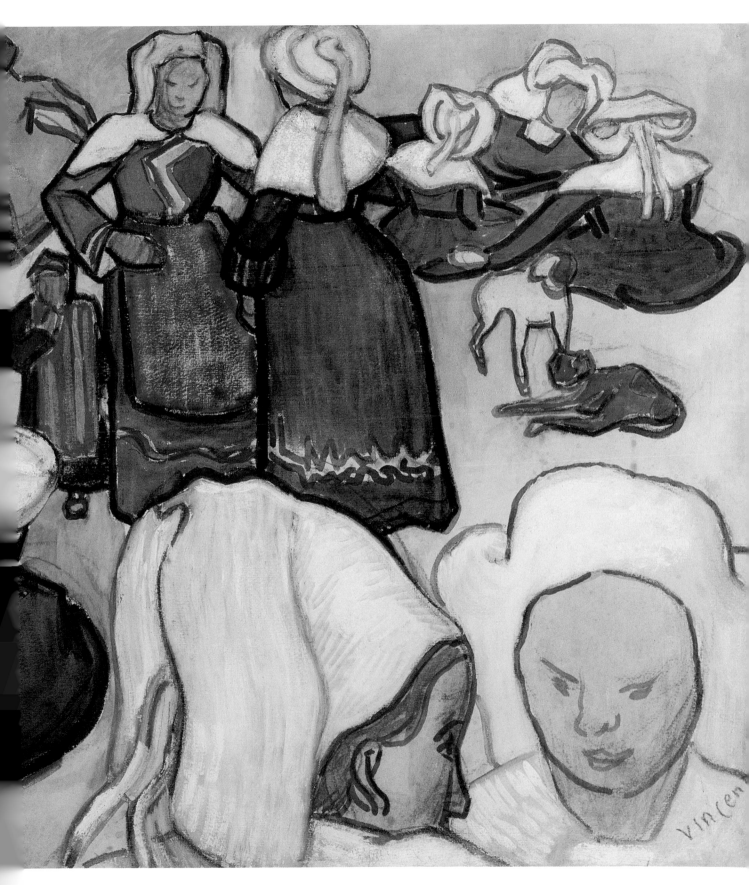

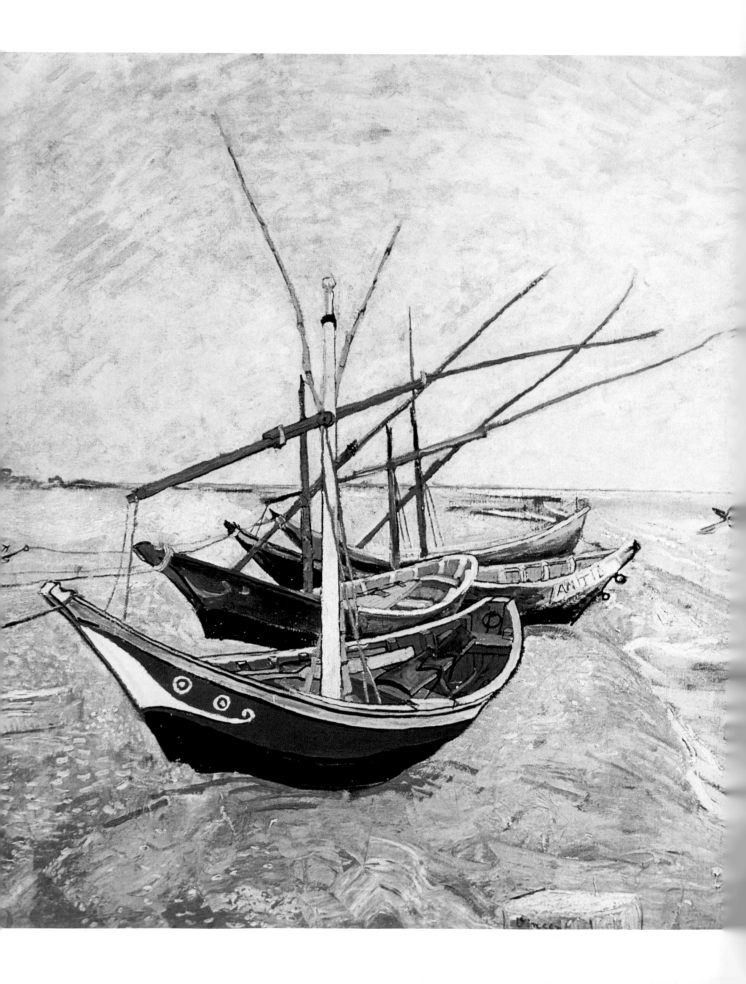

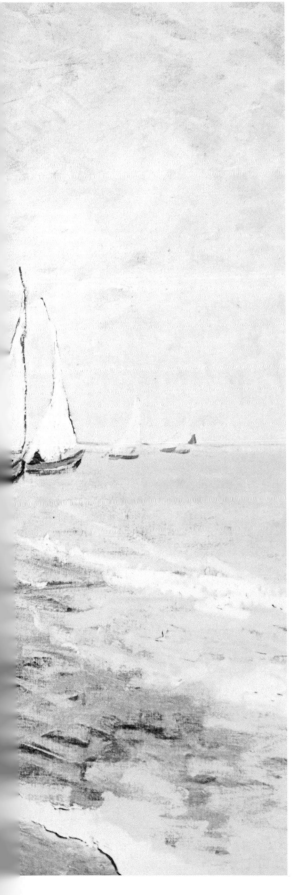

DETAIL FROM BOATS AT SAINTES-MARIES-DE-LA-MER (1888)
Courtesy of Edimedia

THIS painting is stylistically unique for a work by Van Gogh, as it has been executed in pastel and watercolor. It retains the bold yet harmonious qualities of his other paintings, while offering something that is quite original. The image has been finished with a semi-Fauvist flavor.

Boats at Saintes-Maries-de-la-Mer was completed during the artist's short stay at Saintes-Maries, where he became instantly mesmerized by the tranquil effect of the sea. This depiction of boats along the sandy shore is calm and reposed in comparison to the lively color and brush technique of his other works from Saintes-Maries, such as *The Sea at Les Saintes-Maries-de-la-Mer*. In this painting we view Van Gogh's ecstatic and liberated use of brushstroke to suggest the movement of the waves.

The palette adopted is far more subdued and flat in terms of its application. However, it does successfully illustrate Vincent's dextrous ability as a draftsman, with its precise and elegant dimensions, to describe the shapes of the boats. Van Gogh has painted this water scene with an accurate use of fine line and detail to display the hubs of the vessels, the grain of the sand, and the translucency of the water.

PORTRAIT OF A PEASANT (1889)

Verusio Collection, Rome. Celimage.sa/Scala Archives

*T*HIS particular portrait of a peasant was painted at Saint-Rémy, in September 1889. The work illustrates Van Gogh's broad spectrum of stylistic techniques, with its intertwining areas of pronounced line and color, strong composition, and a confident use of his palette.

Stylistically, *Portrait of a Peasant* is very different from the works of Van Gogh's Nuenen period. His use of color is noticeably more varied and even curious. The loose flow of the lines and the hazy areas of blended yellow-green convey the heat and blazing sunlight that one would expect on a summer's day. The tones of the hat and face are repeated in the background, as though Van Gogh presents the peasant as an integral part of his craft. He adopts a sensitive approach to the depiction of the face and features. It is this attentiveness that invests *Portrait of a Peasant* with a particularly intimate quality.

Vincent always felt compassion toward laborers, and this is clearly evident in *Portrait of a Peasant* and in the works from Nuenen, such as *The Potato Eaters* (1885), in which he realistically portrays their movements.

After living with his brother in Paris, Vincent came under the influence of artists such as Paul Gauguin and Georges Seurat. However, in a letter to Theo, he implies that he is reverting to an earlier approach, but departing from the influence of Impressionism. This piece charts part of the journey that Van Gogh embarked upon, to achieve the artistic style that was to become his leading trademark.

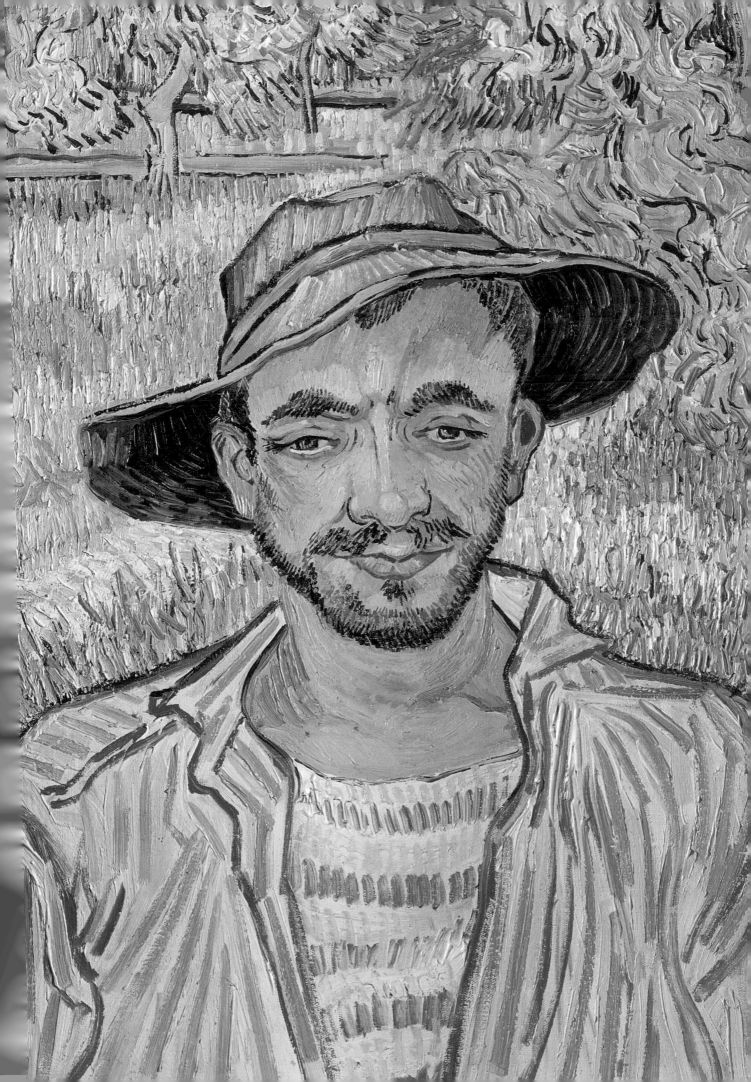

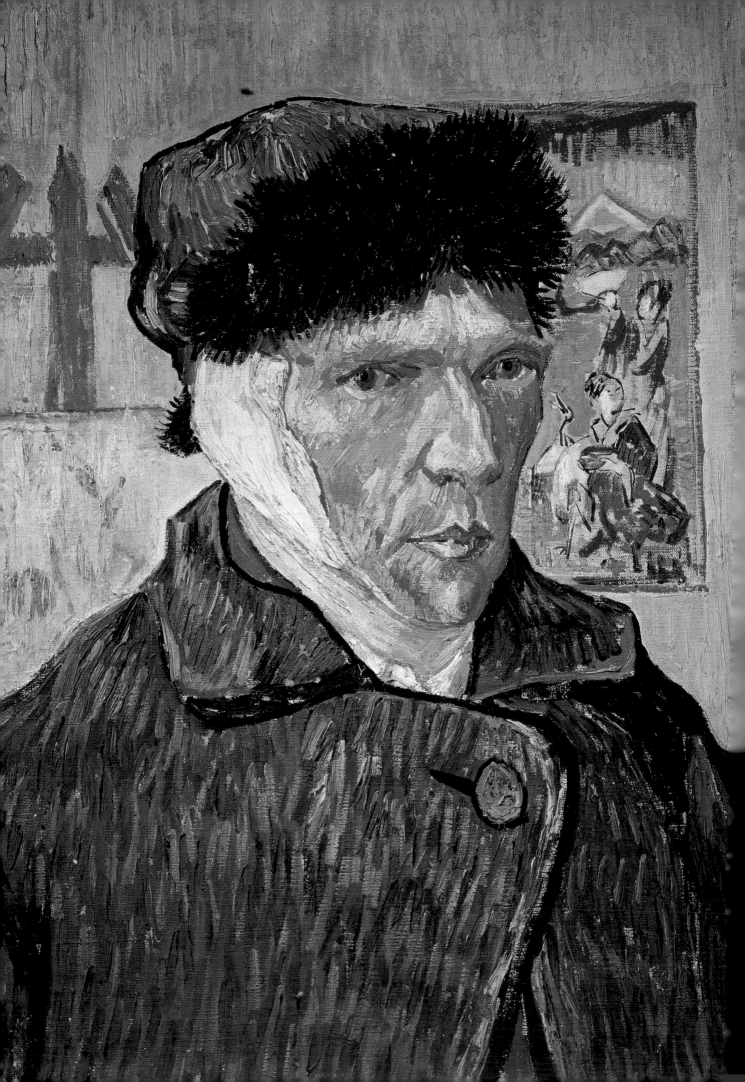

SELF-PORTRAIT WITH BANDAGED EAR (1889)

Private Collection, Paris. Courtesy of Edimedia

*I*N December 1888, Van Gogh chopped off a part of his ear and presented it to a prostitute called Rachel, so the story goes. *Self-Portrait with Bandaged Ear* depicts the aftermath of these events, but provides us with few clues to their motivation. Rumors surrounding the notorious incident abound, but surprisingly all that is known for sure is that it was triggered by a conflict with Gauguin. Some have proposed that illnesses such as schizophrenia, epilepsy, or even alcoholism were to blame. Certainly his neighbors considered Van Gogh a dangerous man and, on his returning to the Yellow House from hospital just two weeks later, they signed a petition to the mayor expressing their displeasure at his reappearance.

Similar to *Self-Portrait with Bandaged Ear and Pipe* (1889), this painting, unlike the other, gives a real sense of personal catastrophe. Still dressed in winter coat and fur hat, this self-portrait includes an easel in the background. Van Gogh seems to be relating his suffering to his art. "Look what art did to me," he appears to be saying. Alternatively, the theory goes, the easel reaffirms his continuing commitment to his art despite his recent breakdown. The Japanese prints in the background remain an important influence for the artist who here has a vulnerable yet steady gaze. He seems to be looking but not seeing, deep in contemplation of his own anguish.

OLIVE TREES (1889)
Courtesy of Edimedia

*H*ERE, we find Van Gogh executing a plethora of wild and hasty strokes in this vivacious and exciting pen and ink drawing. The olive trees are constructed from swirling, loose line patterns. The ground is a design of short, erratic, horizontal and vertical lines. The only break in this sea of lines is a small blank space representing the sky, which peers through the treetops.

In style *Olive Trees* is overtly Impressionistic yet bears little resemblance to previous Van Gogh paintings. He admitted as much in his correspondence with Theo, when writing about his series of pen-and-ink sketches. Although similar motifs appear in his ink works and his paintings, they remain largely distinct from one another.

Van Gogh became less concerned with creating paintings of sun-drenched landscapes, and started to focus upon revealing the essence of country life through his own life experiences. His first 24 pen-and-ink drawings were completed between late April and early May 1888. Then, during a single fortnight in May and June 1989, he produced a further series of large drawings, in the garden of the Saint-Rémy asylum.

Olive Trees has been rendered with a range of golden browns, although Van Gogh's use of varied strokes of the pen provides a surface tension that underlines the unsettled nature of the artist at this time.

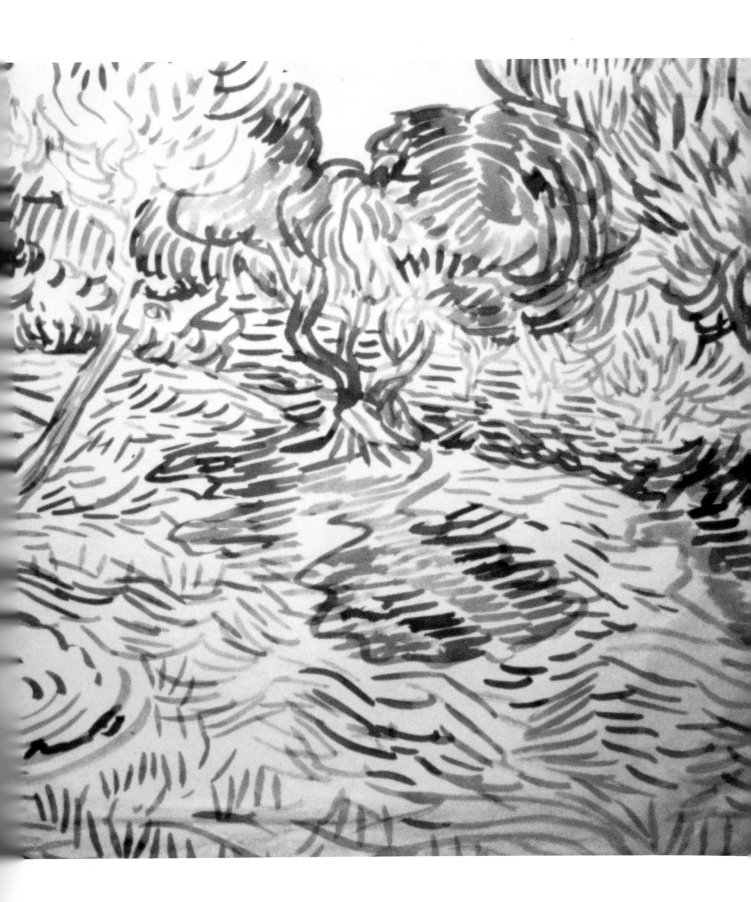

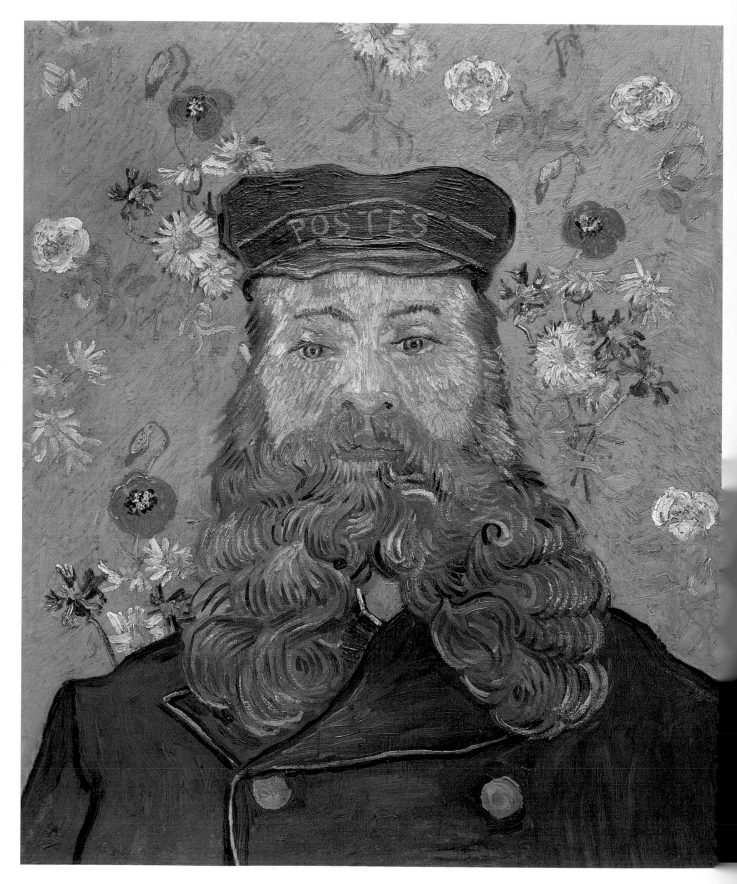

ROULIN THE POSTMAN (1889)

Rijksmuseum Kröller-Müller, Otterlo. Celimage.sa/Lessing Archive

WITH a paucity of potential models during this period, Van Gogh increasingly turned for his subject-matter to the landscape. However, when a model was found that did appeal to him, he jumped at the chance of immortalizing them in oils. Originally he met, or discovered, the postman Joseph-Etienne Roulin at the Café de la Gare in Arles, where he was renting a room. Roulin's easy-going demeanor, Republican convictions (like those of Père Tanguy), and lifestyle of heavy drinking (like the artist Monticelli in Paris) all appealed to Van Gogh. Furthermore, he also came to consider Roulin as something of a father figure, whose wisdom he compared to that of Socrates. Van Gogh painted him many times but in all his portraits, whether only of his head or featuring the whole man, his profession remains clear; Roulin may have had the mind of a philosopher, but his blue uniform with yellow buttons always showed his actual vocation to be somewhat less elevated.

This portrait was painted after Van Gogh was allowed out of hospital and may well have been executed as a token of friendship between the two men: Roulin stood loyally by when others began to regard Van Gogh as a dangerous menace. This painting differs from the other portraits of the postman mainly in its densely decorated background. Van Gogh's desire to fill the whole canvas with an overall design style can also be seen in works such as *Portrait of Dr Rey* (1889).

PORTRAIT OF DR REY (1889)

Pushkin Museum, Moscow. Courtesy of Edimedia

R Felix Rey treated Van Gogh in hospital after his "trifle"—in the artist's words—caused him to be admitted there in December 1888. Van Gogh's friend, Roulin the postman, persuaded Dr Rey in January 1889 that the patient was sufficiently recovered to let him leave hospital. The doctor was a sympathetic and liberal type who did just that. In a letter to Theo, he empathized with the anguish Vincent's sibling must have been enduring: "I shall always be glad to send you tidings [of Van Gogh], for I too have a brother, I too have been separated from my family."

This portrait, along with only a few others such as *La Berceuse* (1889), was unusual for its use of a decorative background. The polka-dotted, curlicue wallpaper that frames the sitter's head is reminiscent of Matisse's large, all-over patterned screens painted two decades later. The image is also comparable to Van Gogh's own canvases of subsequent weeks. The swirling forms that resonate throughout this picture were soon to appear in the skies and trees of his landscapes.

It was a mark of the respect and high regard Van Gogh had for Dr Rey that he presented this portrait to him as a gift. However, the picture proved too modern for the doctor's taste. The "new" fashion for color distortion, to convey what one felt rather than saw, proved a bewildering concept. The story goes that the confused doctor eventually used the picture to cover a hole in his chicken coop, where it was discovered years later when Van Gogh had become famous.

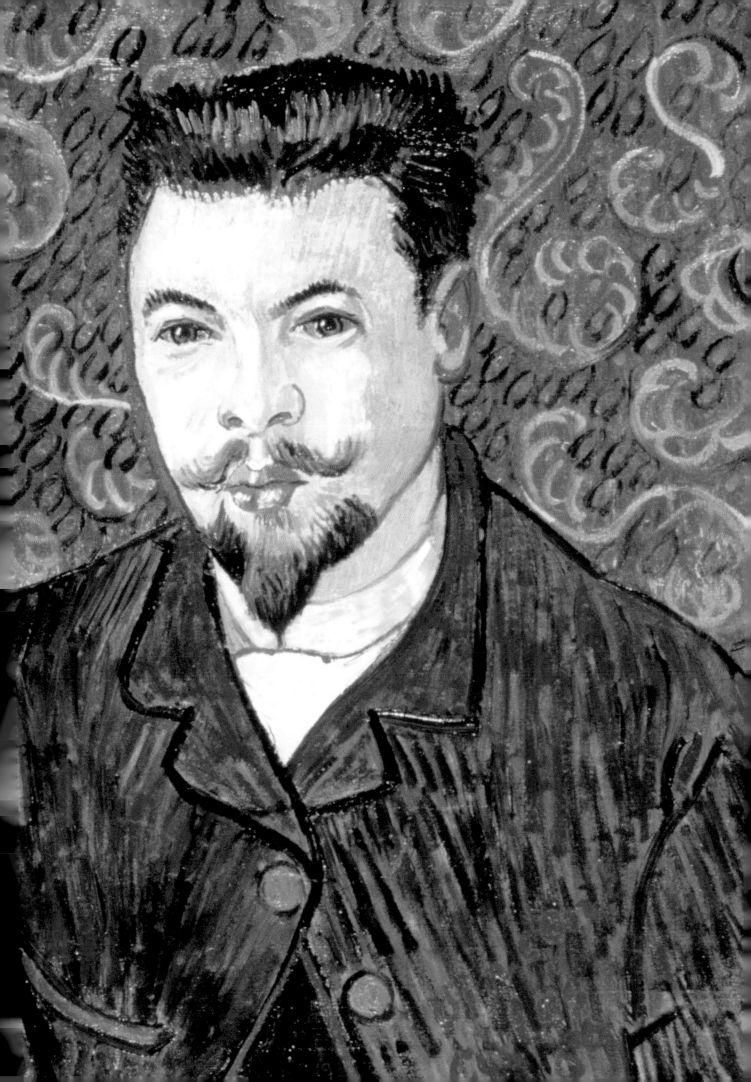

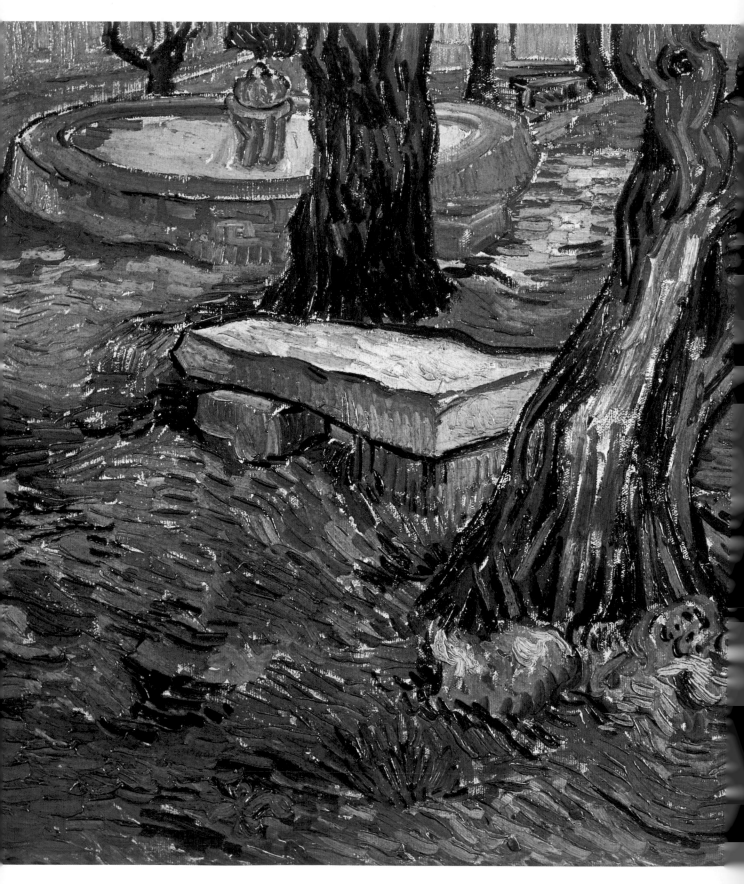

THE BENCH OF SAINT-RÉMY (1889)

Museu de Arte, Sao Paulo. Celimage.sa/Lessing Archive

THE artist painted this private scene of a stone bench in the garden of Saint-Paul's Asylum in June 1889. This particular work was one of the earlier paintings that he produced during this time. He began with recording his immediate surroundings in the asylum, the plants and the trees in the park, and then went on to complete a substantial range of self-portraits. However, Van Gogh often depicted these scenes within a limited frame, in which he omitted the sky and portrayed them from a close perspective. The restrictions he imposed on his canvases may have been intended to reflect his own internal imprisonment at the time.

Vincent's stay in Provence, first in Arles, from February 1888 to May 1890, and then in the asylum of Saint-Paul at Saint-Rémy, from May 1889 to May 1890, is characterized by a magnificent collection of landscapes, portraits and still-life drawings as well as watercolors. Through these works, we witness part of the transformation that Van Gogh underwent during his short career.

This painting is dominated by a series of thick and well-defined brushstrokes. Their large size and intense detail make the objects in the image appear even closer to us. Equally striking and alluring is Van Gogh's use of color, which darts across the canvas.

DETAIL FROM VASE WITH FIFTEEN SUNFLOWERS (1889)

Sompo Japan Museum of Art Seiji Togo Yasuda Memorial, Tokyo.
Courtesy of Edimedia

ART scholars and historians have suggested that Van Gogh's sunflower series are amongst the most recognized works of the artist and are the primary reason for his international success. The most renowned sunflower paintings are those produced in Arles between 1888 and 1889, although part of the series was completed during his time in Paris. Both sets are profoundly different and yet, as with many of Van Gogh's works, they both map his development as an artist.

This particular detail from *Vase with Fifteen Sunflowers* shows one of the central flowers of the composition. It stands out obviously from the others, because of a red circle at its center. Each flower is delicately and individually portrayed with its own unique identity. The colors of the flowers are all different, with their individual shades and highlights of yellow, orange, red, and green. They are not so much realistically portrayed as skillfully painted. It is the method and application of his medium that provides each of Van Gogh's sunflower paintings with their elements of distinction. In this sense, they are similar to his self-portraits. Each one has been painted with a distinctive method of brushstroke, such as illustrated here, in the alteration of the strokes across the petals and heart of the sunflower. Streaks of paint form areas of relief at the center of the flowers, as they appear shorter and more circular. The petals are executed with longer and looser lines of color.

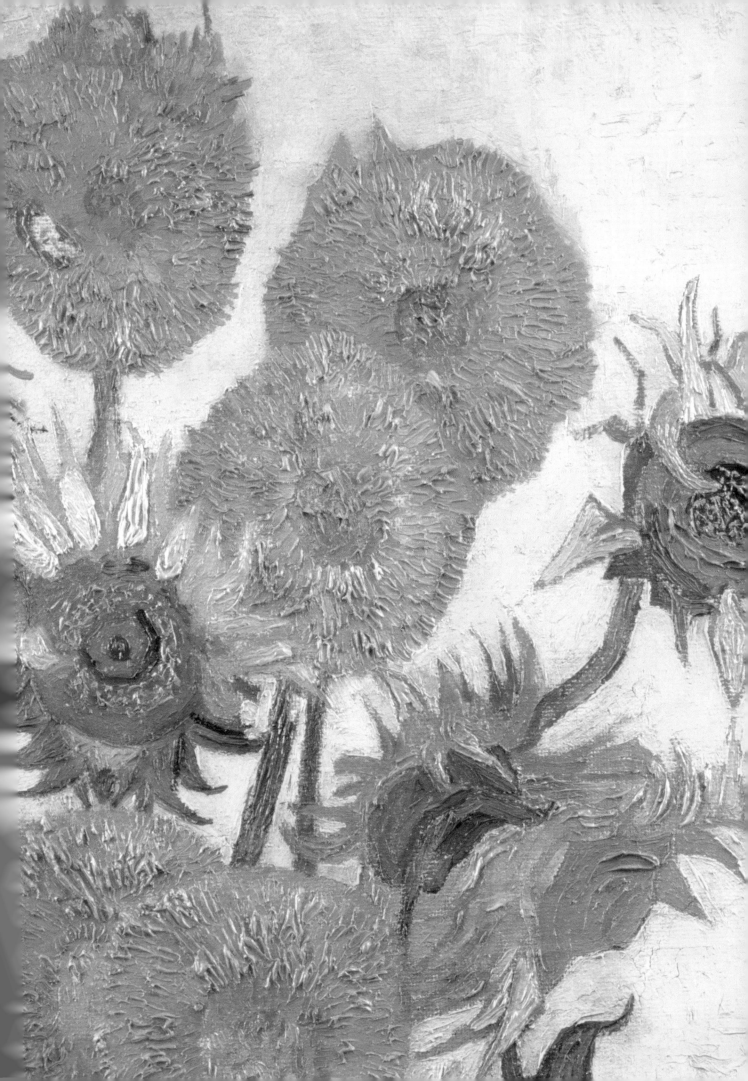

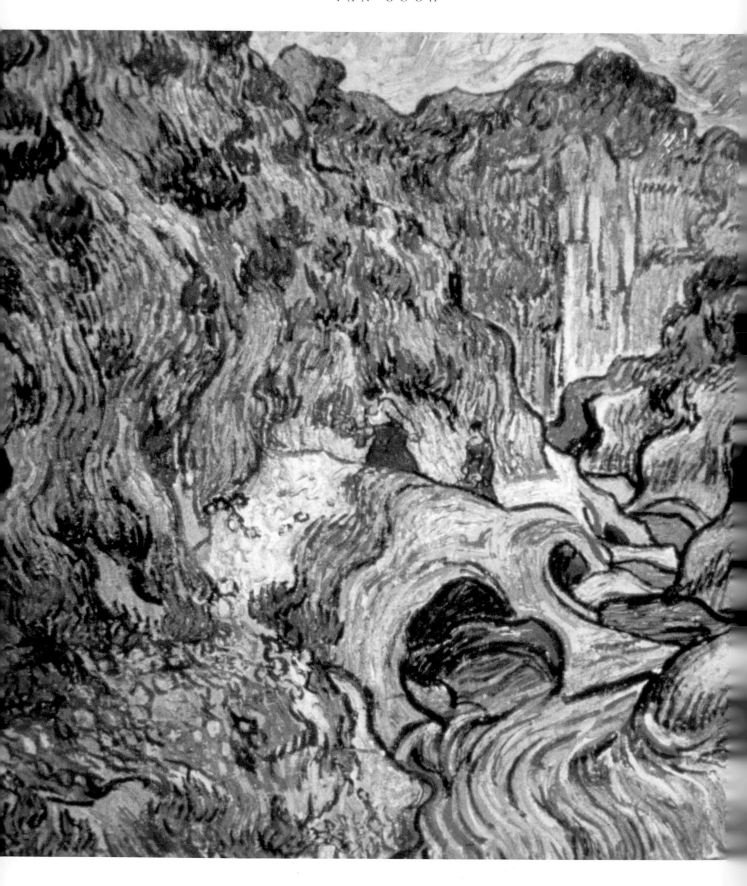

RAVINE "LES PEIROULETS" (1889)
Courtesy of Edimedia

*R*AVINE *'Les Peiroulets'* displays an extravagant, bordering on abstract, brushstroke. The blue, green, and gray palette is gloomy and monochromatic, and the red fires of the trees, rising up in the hills, contrast deeply with the cool shades of the land and river. This is one of several scenes that Van Gogh painted of the ravine, although in this particular work, it seems as though the artist's brush is the painting's dominant feature. It is almost as if the landscape is just a means of expressing his vivacious and expressive technique.

However, despite the darker tones of his palette, Van Gogh still conveys an exciting account of this ravine. The directional, Fauve-like brushstrokes act like a maze of characters rushing on and off the face of the canvas.

This work was produced during the time that Van Gogh spent at the asylum in Saint-Rémy-de-Provence. Here, he produced many of the best works of his career, particularly his landscapes. He worked on these during his more rational periods, when he was allowed to paint outside. The atmosphere of most of these works varies quite significantly, although *Ravine "Les Peiroulets,"* like several other paintings, seems to convey the artist's mood of the time, by means of their opposing and somewhat erratic brushstrokes and dark shades.

DETAIL FROM LES PEIROULETS RAVINE (1889)
Courtesy of Edimedia

*D*URING a decade of great personal and artistic intensity, Van Gogh produced a large number of works. From 1888 to 1889, whilst residing in Arles, he generated 200 paintings, and a further 200 drawings and watercolors.

Such an achievement far exceeded that of the renowned Renaissance and Baroque artists, who, unlike Van Gogh, painted with the aid of numerous students and assistants. Van Gogh painted alone, driven by a sense of purpose.

This particular work appears as though the canvas has been constructed as a woven tapestry. Van Gogh has crafted his medium so thickly that the surface of the calico is strewn with a relief of strands of color. This draws our attention to the individual methods that Van Gogh has used over the surface of the work.

This detail launches us directly into a small part of a ravine in which a network of nervous brushstrokes defines the contours of the mountainous terrain, and an abundance of pale blue and golden yellow shades crowds our vision and distorts the subject of the painting. Subtle flickers of green flow through the yellow foliage and reflect Van Gogh's use of a similar shade for the sky. His palette has softened somewhat in this work, although the application of his medium has become increasingly agitated. *Les Peiroulets*, with its unique perspective, has a surreal or eerie aspect.

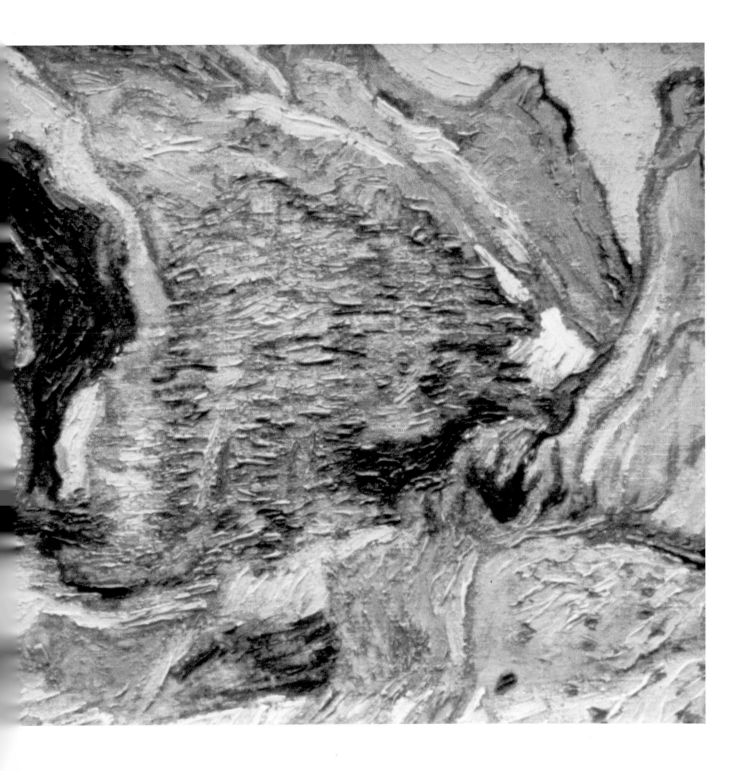

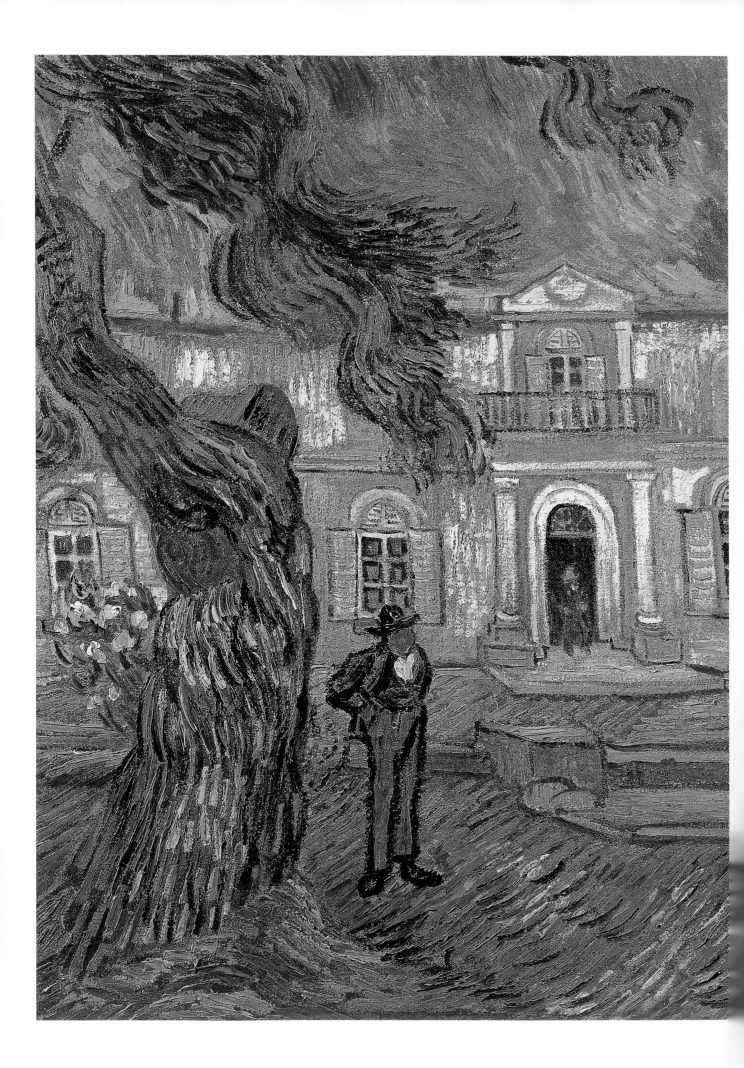

SAINT-PAUL'S ASYLUM (1889)

Musée d'Orsay, Paris. Celimage.sa/Lessing Archive

THIS particular picture is one of a series of images depicting the asylum Van Gogh stayed in from 1889 to 1890. Situated in a peaceful country setting, Saint-Paul-de-Mausole was a large building with separate wings for its male and female patients. A few years before Van Gogh's visit, the establishment's reputation for "modern" treatments, good food, and plentiful amenities had brought it a fair measure of success. However, by 1889 the institution had seen better days. A steady decline in patient numbers meant insufficient funds had been supplied for its adequate upkeep. Nevertheless, Van Gogh's stay was purely voluntary and he even managed to find a positive side to his illness. As he wrote to Monsieur and Madame Ginoux (his ex-landlords, the owners of the Café de la Gare) "…my disease has done me good—it would be ungrateful not to acknowledge it."

Having said this, Saint-Paul's was a depressing place in which to live and work. Its rundown and shabby condition were hardly conducive to recovering from a life-threatening illness. This painting gives us a reasonable impression of the building's neglected architecture, which is further exaggerated by contrasting it with the dominant foreground pine tree. Flowing like a curtain or huge flame over the whole scene, the tree's overhanging branches operate as a classic Baroque device with which to frame the stage. Together with the equally fluid and dynamic trunk, they draw us into the middle ground where a heavily outlined man stands, literally faceless. Compared to everything around him, he is entirely static: the strangely still, calm center of the picture.

LILAC BUSH (1889)

The Hermitage, St Petersburg. Celimage.sa/Scala Archives

AFTER entering the asylum at Saint-Rémy of his own volition, it was not long before Van Gogh was seeking new subject matter to paint. His first tentative forays into the adjoining garden soon suggested a whole range of possibilities. As well as the famous irises, he also discovered these lovely lilacs in the rambling but still beautiful grounds.

Despite frequent mental lapses during this period, Van Gogh's creative faculties remained largely intact for most of the time. Painting helped occupy his mind and prevented him from falling into depressive moods. The harder he worked, the healthier and more lucid he felt.

The way in which this painting has been delicately and painstakingly rendered is rather unusual for such a late work. Its method is Impressionistic, with dabs of paint scattered evenly across the canvas. The bucolic scene itself is in accordance with Van Gogh's ideas about creating an unsophisticated art, free of pretension. It would, he believed, give pleasure and consolation to all—from the wealthy art dealer in Paris to the humble Provençal peasant. Nature, then, was to be the great leveling theme.

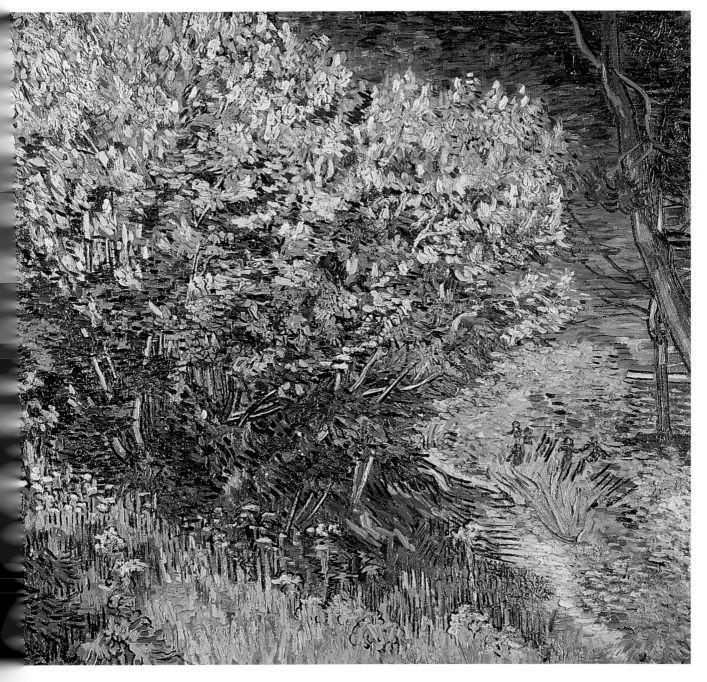

LILAC BUSH

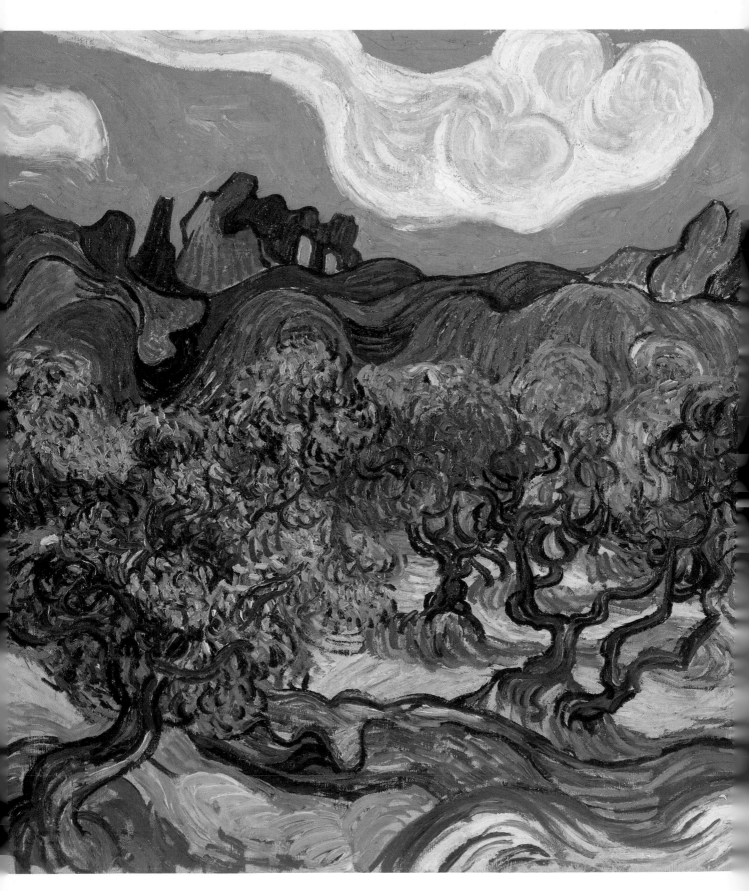

THE OLIVE TREES (1889)
The Museum of Modern Art, New York.
Celimage.sa/Scala Archives

VAN Gogh spent several months painting olive trees after his experience with the Impressionists in Paris. In letters to Theo he conveyed his fascination with the trees, their diverse color and varying dimensions. He was captivated by their distinct characters, and tried to capture the textural nature of the foliage with a novel brushstroke technique. However, he also wrote about how arduous it was to master the silvery-gray colors of the leaves.

During the last year of his life, at the asylum at Saint-Rémy, Van Gogh produced several works that recorded the growth patterns of the local olive trees. By the end of the year, he had painted 15 canvases, using olive trees as a subject. This particular painting, *The Olive Trees*, was completed in June 1889.

The work reflects the mood of the season, with its vibrant light and dark shades of yellow, white, blue, green, and silver, which meander across the canvas. Van Gogh incorporates a broad range of color in his work. The pen-and-ink drawings of olive trees that he also produced during this time, of their nature, did not explore this aspect. Thus, we can see how Van Gogh's approach to the same subject varied dramatically within such a short space of time.

GARDEN AT SAINT-PAUL'S ASYLUM (1889)
Museum Folkwang, Essen. Celimage.sa/Lessing Archive

AN Gogh was extremely satisfied with this portrayal of the asylum garden, probably as much for sentimental reasons as its excellent technical and expressive qualities. Although he lamented his fragile physical and mental state, he never desired—at least until Theo's son Vincent was born—to be anywhere else. He fully realized he was incapable of looking after himself because the "attacks" could strike at any time. Although he was, at times, critical of the treatment he received in the asylum, which he said amounted to "absolutely nothing," at least he was under surveillance. His suicide may well have come sooner without the warden's watchful gaze.

This painting is an eloquent illustration of Van Gogh's belief that it was the artist's duty to remain faithful to nature and to reality. He places huge emphasis on the trunk and and the gnarled tree, which he refers to as "that somber giant—like a proud man defeated." Like *The Olive Grove* (1889), it was partly painted as a response to the biblical scenes painted by Gauguin and Émile Bernard (1868–1941). Steadfast in his belief that such images had no place in the artist's *oeuvre*, he wrote to Bernard in a rather peremptory manner: "I ask you again, roaring my loudest, and calling you all kinds of names with the full power of my lungs—to be so kind as to come back to your own self again a little." It was ironic that Van Gogh was to paint *The Angel* (1889) after the style of Rembrandt a few months later.

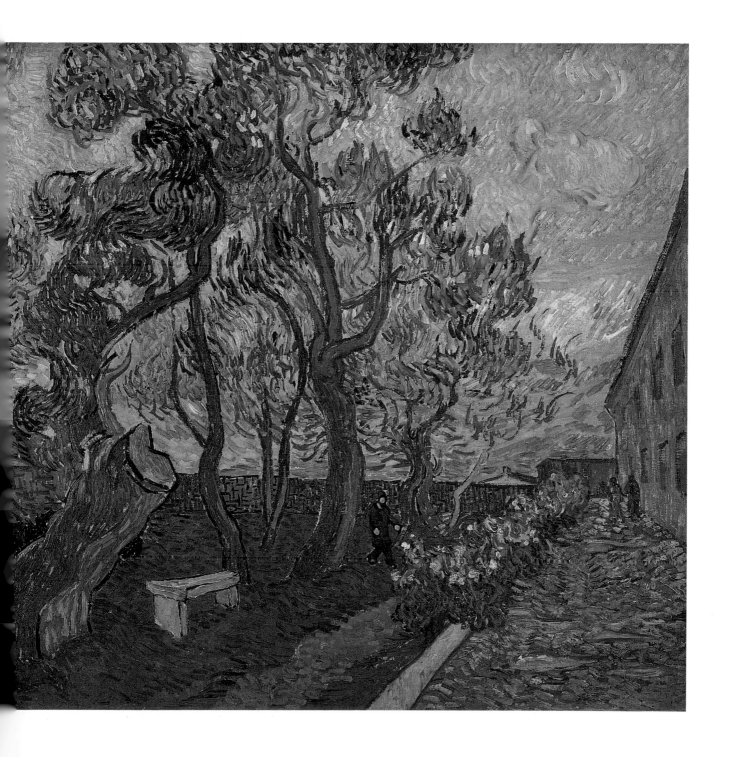

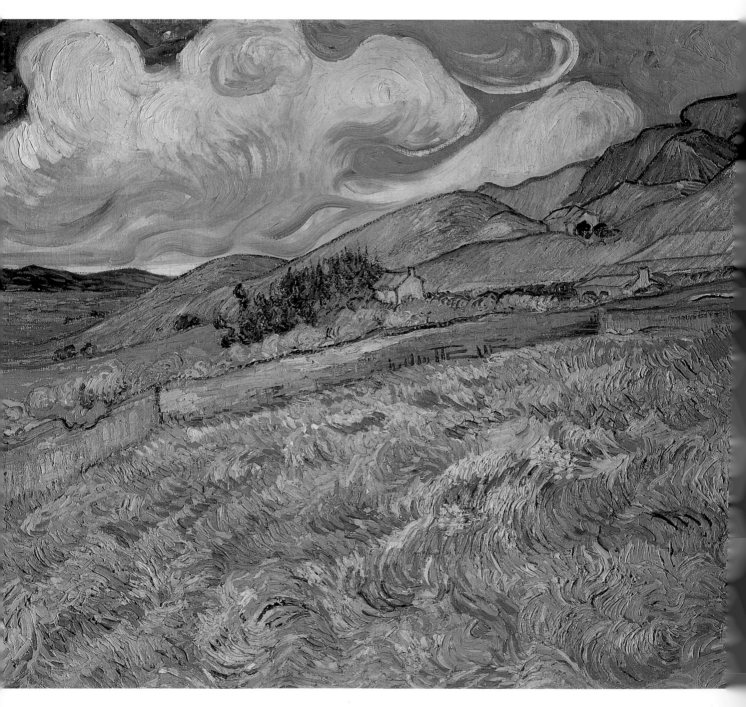

WHEAT FIELD WITH MOUNTAINOUS BACKGROUND (1889)

Ny Carlsberg Glyptothek, Copenhagen. Celimage.sa/Lessing Archive

AFTER an initial two or three months spent solely in the asylum and its grounds, Van Gogh was allowed out into the surrounding countryside. Here he rediscovered familiar and well loved themes and motifs, such as those seen in this painting. At first, Van Gogh didn't venture far from Saint-Paul's and indeed this view of a wheat field within a wall is one that he had meditated upon time and time again from behind the protective bars of his bedroom window. He commented that it was "[the scene] above which I see the morning sun rise in all its glory." Van Gogh was fascinated by wheat fields and painted them at different times of year, from plowing and sowing to the summer's harvesting. All this he recorded on canvas with the earnest dedication and personal interest of a true peasant painter.

In the preliminary sketches of this landscape, the wall dominates the composition, almost entirely blotting out the rest of the view, but in this version the scene is considerably broader. The wheat field in the foreground remains the largest element of the composition but the hills, mountains, and clouds do have a significant role to play. Various loose horizontal bands constitute what Van Gogh referred to as "a landscape of the utmost simplicity."

STARRY NIGHT (1889)

Metropolitan Museum of Modern Art, New York. Celimage.sa/Lessing Archive

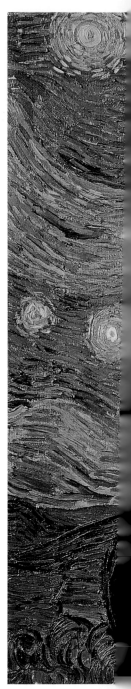

*A*NOTHER of the many asylum pictures, *Starry Night* surely ranks among Van Gogh's most famous works. Much of this recognition must go down to Don McLean's eponymous ballad, in which Vincent's mythic status as the archetypal tragic and misunderstood genius reached one of its more sickly apotheoses. No one would have been more surprised by this sentimentalizing rhetoric than Van Gogh himself, who considered the image to be one of his less successful renditions of nature. In his opinion, it was just not realistic enough.

Nevertheless, it is precisely this aspect of the work that has appealed to critics and crooners alike. What these admirers almost unanimously pick up on is its visionary quality. The painting may not be a naturalistic representation of the Provençal countryside, but it does evoke another previous reality. The small cluster of houses and the silhouetted cypress tree look just like a nestling Dutch village, with its typical church spire. The sky, reminiscent of Rembrandt's etching *The Annunciation to the Shepherds* (1634) is a further throwback to Van Gogh's strict Protestant past. In some ways it also points the way toward abstraction, and certainly Expressionism. Its rhythmically swirling forms and bold patterns are also similar to those that appeared under Gaugin's influence in Arles, although surprisingly neither Gauguin nor Bernard recognized this painting as bearing their imprint, seeing it "merely" as a scene of a village at night.

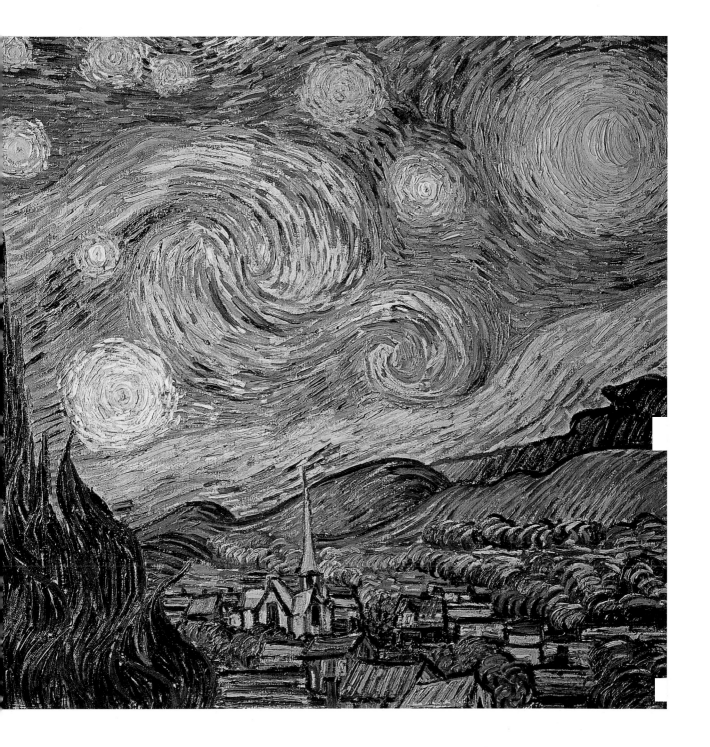

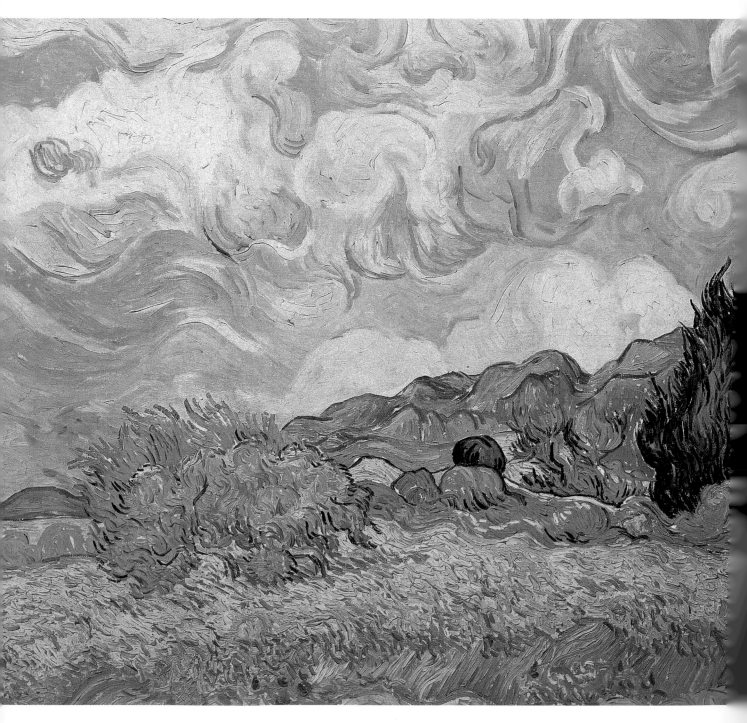

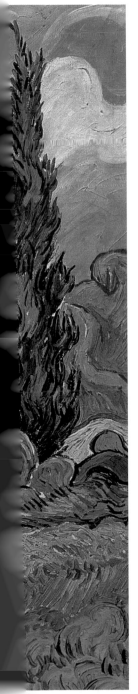

FIELD OF WHEAT WITH CYPRESSES (1889)

National Gallery, London. Celimage.sa/Lessing Archive

WHEN Van Gogh was well enough to venture into the countryside in late May, this magnificent painting, completed a little later, was one of the results. Throughout June, he created a series of famously powerful landscapes, each bursting with a violent energy that many have attributed to his madness. However, for all the potential signs of a tormented mind that such works display, they were all painted during periods of remission. The swirling, heavily stylized forms, now instantly associated with Van Gogh, did not suddenly appear from nowhere—they mark a progressive development in his work rather than a radical break. The earlier Cloissonist influence of Gauguin and Bernard is finally assimilated.

In the history of art, cypresses are traditionally a motif signifying death. Dark and somber, they normally belong in the cemetery. Despite a certain sinister air, which some have linked to Van Gogh's suicidal tendencies, the trees here are alive and vibrant. In fact the whole scene is vigorously animated, with each part shading into others. Nothing is stable; everything that is solid melts into air.

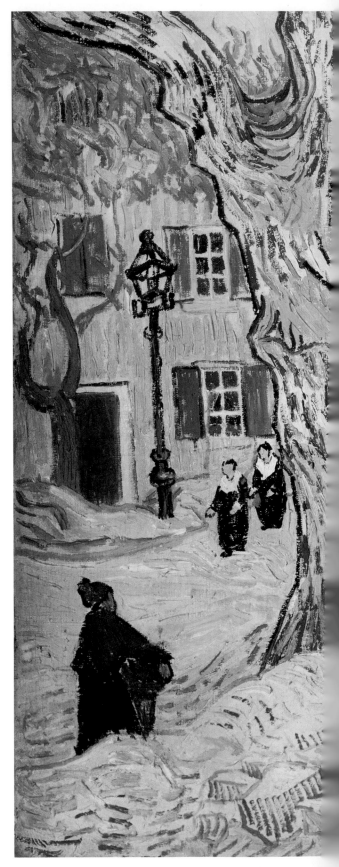

ROAD WORKERS IN SAINT-RÉMY (1889)

Phillips Collection, Washington D.C.
Celimage.sa/Lessing Archive

THE principal colors used by Van Gogh in *Road Workers in Saint-Rémy* are green, brown, and, increasingly, white. Van Gogh's palette has an almost clinical feel, perhaps like that of his surroundings in the hospital at Saint-Rémy. The white in this painting is enhanced by the thick black outlines of the trees, and is a particularly unsettled aspect of the painting. The usual bright colors that so often pervade the canvases of this artist, are notably absent from this work. It is as though Van Gogh offers color, not only as a method of aesthetic presentation, but as a means of reflecting his own personal experience.

However, though such a colorless scene appears bleak, this work has certainly not lost its dramatic tension. The strewn lines of color and black outline seem only to concentrate the vibrancy of color that simmers beneath its surface. The patterned trees dominate most of the painting, their wavy lines contrasting with the impression of stillness created by the rest of the scene. A mere hint of Van Gogh's past golden palette reveals itself through the treetops.

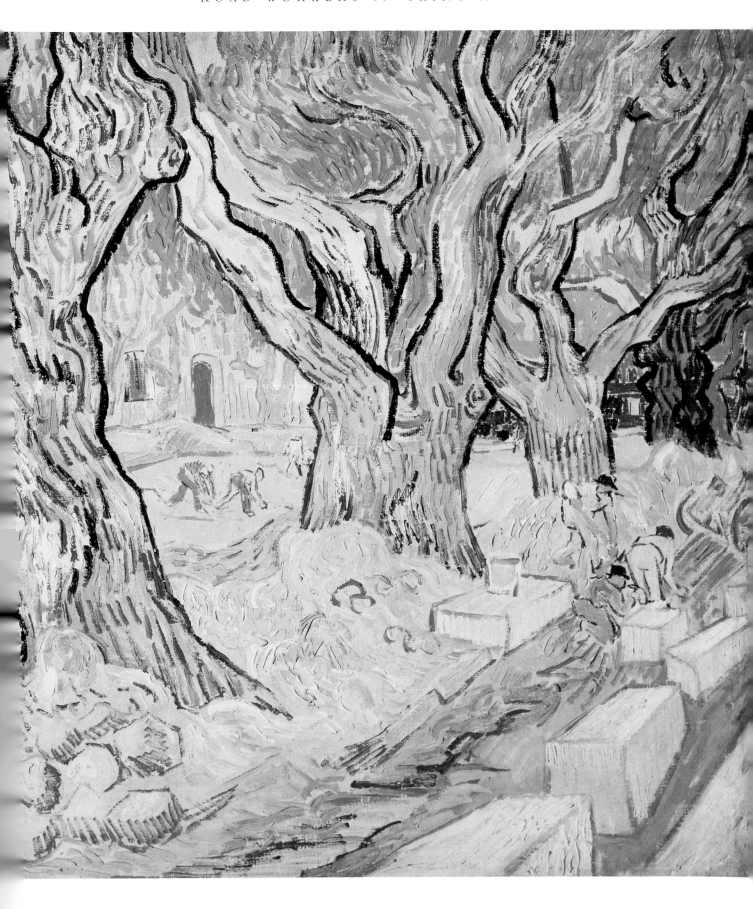

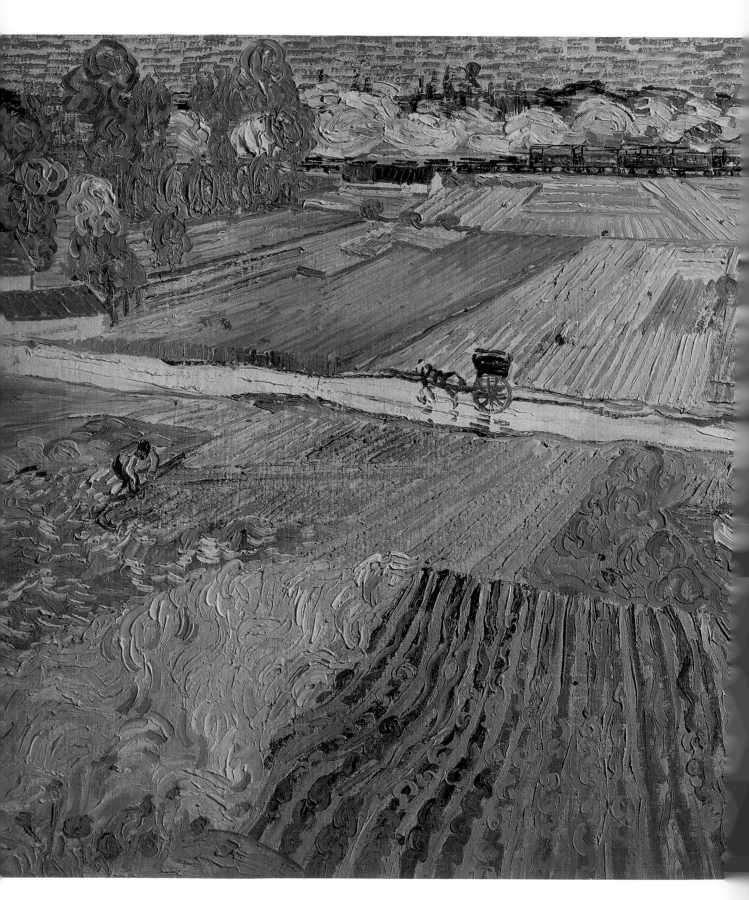

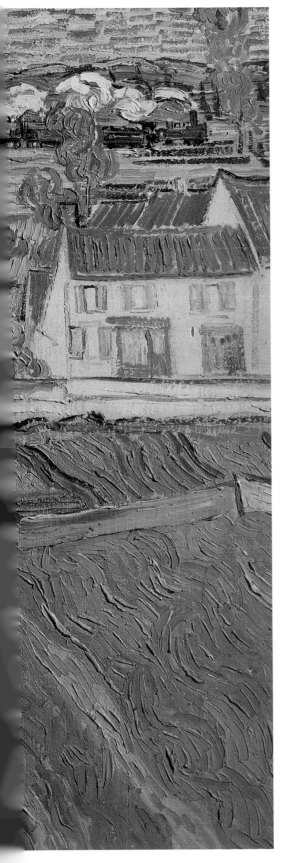

LANDSCAPE WITH CART AND TRAIN
Pushkin Museum, Moscow. Celimage.sa/Scala Archives

THIS work lacks some of the majesty and turbulence that so often identify a painting by Van Gogh. The artistic style of *Landscape with Cart and Train* is less evocative than that of many of his other landscapes, although it still has an element that is unmistakably his. The painting was completed during the middle of the day—Van Gogh was often to be found working on his canvases in the blazing heat of the mid-afternoon. The work boasts a splendid variety of patterned brushstrokes.

Van Gogh produced nearly 900 works in his lifetime, although few were painted from this unusual perspective. Instead of looking straight on at eye level, we find ourselves at the top of a hill, gazing down across the fields, and toward the house to the right of the image. A similar method is adopted in *The Poppy Field* (1888) and *Plain near Auvers* (1890). Also, in these paintings, Van Gogh almost completely omits the sky from the horizon. This painting abandons the heavy shadow and lines that we see in landscapes such as *Wheat Fields with Crows* (1890). This unfamiliar treatment of his subject enhances its more subtle values, such as the alternating brush technique and intrinsic balance of shade.

Landscape with Cart and Train is rectangular in format, and shows the inspiration that Van Gogh gained from the bright colors and strong light of Provence.

Detail from Wheat Field with a Reaper (1889)

Van Gogh Museum, Amsterdam. Courtesy of Edimedia

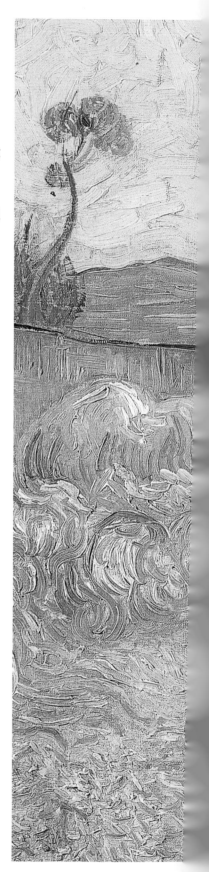

*T*HE warm rays of the sun can almost be felt through the twisting and curling of the wheat grains, as they spiral across the foreground of the image like flowing lava. This circular and flowing feel is reflected along the contours of the mountains in the distance, and in the sweeping brushstrokes of the sky. Varying tones of golden and orange-yellow are repeated across the canvas, suggesting the heat of a blistering summer's day.

The style and technique of this painting is similar to that of numerous earlier paintings by Van Gogh, such as *Harvest in Provence* (1888), *The Sower* (1888), and La *Sieste* (1889–90). All of these paintings have broken directional brushstrokes and a warm complementary palette of blue and yellow.

Wheat Field with a Reaper is now held in The Van Gogh Museum in Amsterdam, which houses the largest collection of the artist's work. The collection includes several of his works of nature, in which his artistry is most apparent. In these works his favorite color, yellow, dominates the canvas. Yellow signified love to Van Gogh, and that color is now considered to be one of his signature traits.

Vincent lived in the south of France until his untimely death, painting at a frantic pace, in between bouts of mental depression.

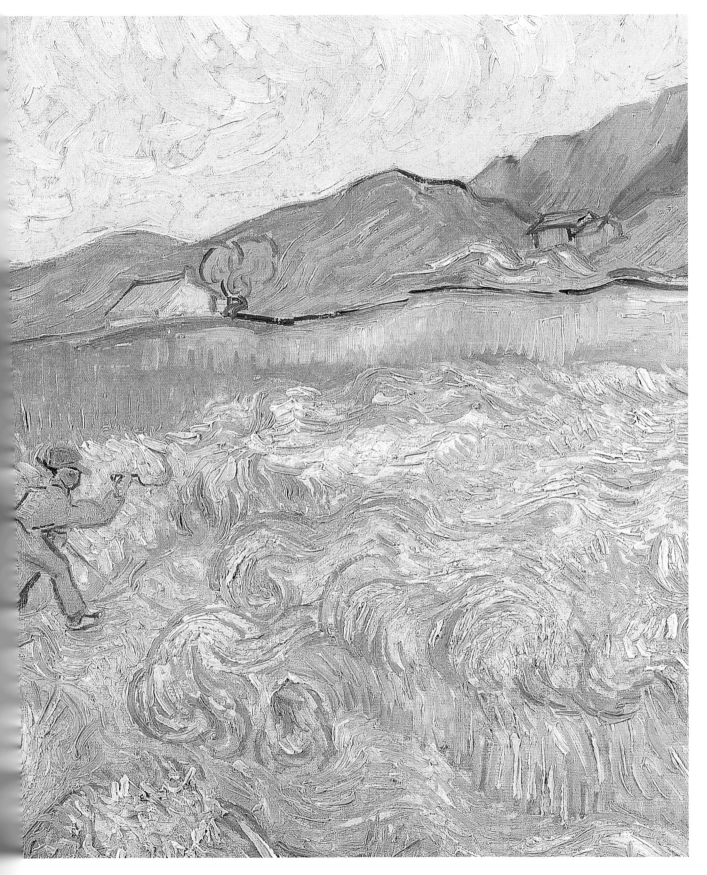

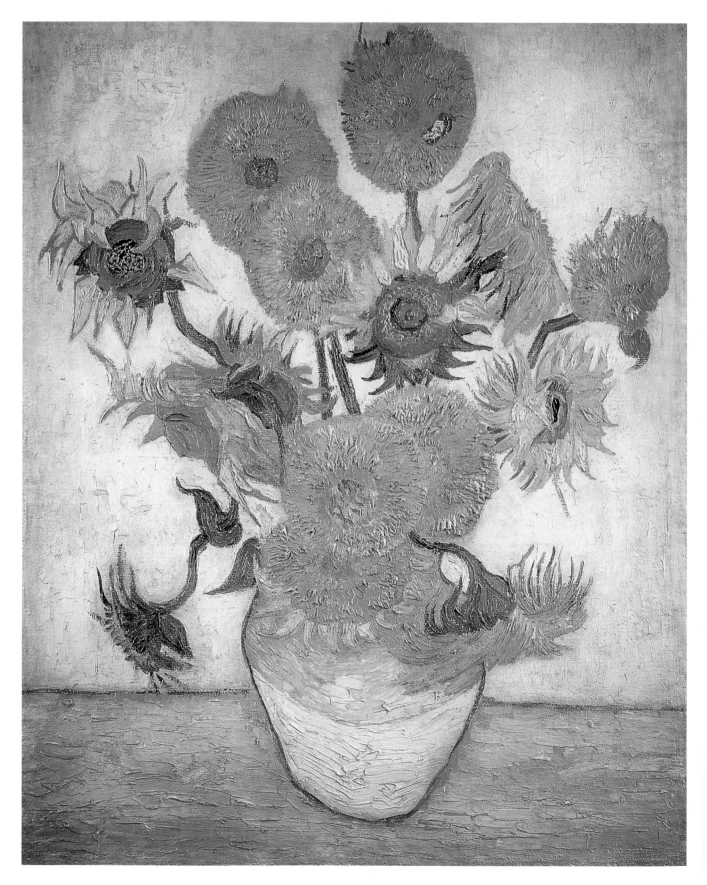

VASE WITH TWELVE SUNFLOWERS (1889)

Yasuda Fire and Marine Insurance Company, Tokyo. Courtesy of Edimedia

*T*HIS is one of three copies Van Gogh made of the famous sunflowers whilst in the asylum of Saint-Paul. He referred to them all as being "absolutely equal and identical." In reproducing his own work in this way, Van Gogh was openly flouting the accepted notion of the supremacy of the "one-off" and "never-to-be-repeated" original. In fact, Van Gogh often repainted earlier works in order that he might retain a copy of the canvases he gave away to friends.

Vase with Twelve Sunflowers is another example of the "light on light" technique so magically employed a year earlier in *The Sunflowers* (1888). Various tints of the same color are used together, layer upon layer, to stunning effect. As with the original Sunflowers series, the vase, background wall, and table surfaces are essentially smooth and almost even in tone, in distinct contrast with the sunflowers themselves. The vibrant heads are bought into sharp relief by the longer brushstrokes of the leaves and stems. Variously described by critics as "an ode to Provence" and "the best still lifes in the history of art," these sunflowers reminded Van Gogh of the happy days he spent in the Yellow House at Arles, full of anticipation for the coming of Gauguin. Confined in an asylum for the mentally disturbed, memories of those joyful days in Arles were surely what helped to prevent the fog of depression enveloping him completely.

BEDROOM AT ARLES (1889)

Musée d'Orsay, Paris. Celimage.sa/Lessing Archive

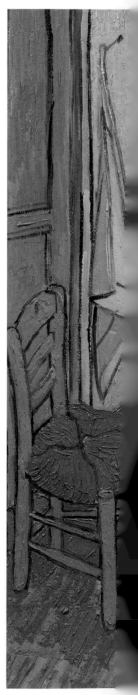

AN Gogh painted two versions of this intimate picture, one either side of Gauguin's unsatisfactory visit in 1888. Excited by the prospect of his friend's arrival, he said about his first effort that, "I am conceited enough to want to make a certain impression on Gauguin by my painting. I have finished as far as possible the things I have undertaken, pushed by the great desire to show him something new, and not to undergo his influence before I have shown him indisputably my own originality." Ironically perhaps, considering this last point, this second painting was a copy of the first. It could be that Van Gogh was trying to relive happier times, or at least the initial calm period before his friend's turbulent departure. "To look at the picture," he explained, "ought to rest the brain, or rather the imagination." Paradoxically the room's very contents—from its wicker furniture to his own paintings hanging on the wall—serve to remind us more keenly of what is not there; namely, its inhabitant. Van Gogh described the room as "an interior without anything." In fact he believed that the inanimate objects left behind in a person's room adopted their owner's personality, as did the empty room itself.

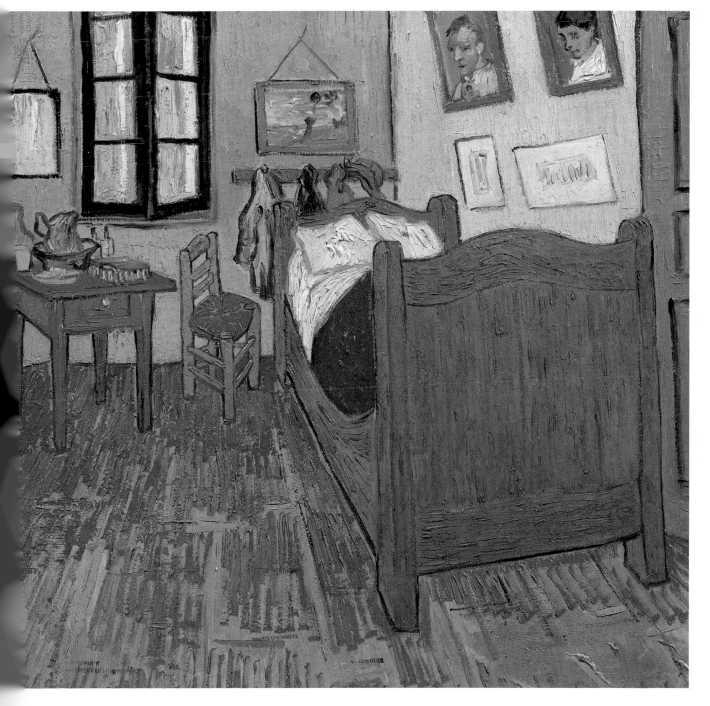

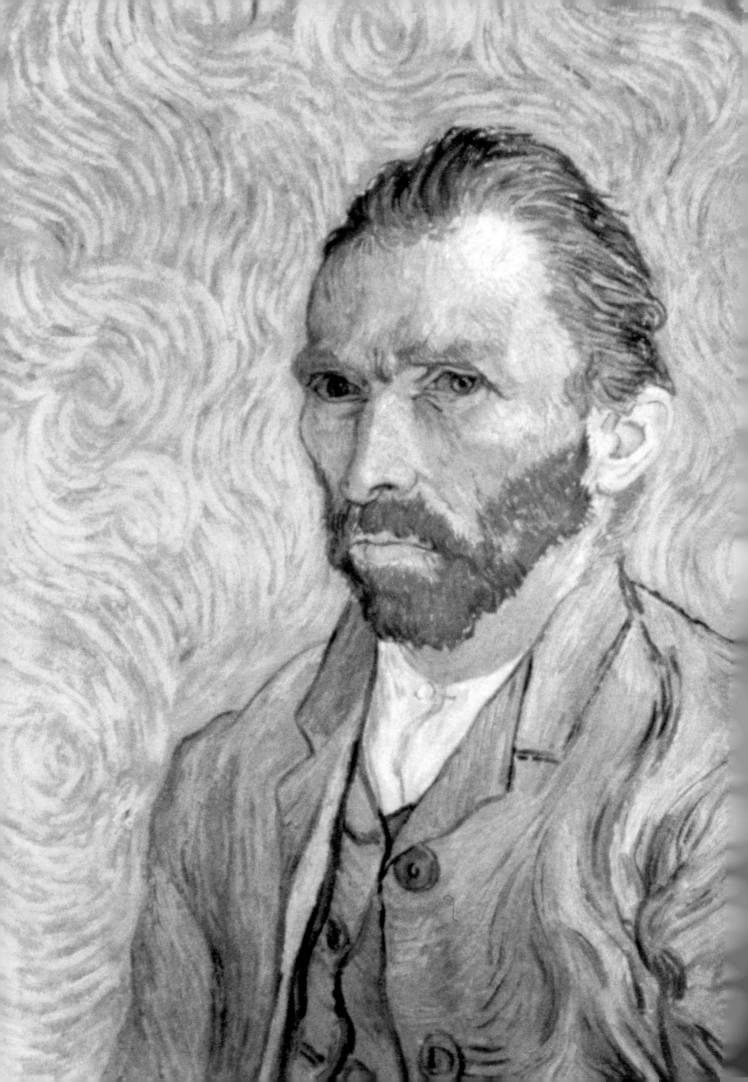

SELF–PORTRAIT (1889)

Musée d'Orsay, Paris. Courtesy of Edimedia

ONE of Van Gogh's best-known works, this portrait was created shortly after the artist's suicide attempt (by swallowing paints) in Saint-Rémy. When his painting materials were eventually restored to him by his attendants, Van Gogh painted three self-portraits in quick succession. Curiously, considering the intense results, he claimed to have chosen the genre as a respite from working outdoors. To avoid the excessive excitement and stimulation he would have felt venturing outside the asylum itself, Van Gogh chose instead to turn inward and paint the landscape of his soul.

In some ways this portrait does not appear to be the work of a man whose inner torment had recently led him to attempt suicide. His furrowed brow may betray a certain dissatisfaction or disturbance, but the face that stares out at us so intently is also confident and surly. If the sitter feels at all depressed or angst-ridden, he is keeping these troubled emotions fairly well hidden. In fact this is the painting's very strength. The artist himself presents us with only a glimpse of his psychological turmoil; the terrible depression that his strained facial expression attempts to hide, nevertheless comes pouring out around him. The stylized background swirls and the organic flowing lines of his jacket are left to do most of the expressive work. They are reminiscent of other canvases painted around this time, such as *Green Wheat Field with Cypresses* (1889), which feature restless movement as a metaphor for the psyche in constant flux. Van Gogh's frown is ultimately directed beyond the viewer. His eyes seem focused on different things; the object of his gaze remains unclear. He seems to be scrutinizing himself and not liking what he sees.

PARK OF SAINT-PAUL'S ASYLUM (1889)

Private Collection, Geneva. Celimage.sa / Scala Archives

THE enthusiasm of the artist can be felt through the commitment of his medium to the canvas surface. Compared with the more refined, smaller brushstrokes of his earlier works, *Park of Saint-Paul's Asylum* deploys shorter, more varied strokes of color. The palette and textures are light and subtle, as Van Gogh incorporates an Impressionist influence into this work. There is an obvious lyrical flow to the painting, discernible through the wavy brushstrokes that Van Gogh has reserved to depict the trees.

The two trees in the foreground hold dual significance. At a first glance, it seems as though they are deliberately positioned to form a frame or cage around the image, restricting our view of the park. However, on a broader level, they also sustain the liquid motion of the painting.

This was one of several canvases that featured the hospital park, and one of quite a number of paintings that Van Gogh completed during his stay there. He believed that if he continued to work, painting outside, it would restore his health. He often conveyed this belief in his letters to Theo.

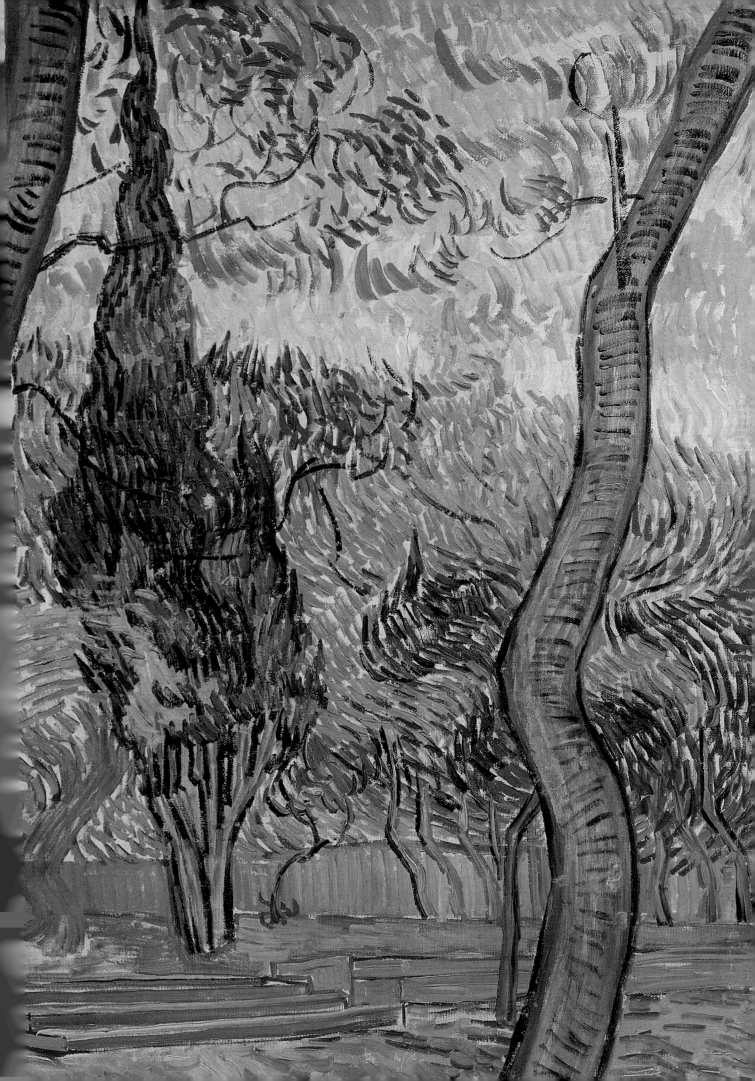

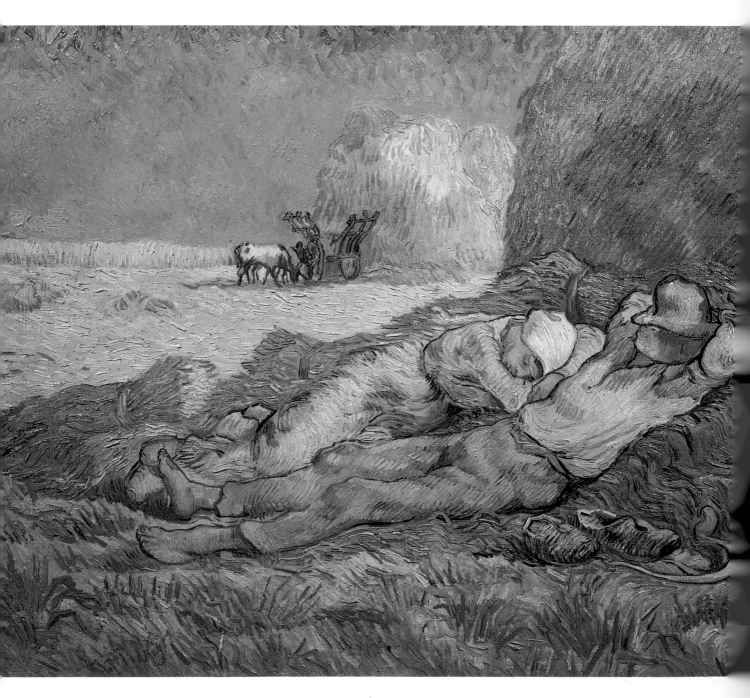

LA SIESTE (1889–90)

Musée d'Orsay, Paris. Celimage.sa/Lessing Archive

THAT many of Van Gogh's paintings made during his final days at Saint-Rémy were copies, and not originals, did not seem to worry him at all. Writing to Theo he commented: "Many people do not copy, many others do, I started on it accidentally and I find that it teaches me things..." Van Gogh was never afraid to acknowledge his debt to past masters and one of his favorites was the great peasant painter, Jean-François Millet.

In his youth in Holland, Van Gogh had admired Millet's rustic scenes of farm laborers, peasants, and the economically disadvantaged. However, such themes had all but been abandoned in Arles, and it is significant that Van Gogh chose to return to these subjects at this point in his life. It was possibly a longing for the north and "escape" from the asylum that prompted Van Gogh to paint works so associated with his past. *La Sieste* is arguably the most famous of all Van Gogh's copies. There is no trace in this painting of the agonizing depression he was feeling at the time—the whole idyllic scene is bathed in warm yellows and complementary blues. These colors imbue the picture with a relaxed sense of calm, an effect heightened in this instance by the strong and vital brushwork.

PORTRAIT OF A MAN (1889–90)

Rijksmuseum Kröller-Müller, Otterlo. Celimage.sa/Lessing Archive

VINCENT Van Gogh spent one year at the asylum in Saint-Rémy de Provence, and this period was probably one of the most arduous of his entire life and career. However, it was also arguably his most creative.

Van Gogh admitted himself to the hospital after the self-mutilation of his ear in Arles. Whilst staying there, he would at times be completely incapacitated by his illness. However, on other occasions, he was permitted to work outdoors and paint.

Portrait of a Man, with its distorted appearance of the male subject, looks as though it has been produced under the effects of medication. A more extreme contortion of a subject's face can be seen in another painting from Saint-Rémy, *Portrait of a Patient in Saint-Paul Hospital* (1889).

In terms of its palette, this work is reminiscent of Van Gogh's earlier portraits, such as *Young Man with a Cap* (1888), or *The Italian Woman* (1887), in which the background has been painted in a strong, citrus yellow. A strong comparison can be drawn between the color scheme of this piece, and that used in one of Van Gogh's self-portraits from 1888, in which bright, citrus colors are placed in close but sharp proximity; like visual equivalents of the sitter's emotions. The features of the two men's faces and the folds of their jackets are also clearly defined by dark outlines, emphasizing their presence.

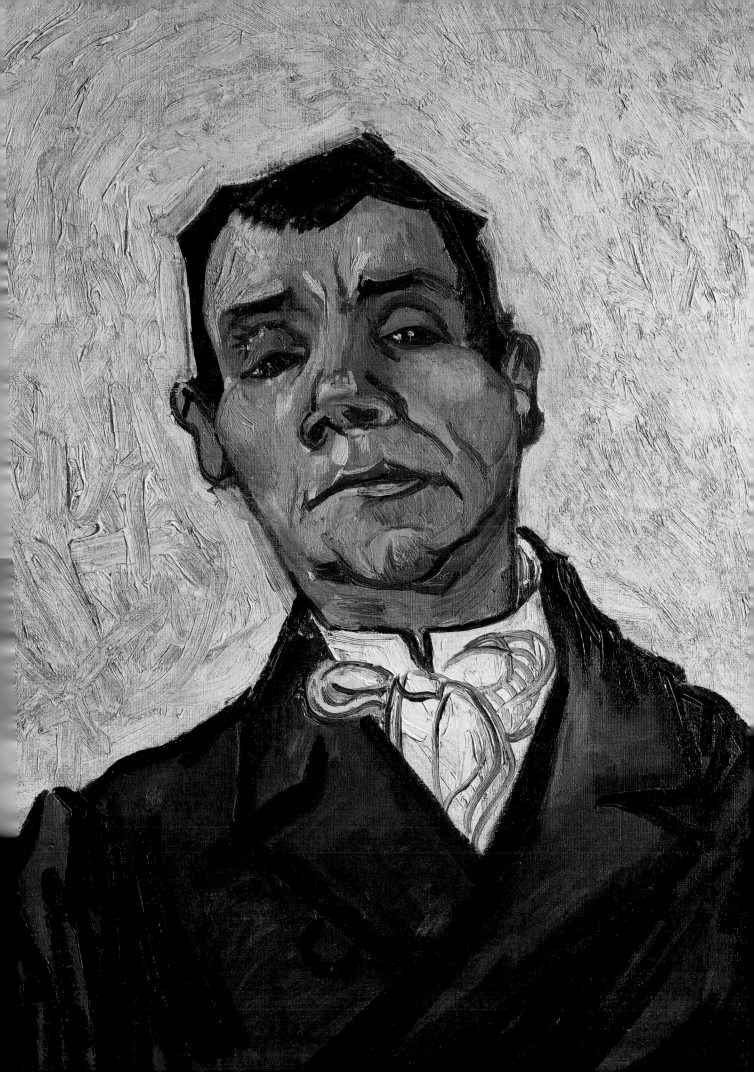

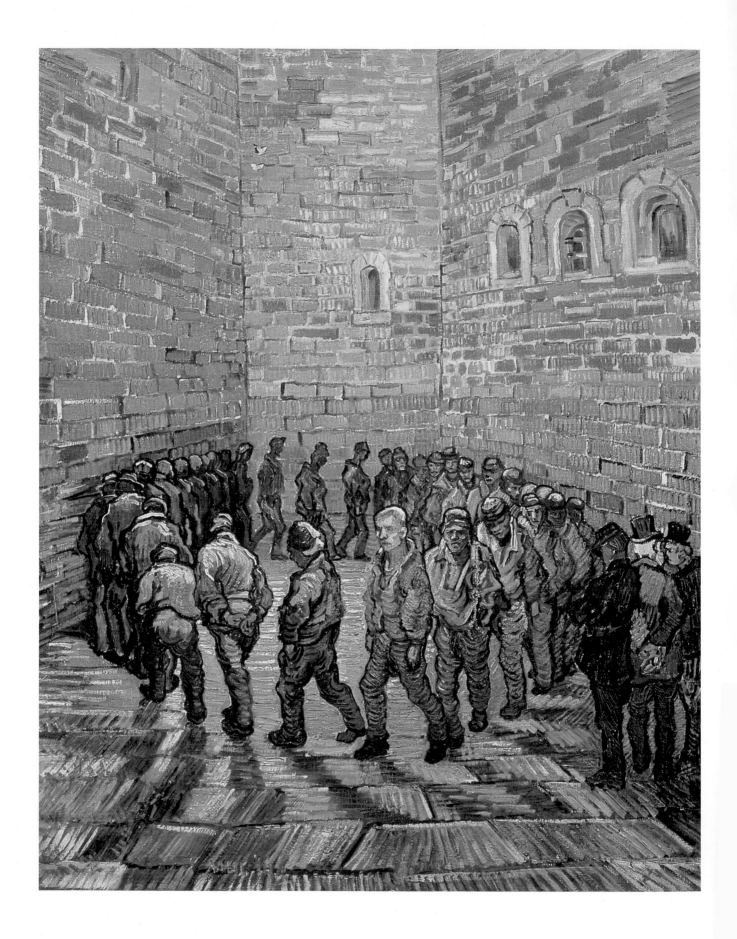

THE PRISON EXERCISE YARD (1890)

Pushkin Museum, Moscow. Courtesy of Edimedia

*T*HIS is another example of the "creative copying" Van Gogh practiced during his final months in Saint-Paul's Asylum. This is a painting after Gustave Doré's (1832–83) painting which bears the same name. Van Gogh certainly admired Doré's brand of social realism, but probably more to the point, he simply did not want to "lose sight of the figure," as he put it. As has been mentioned earlier, Van Gogh thought of himself as being primarily a portrait artist, and was frustrated by the lack of opportunities the asylum offered for this type of activity.

The Prison Exercise Yard was not in any way a straight copy of the original, and the colors at least were purely Van Gogh's own. This did not of course perturb him, and he remarked to Theo of the painting: "The vague consonance of colors are at least right in feeling." Van Gogh's interpretation of the picture was more alive than Doré's version, partly because of the use of enriched color, but also because, inevitably, the picture's strong sense of sadness and confinement are depicted with an understanding and an intimacy that can only come from experience. Van Gogh was confined within the asylum, but more particularly, he was trapped within himself, at the mercy of the psychological attacks that could strike at any time and for no apparent reason. Like the patients in the asylum, the prisoners appear here together, yet alone— each is struggling with his own problems and experiences.

THE ROAD TO SAINT-RÉMY (1890)
Private Collection, Switzerland. Celimage.sa/Lessing Archive

LARGE sweeping brushstrokes cradle the road at the center of this canvas, and extravagant flares of green, orange, and yellow brim from the sides of the path. Through the wild and vibrant essence of this work, we can see how Van Gogh was to hold such a pivotal role in the Fauvist movement, to which color was everything. Van Gogh was personally hypnotized by the effects and emotions that color could create. Although, in this work, his palette is naturalistic, it still demonstrates his immense passion for color and brushstroke.

The road to Saint-Rémy is lined by lovely plane trees that give beautiful shade during the summer. The shade of the trees in this painting is merely indicated through random strokes of black along the ground. Apart from these, Van Gogh's palette is rich, yet light, with no single shade dominating. Instead, he creates a mosaic of interweaving lines of color. His fast pace is demonstrated by their hasty application, and by the little swatches of the canvas base that show through the bright blue of the sky. In other areas of the painting, Van Gogh has added modest touches of white to give the impression of shining light.

The woman walking along the path is almost completely camouflaged because her tones are replicated in her surroundings. Farther along the path, a small white house, crowned by a bright red roof, sits invitingly in the distance. Despite its size, the house acts as a focal point in the painting, since it is the only object that has not been constructed by means of frantic brushstrokes.

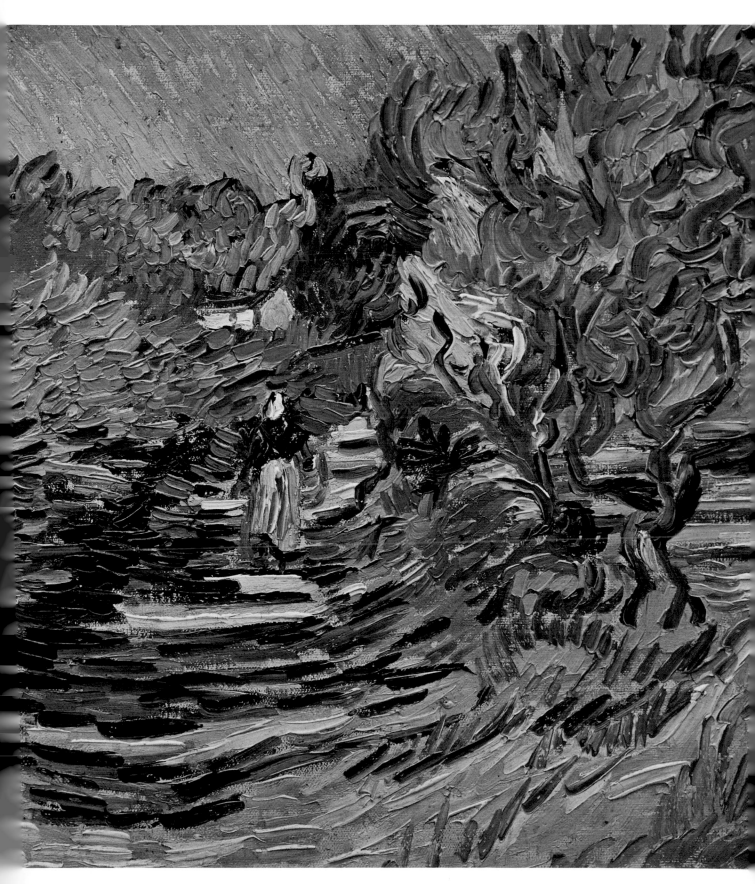

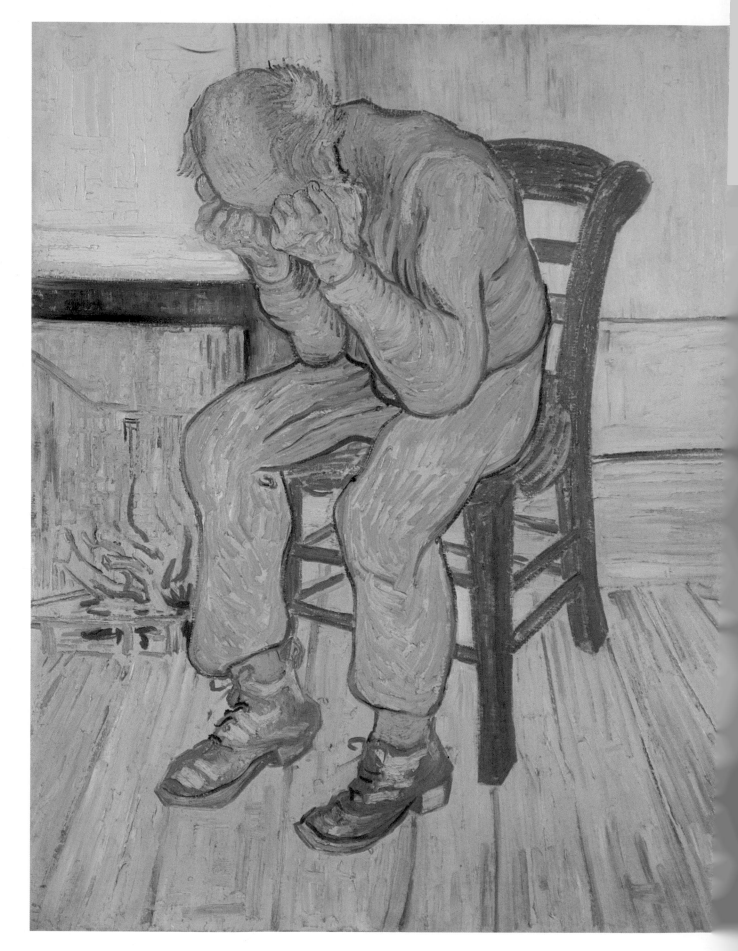

Mourning Old Man (1890)

Rijksmuseum Kröller-Müller, Otterlo. Courtesy of Edimedia

*T*HIS is a reworking of the drawing Van Gogh made in the Hague in 1882, which was rather grandiloquently titled *From Here To Eternity's Gate.* In this version though, the man looks less like a peasant collapsed in his chair (as the original obviously was), and much more like an asylum patient, dressed in a sort of regulation hospital blue. The misery or anguish the bent man is clearly exuding would also have been a familiar sight to Van Gogh as he painted quietly in the asylum's hallways and gardens. Indeed, Van Gogh commented that the strange shrieks and cries he heard at night, and one particularly powerful encounter with an old man who was unable to enunciate clearly, "put my own attacks into perspective."

This painting then, although ostensibly "simply" a copy of an earlier peasant painting, is rendered with an intimacy and a sympathy borne of long, lonely days spent interned. Van Gogh only managed to paint one actual fellow sufferer whilst in the asylum, and this was done, not from any quasi-psychological or scientific motive, but simply because there was no one else willing or interesting enough around. This copy was probably made for similar reasons. As usual with Van Gogh's figure paintings, its anguish says more about his inner state than that of his sitters.

THE GARDEN IN WINTER (UNDATED)
Courtesy of Edimedia

VAN Gogh's detailed consideration of this garden scene is remarkable. Each strand of bark and branch is clearly defined and individually treated. Unlike some of Van Gogh's other paintings, which are laced with color and exaggerated swirls of paint, this gentle black and white drawing reveals more about the subject than the artist's palette. This is a subtle but telling aspect of this work, as it would often seem that Van Gogh's method and subject reflected his state of mind.

Stylistically and technically, *The Garden in Winter* makes a strong impact. The restrained use of color serves to enhance the mood of a winter's scene, and the absence of flowers and motion generates a haunting stillness. The work maintains a semi-surreal quality. The single standing building in the distance appears out of place, as does the only bird in the foreground. There is an uncomfortable absence of people, and the multiple angles of the tree branches form a cage-like frame to a stark white sky. There is an obvious surface tension within the painting. This is seen within the lines of the composition and specifically in the sharp and contorted depiction of the tree.

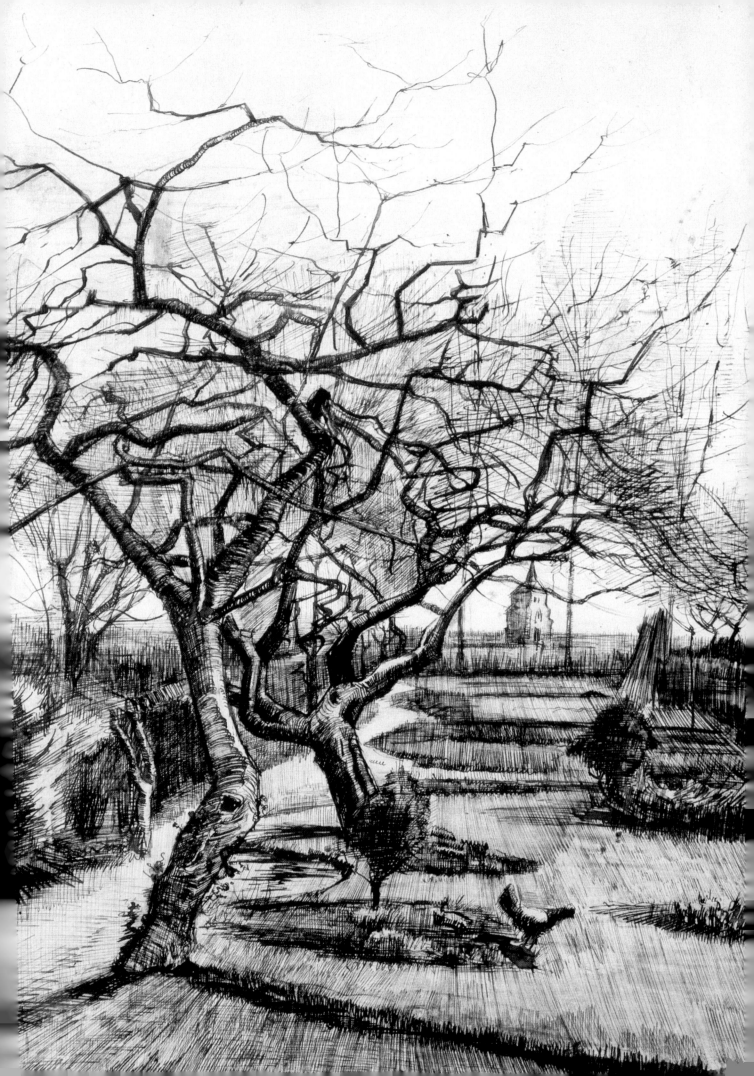

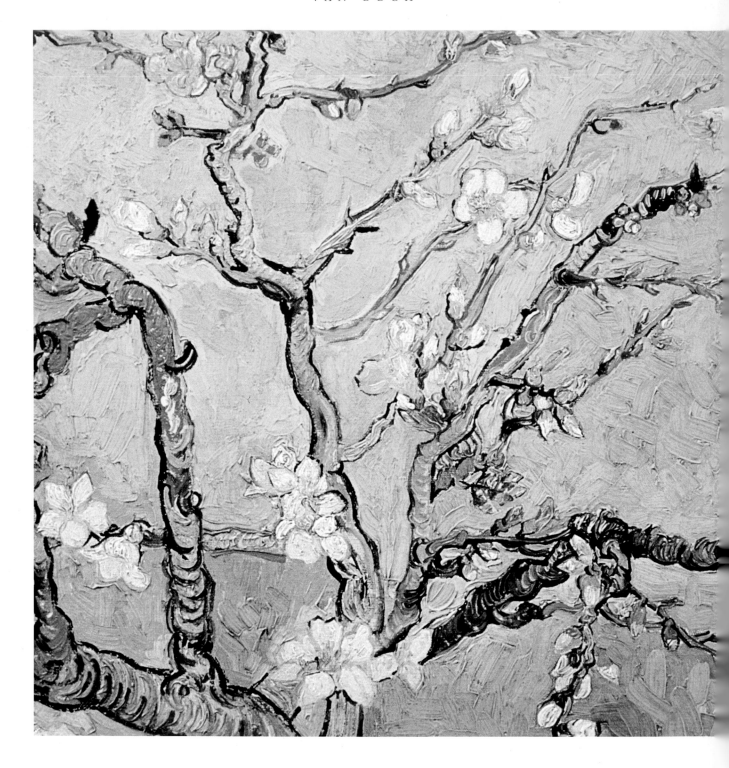

DETAIL FROM BRANCHES WITH ALMOND BLOSSOM (1890)

The Van Gogh Museum, Amsterdam.
Courtesy of Edimedia

TOWARD the end of Van Gogh's stay in Saint-Rémy, his brother's wife, Joanna, gave birth to a son who they named after him. Van Gogh referred to the happy event as "the thing I have so much desired for such a long time" and painted *Branches with Almond Blossom* as a gift for his new nephew. However, his joy at this time was tempered by the fast-dawning realization that he would probably never become a father himself. Admitting himself to the asylum at Saint-Rémy seemingly ended his chances of marriage, once and for all. Up until that point Theo, for one, had not given up anticipating. He wrote to Joanna about the matter: "I hope that he will find sometime, a wife who will love him so much that she will share his life." This of course never happened, and Van Gogh was instead left to revel in his brother's happiness.

After the barren winter months, an almond tree represented a symbol of renewal that the artist felt was entirely appropriate as a gift for a newborn baby. Also fitting was the way in which it was painted. Again the delicate stylization of Japanese prints is much in evidence; a sign of Van Gogh's allegiance to the avant-garde, here it also conveys a wonderful sense of the combined fragility and energy of infants. It is a joyous, hopeful scene. The colorful branches strain upward and are not confined within the canvas's perimeters. The painting is an image of abounding optimism for the child's future and the continuation of a family tree.

CHURCH AT AUVERS (1890)

Musée d'Orsay, Paris. Celimage.sa/Lessing Archive

AFTER a year in the asylum at Saint-Rémy, Van Gogh began to feel that prolonging his stay there would be futile. He, and the authorities at the asylum, were forced to conclude that if his condition were ever to significantly improve, Van Gogh would have to get away from the south of France with its intense heat and painful memories. Thus, upon hearing the joyful news of Theo's new son, he decided to move to Auvers. He chose this village as much for its proximity to his family in Paris as for its reputation amongst contemporary artists for being picturesque and also highly paintable.

After sending his canvases on ahead of him, Van Gogh left the south of France, never to return. This painting is one of many he completed of Auvers and its environs and, as usual, he was clearly more interested in the coloristic effects he could achieve than in the church's historic significance. The entire painting is alive with emotion; even the building, with its rounded, softly undulating lines, is organic. The whole effect is disorientating and confusing, the church seems to be heaving and folding under a great pressure. In choosing to paint a church, Van Gogh is taking up a religious theme he had abandoned after his father, a Dutch pastor, died some years earlier.

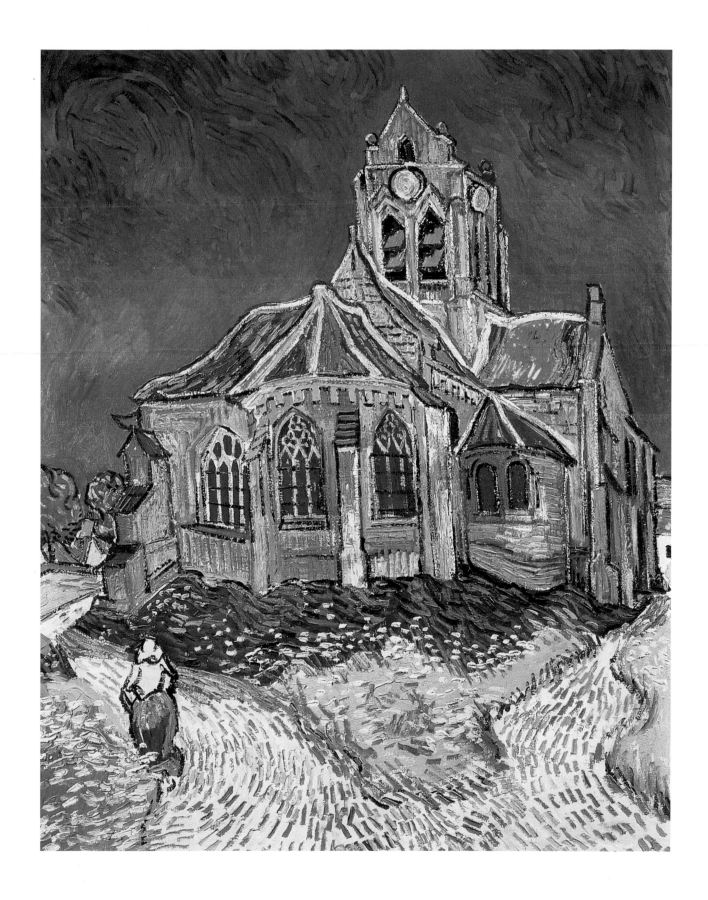

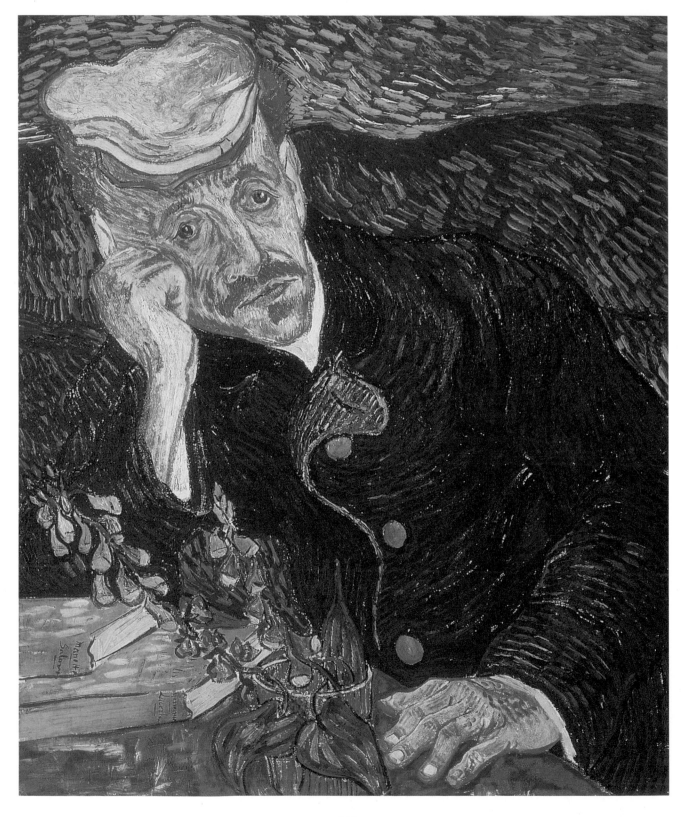

PORTRAIT OF DR GACHET (1890)

Celimage.sa / Lessing Archive

WITH so many barren months behind him, Van Gogh relished the ample opportunities Auvers afforded him of returning to his first love: portraits. Dr Gachet, seen here, was the rather eccentric homeopathic doctor responsible for Van Gogh's medical care and supervision. The doctor also dabbled in painting himself and was a fervent admirer of Van Gogh. This obviously helped to get the two men's relationship off to a good start, and it was further consolidated by what Van Gogh called Gachet's "nervous troubles ... from which he certainly seems to be suffering at least as seriously as I." Van Gogh obviously felt he had found, in Dr Gachet, a kindred spirit.

Dr Gachet persuaded Van Gogh (who needed little encouragement) to paint this portrait after he had seen *L'Arlesienne* (1888), which he particularly liked. Indeed, a number of similarities can be seen between *L'Arlesienne* and the two portraits the artist painted of Dr Gachet. Both subjects are warm yet melancholy in attitude, and both fall prey to decorative stylization. Dr Gachet sports a white sailor's hat. His status as a homeopathic doctor is highlighted by the variety of foxgloves, which have beneficial properties, on the table in front of him. Van Gogh's rather bleak words to Gauguin about wanting "to portray the sorrowful expression of our age" show us that he was emphasizing expression rather than attempting a perfect likeness.

DETAIL FROM PORTRAIT OF DR GACHET (1890)

Courtesy of Edimedia

*I*N this detail we are drawn instantly into the eyes of the subject. His tired gaze and tilted head make it appear as though the artist was reflecting a mood of sadness. As in Van Gogh's self-portraits, the eyes of Dr Gachet seem to reveal something about his character.

At such close proximity, we can value the intimate and decorative brushstrokes with which Van Gogh has applied the tones and contours to his sitter's face. The background rhythm of the portrait reminds us of the vibrant flow of his landscapes.

The melancholy expression of the doctor is reflected in the dominant blue of the backdrop and the pale wash of his eyes. We can see that there was an acute assertion of the painter's hand in depicting the features and lines of Dr Gachet's face. It is clear that, regardless of the artist's emotional or mental state, he could still succeed in capturing the essence of a mood.

Van Gogh came into contact with the doctor through Gachet's friendship with a number of artists whose work he collected. The two men became close companions, and occasionally worked together. Van Gogh's portraits of Gachet have become world famous. This work was sold at auction in 1990 for a record sum, becoming the world's most expenisive painting. Sadly the portrait has never been seen since the auction and even its ownership and location are now unknown.

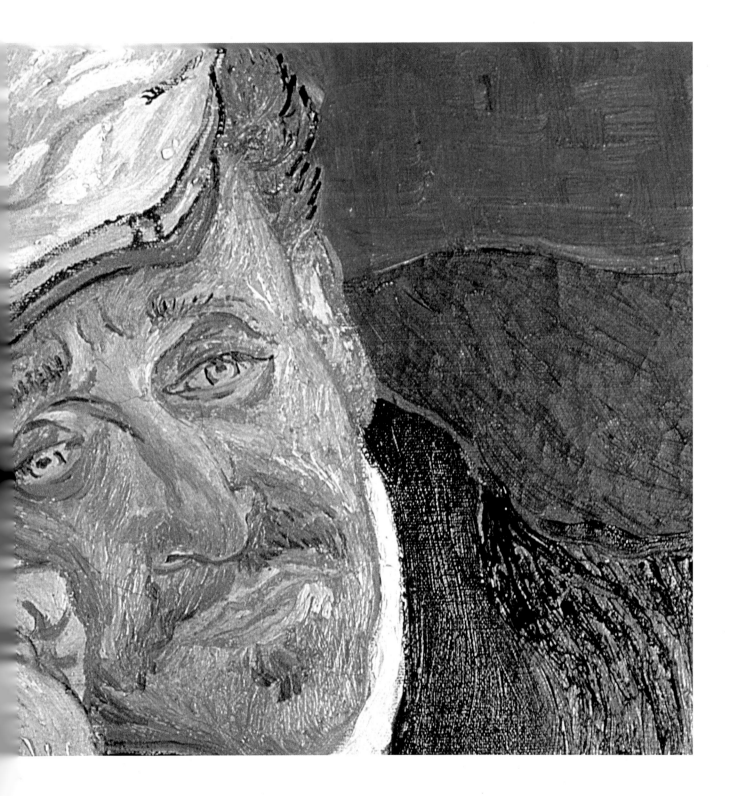

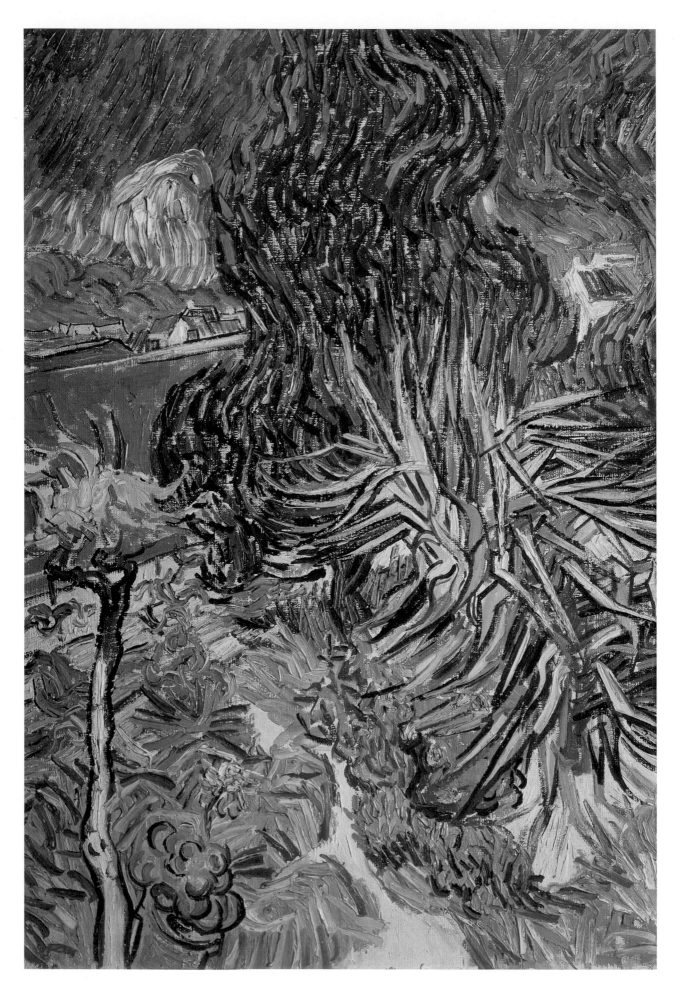

DR GACHET'S GARDEN (1890)

Musée d'Orsay, Paris. Celimage.sa/Lessing Archive

AN Gogh's affection for Dr Gachet grew the more he saw of him. Furthermore, the artist felt their friendship had a beneficial effect on his art, as he explained to Theo: "I feel that I can produce not too bad a painting every time I go to his house." During this period Van Gogh had supper with the family nearly every week. He undoubtedly appreciated this regular invitation, but had his reservations about the quantities of food consumed chez Gachet. "It is rather a burden for me to dine there," he told his brother, "for the good soul takes the trouble to have four-or-five course dinners, which is as dreadful for him as it is for me— for he certainly hasn't a strong digestion." However, excessive meals apart, Van Gogh was happy in Gachet's company, and particularly pleased when the doctor invited Theo, Jo, and their baby Vincent to spend the day with them.

Van Gogh took particular pleasure in showing 'little Vincent' the doctor's garden, with its multitude of plants and animals. This picture gives a good impression of the somewhat ramshackle condition in which it was kept—a quality of wild freedom that attracted him to the site as a source of artistic inspiration. The close-up focus gives this particular study a strange energy; an ostensibly domestic scene borders on jungle chaos. Only the rooftops peeping through in the distance remind us that humanity has not been abandoned to nature completely.

MARGUERITE GACHET IN HER GARDEN (1890)

Musée d'Orsay, Paris. Celimage.sa/Lessing Archive

*T*HIS painting of Dr Gachet's daughter was presented to him as a token of Van Gogh's thanks for his kindness and friendship. Marguerite, who had just turned 20, is standing in her garden which is bursting with flowers in full bloom. The sexual parallels are obvious; here is a young woman surrounded by Mother Nature and very much part of it. The entire scene forms a homogenous whole by being painted in an all-over decorative style. Color is deployed only modestly, mainly restricted to greens and whites. Van Gogh has represented the garden as a rural idyll in which Marguerite Gachet blends in with her surroundings, rather than making her own distinctively human mark. She is made to fit in with the abundant environment rather than it fitting in around her. Nevertheless, she does remain the picture's focal point, a status reinforced by her position just off-center. She is literally a faceless center, though like the patient in *St Paul's Asylum* (1889), who stands outside the asylum, she has no eyes, nose, or mouth. Along with the background cypresses, like flames sprouting from the countryside, she is not unique but stands in as a "type."

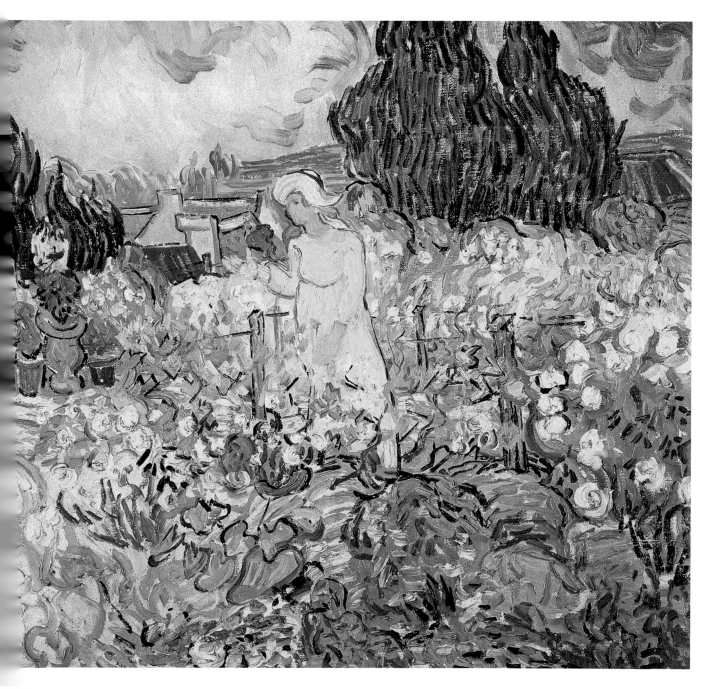

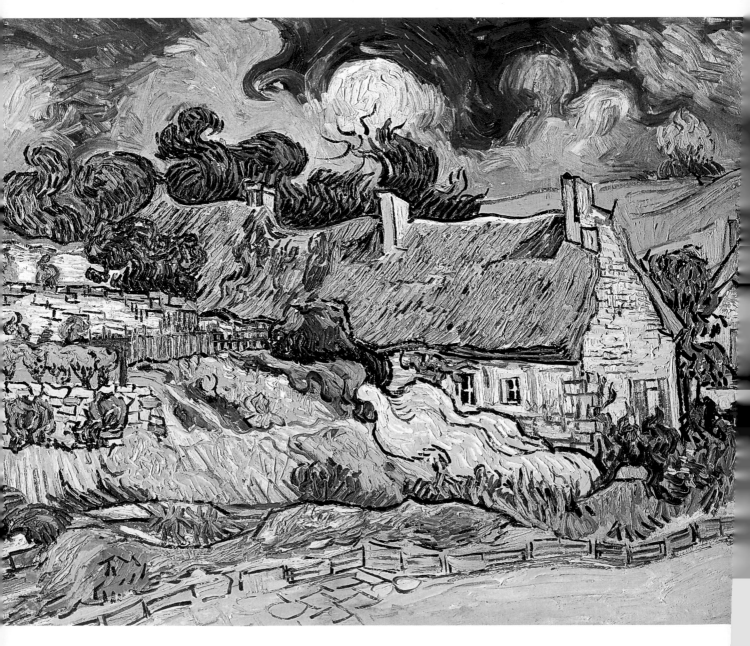

THATCHED HOUSES IN CORDEVILLE (1890)

Musée d'Orsay, Paris. Celimage.sa/Lessing Archive

*A*PART from the village church, Auvers and its surrounding hamlets—of which Cordeville was one—boasted no particular tourist attractions. Its appeal to visitors was that of the "rustic, unspoilt" countryside. Van Gogh's response to the area was no different, and his choice of subjects from this period reflects that fact. However, his comment that Cordeville possessed a "solemn beauty" is perhaps at odds with this painting's representation of the place. Certainly the hamlet seems more alive than Van Gogh's description might suggest. Every element in the composition appears to be fusing with another, as if moved by an invisible force. The moss-covered roofs are becoming as one with nature, consumed by the flame-like trees that crackle and flicker against them. Their curvilinear forms are mirrored by the ceaseless tumult of the clouds, whose thick impasto strokes are in turn echoed by the billowing white hedge, behind which peep a couple of cottage windows like hidden eyes.

Although Van Gogh described Auvers and its environs as being "full of color," here he has deliberately avoided the color contrasts of which he was so fond. The painting—a gift for Dr Gachet—possesses a marked coherence of style and color. It is an image of man's habitat almost overcome by the fecundity of God's gifts. The jungle of greens and blues that dominates the scene is a startling tribute to nature's awesome and awful might.

PLAIN NEAR AUVERS (1890)

Neue Galerie in der Stallburg, Vienna. Celimage.sa/Lessing Archive

A CHANGE of scene seemed to inspire Van Gogh, who took up painting with renewed energy and vigor. During the 70 days he spent in Auvers he finished over 80 paintings. Most were, like this one, views of the countryside near the town. The great variety of patterned brushstrokes give us a glimpse of the inner sadness he was feeling at this time. Devoid of humans, it is a very lonely landscape. Nevertheless it is a painting full of life; the clouds, as usual, are especially animated, although so too is nearly everything else. He expressed his delight in the countryside at Auvers in a letter to Theo on first arriving. In it he described the land as being "lush" with "lovely greenery in abundance and well kept." This last point is interesting. For all his frenetic brushwork, nearly all this series of works reveal a clear sense of control and order.

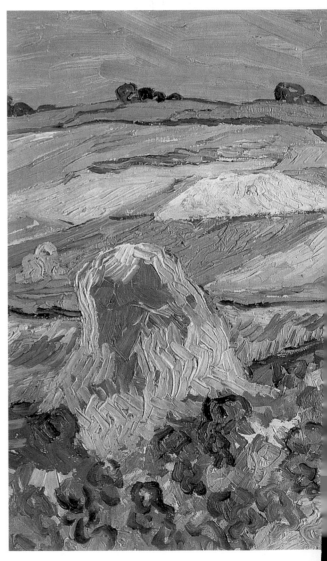

During this period Van Gogh was happy at being nearer Paris, and hence his brother, but still suffered from intense bouts of loneliness. He kept trying to persuade Theo to bring "the little one" (his son Vincent) to Auvers for "les grandes vacances." "How I do wish that you, Jo and the little one would take a rest in the country instead of the customary journey to Holland," he wrote. Despite these pleas, Theo returned to Holland anyway, to see their mother, and Vincent's sense of isolation increased. Painting was a significant source of consolation and comfort during this period, but could never be a substitute for actual company.

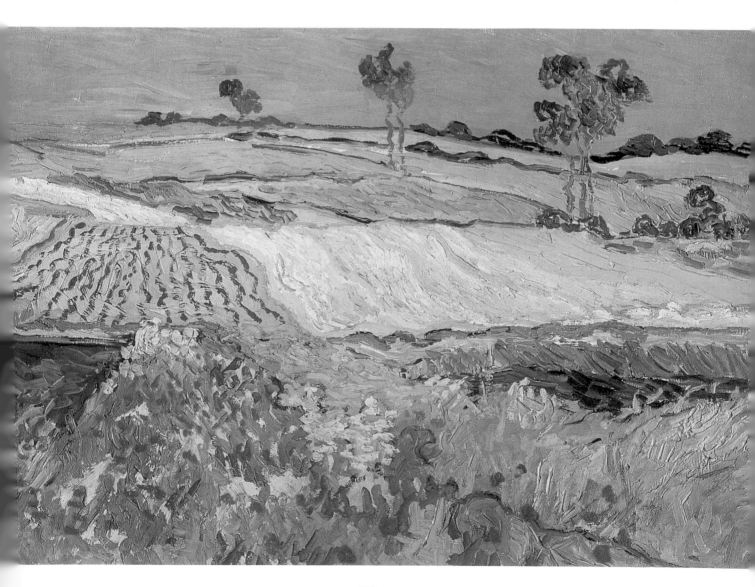

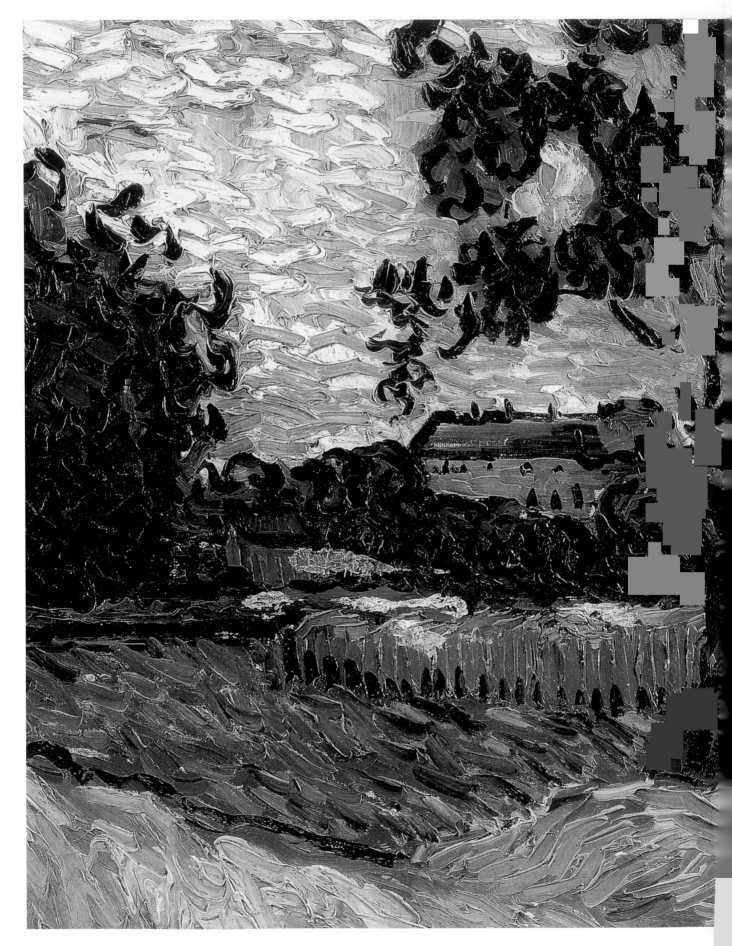

LANDSCAPE AT TWILIGHT (1890)

Van Gogh Museum, Amsterdam. Courtesy of Edimedia

A STRIKING comparison can be drawn between *Landscape at Twilight* and works by Claude Monet from the 1920s. These were produced during a time when Monet's vision had deteriorated to the point where his perception of color had become distorted and he could perceive only shades of red, yellow, and green. In *Landscape at Twilight* Van Gogh uses blue to represent houses and foliage, and, most obviously, green and yellow have become intertwined in a blend of leaves and sky. His loose and free approach to the subject is apparent in the hasty, yet fluid brushstrokes, which fill the surface of the canvas as thick and sumptuous bars of light.

Landscape at Twilight, painted in June 1890, was one of Vincent's last paintings, produced shortly before his suicide in July. The work demonstrates a fine combination of the Impressionist influence and his own highly-tuned signature style, which he successfully conjured into this wonderful expression of color and form.

Whilst working on this painting, Vincent was living in tranquil Auvers-sur-Oise. In his letters, he expressed his contentment at living there, since the place afforded him the freedom to paint. He commented that this had been a freedom that had been denied him in Saint-Rémy. Van Gogh had no shortage of subjects in Auvers-sur-Oise, and spent his last days engaged in a frenetic output of work.

TWO LITTLE GIRLS (1890)

Musée d'Orsay, Paris. Celimage.sa/Lessing Archive

*I*T has been suggested that owing to the multitude of styles Van Gogh experimented with during this period in Auvers, he was on the brink of another artistic breakthrough. His premature death means, of course, that we shall never know whether this was the case or not, but the picture we see here certainly provides another example of his stylistic variety at this time. The technique of heavy outlines and blocks of color, with the figures dominating the canvas, was inspired by Emile Bernard's peasant paintings from Brittany. In fact the whole painting is more reminiscent of Bernard's Symbolism than Van Gogh's distinctive style. As with *The Poppy Field* (1889), it is an experiment thar did not really come off.

Van Gogh was never entirely comfortable when painting children, and he invariably made them look like small adults. These young faces are wise beyond their years—they stare out of the canvas with knowing, almost weary expressions. The frenetic use of the curved line which usually serves a dramatic purpose, as in *Church at Auvers* (1890), here merely implodes. Similarly, the various shades of blue fail to create the "light on light" effect so successfully managed in *The Sunflowers* (1888), when he employed a thousand yellow hues to such wonderful effect.

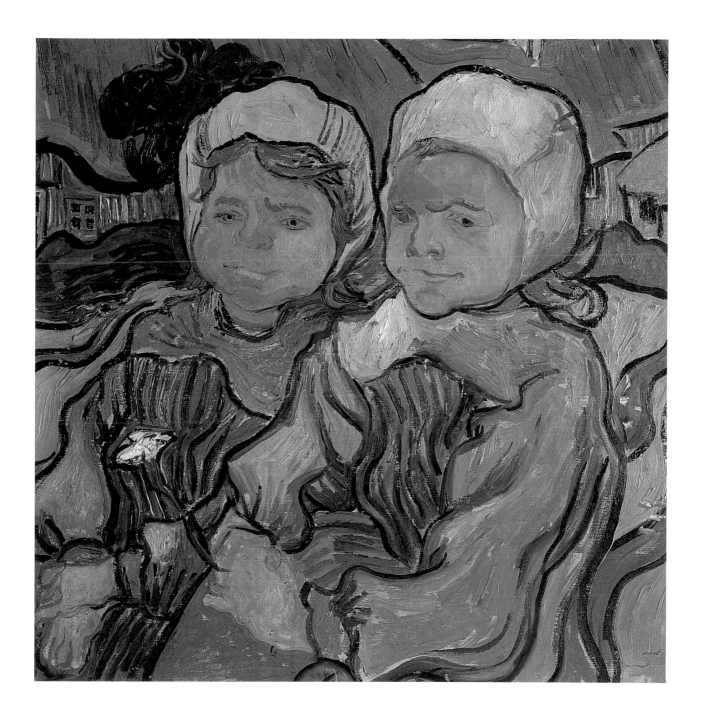

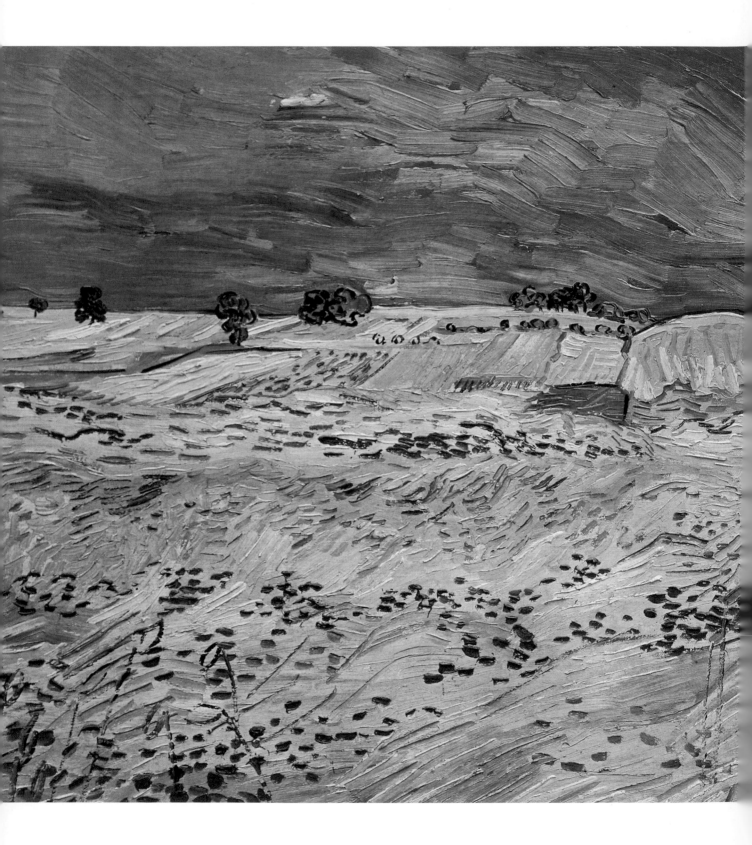

LANDSCAPE WITH A DARK SKY (1890)

Private Collection, Zurich. Celimage.sa/Lessing Archive

ONE of the striking aspects of this painting is the stark contrast between the gloomy gray sky and the bright and vibrant yellow landscape. A dull gray wash over the field enhances the lowering impression of this sky.

Another equally notable element of *Landscape with a Dark Sky* is Van Gogh's assortment of brush techniques, which pervade the painting. In the foreground, we are drawn to the long, sweeping, and exaggerated strokes of the yellow field. Small dots of red are scattered around it, representing small flowering plants. Even in the distance, the trees along the horizon are tailored with spiralling strokes of deep green. The sky also forms a general flow across the sky.

The onlooker is placed directly in front of the field. At this level, we can see a general movement of the field and sky to the right, as though a wind is blowing over the scene.

Van Gogh often visited the Hague's museums and art galleries, such as the Mauritshuis and the Mesdag, where he saw the lyrical contemporary landscapes of the Barbizon and Hague schools. Part of this admiration was reflected in his own landscape works.

Although he spent time in and lived in various cities, including London, Paris, Brussels, and Amsterdam, Van Gogh favored the Dutch landscape. He admired the flat and fertile fields, thatched cottages, and dark, damp atmosphere. Such elements are reflected in *Landscape with a Dark Sky.*

DRINKERS (1890)

Art Institute of Chicago, Chicago. Courtesy of Edimedia

DRINKERS was produced in the style of Honoré Daumier (1808–79), the French artist, sculptor, and caricaturist. He is renowned for his political cartoons, which were published in the anti-government weekly, *Caricature*. In 1832, Daumier produced a satirical sketch of King Louis-Philippe of France, for which he served six months in prison at Sainte-Pelagie.

The intention of a caricature is to exaggerate certain aspects and features of a person's physical demeanor, or perhaps to reveal and mimic certain traits of their personality. *Drinkers* was drawn in an attempt to understand the subject's nature. Such works often bestow an overt political message or criticism, as did those produced by Daumier.

We are confronted with an image of three sad, poor, ordinary workers, who have met for an afternoon beverage. Behind them, light clouds and a blue sky suggest the warmth of a summer's day, although the dark attire and expressions of the men appear out of context in this pleasant environment. Looking closely at their features, we can see that they have been detailed with shadowed and heavily drawn lines. Their postures too, appear skewed and bent, giving them an almost emaciated appearance.

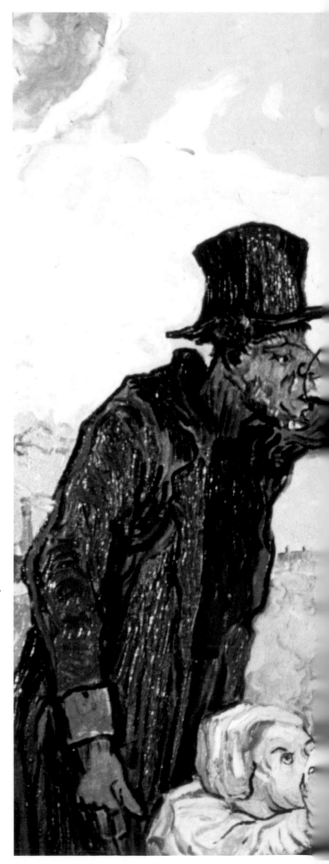

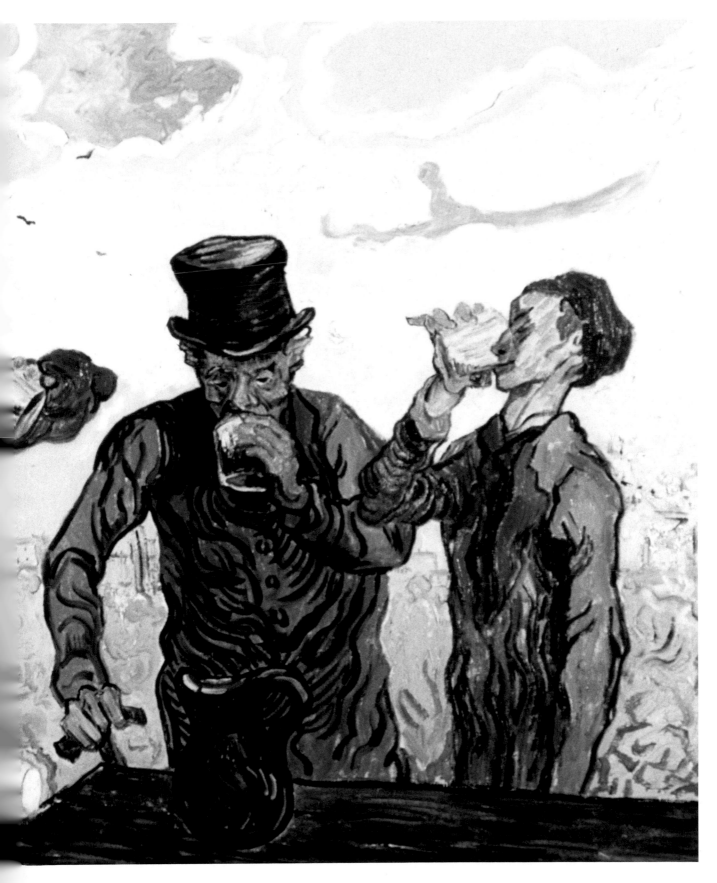

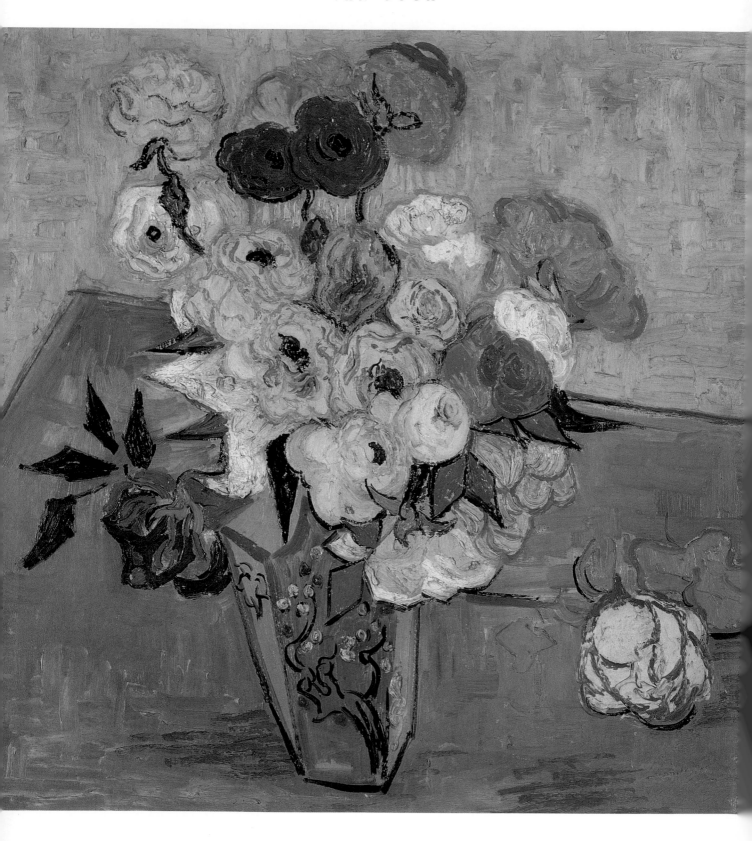

STILL LIFE WITH ROSES AND ANEMONES (1890)

Musée d'Orsay, Paris. Celimage.sa/Lessing Archive

WHILST in Auvers and Saint-Rémy Van Gogh painted a whole series of still lifes with flowers. His prolific output has been attributed by some to a "bout of creative fever" comparable to Nietzsche's (1844–1900), whose life also ended in insanity.

This picture typifies the more decorative style of Van Gogh's art in mid-1890. Nature is rendered as a series of objects whose intrinsic beauty is less important than their potential for artistic transformation. Thus the roses and anemones here are heavily stylized and their shapes clearly defined. Van Gogh was following his own advice "not to copy nature too slavishly." The starkest evidence of this comes in the black, diamond-shaped leaves to the left. Their emphatic flatness is further enforced by being placed against the similarly two-dimensional plane of the table, whose impossible perspective rears up to become a means of display rather than a hard surface on which things could feasibly rest. Everywhere there is similar proof of Van Gogh's commitment—in art-history speak—to "retaining the integrity of the picture plane."

As with *Still Life with Irises* (1890), the rose on the right seems to have been added later. Its rougher, more heavily outlined rendition sits uneasily with the rest of the flowers, which are painted in a delicate, Japanese style.

THATCHED COTTAGES IN AUVERS (1890)

Toledo Museum of Art, Ohio. Courtesy of Edimedia

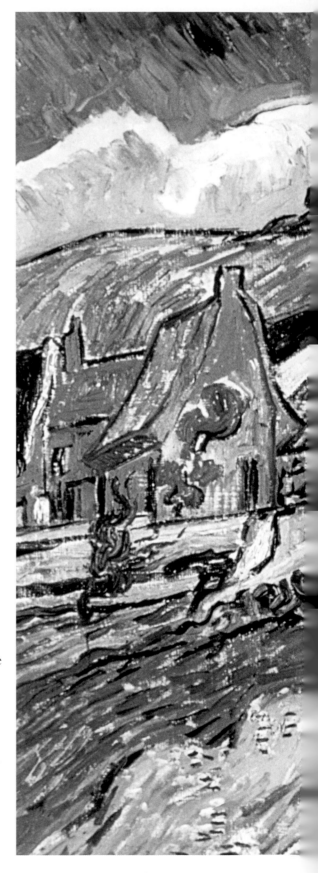

AUVERS had an unassuming character that appealed to Van Gogh at this point in his life. Suitably peaceful and out of the way, it was an ideal retreat from his recent limited successes. Although he had sought critical acclaim in the early days, now that it was almost a reality, Van Gogh shied away from its consequences. As he lamented to Theo: "Success is just about the worst thing that could happen." He even went so far as to ask the Dutch critic J. J. Isaacson, who had spoken favorably of his work in local Dutch newspapers, to cease his written approbation. Maybe he was worried about his mental stability and the effects that too much praise may have had on it.

Certainly Van Gogh shunned most forms of excitement at this time, preferring instead the gentle and relaxing life of the country in places such as this. For all the scene's wholesome rusticity, though, this is not the country as a haven of calm. On the contrary, all is wild activity, swirling with barely a straight line in sight. Perhaps it is understandable that the sky and vegetation take on organic forms, but when the cottage roof is also subjected to this treatment, the painting takes on highly symbolic connotations. The image no longer reads as a realistic depiction of nature, but as a visual indication of Van Gogh's tormented soul.

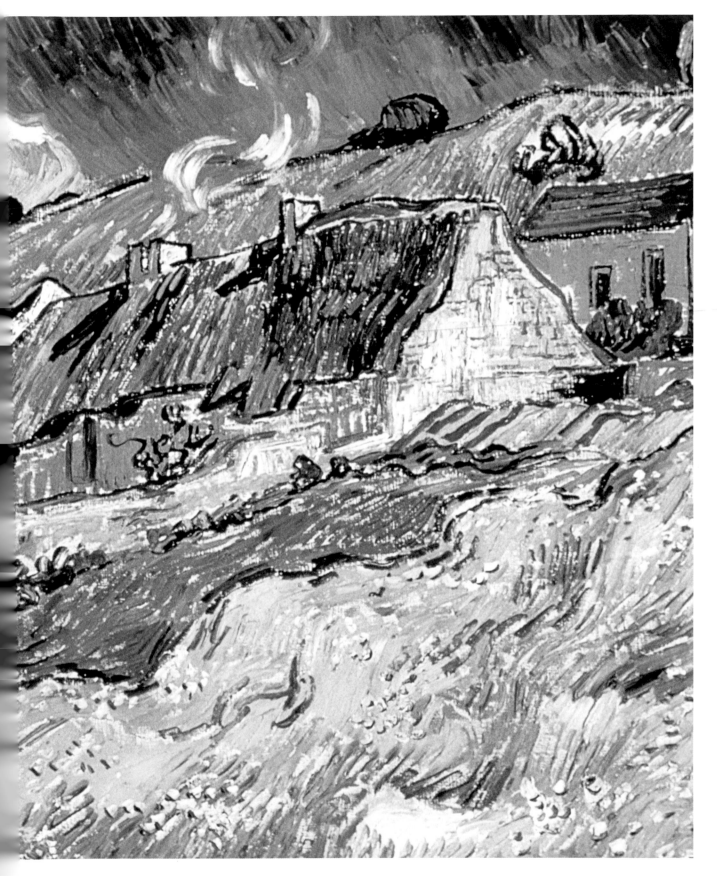

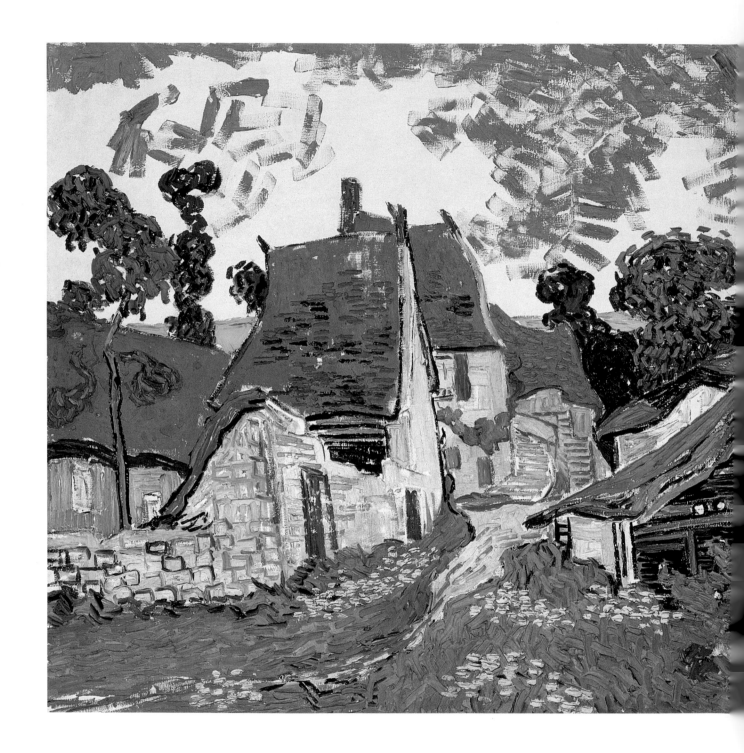

VILLAGE STREET IN AUVERS (1890)
Ateneumin Taidemuseo, Helsinki. Celimage.sa/Lessing Archive

SIMILAR in composition to *Street in Les-Saintes-Maries-de-la-Mer* (1888), painted two years previously, this is a similarly conventional picturesque scene in which the perspectival device of a central street entices us into the pictorial space. Here it is flanked on one side by the sort of village architecture that Van Gogh became so enamored of in Auvers. It is "[the] cottage with its mossy straw roof and sooty chimney" that Van Gogh felt epitomized the rural idyll. In its quaint, vaguely primitive air, he often contrasted the kind of image represented here with "the things of Paris seen à la Baudelaire."

Although Van Gogh's paintings often have bare canvas showing through, the amount revealed here is unprecedented. This has led critics to suggest that the unfinished sky of *Village Street in Auvers* marks it out as Van Gogh's last-ever painting. Whether this is the case or not remains debatable, but it was certainly begun toward the end of his life. This makes it fitting, therefore, that he should have returned to a well-loved theme from his early days in Holland.

WHEAT FIELD WITH CROWS (1890)

The Van Gogh Museum, Amsterdam.
Courtesy of Edimedia

THE identity of Van Gogh's last canvas remains unknown, but this is generally assumed to be it. The reason for such wide concurrence has been determined more by the painting's ominous mood than as a result of any substantial evidence. Van Gogh himself described the image as representing "vast fields of wheat beneath troubled skies." He added: "I did not need to go out of my way to try to express cheerlessness and extreme loneliness in it'" In the same letter, however, he wrote that the picture expressed "the health and forces of renewal that I see in the countryside." Despite these conflicting messages, the former appears to hold sway. The painting undoubtedly contains elements of Van Gogh's extreme melancholy. A major source of his depression was the fact that he remained a financial burden to Theo, who now had a son to support. The vigorous, frustrated brushstrokes bear witness to his troubled mind. A short while after painting this scene, Van Gogh walked into these fields and shot himself in the chest. On July 29, 1890, he died in his brother's arms and was buried the following day in a cemetery nearby.

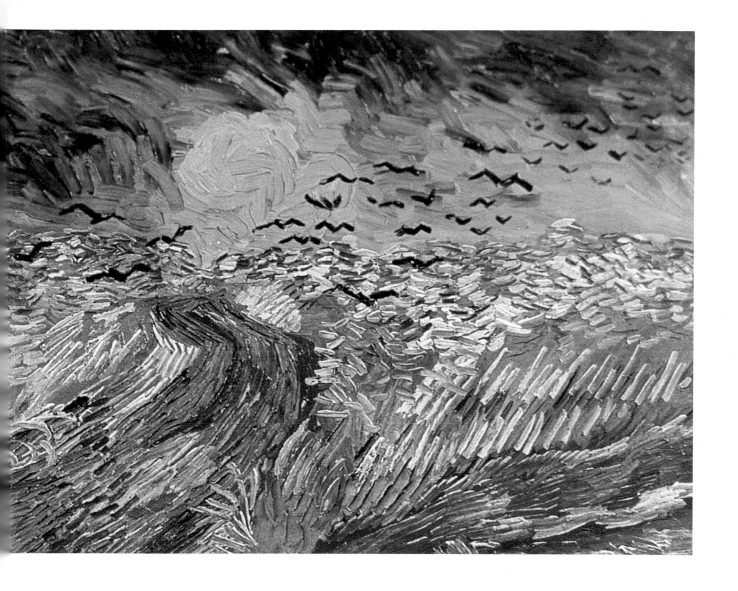

Author Biographies and Acknowledgments

For Alf, another great Francophile

Josephine Cutts and James Smith studied History of Art at the University of Sussex and Goldsmiths College, London, respectively.

For Katie with love

Lucinda Hawksley was born in 1970 and lives in London. She is currently working toward a post-graduate thesis in Literature and History of Art.

Additional and updated text provided by Image Select International, with special thanks to Joanna Nadine Roberts and Peter A. F. Goldberg.

While every endeavor has been made to ensure the accuracy of the reproduction of the images in this book, we would be grateful to receive any comments or suggestions for inclusion in future reprints.

With thanks to Image Select for sourcing the pictures in this book.